THOMSON

COURSE TECHNOLOGY

Professional ■ Technical ■ Reference

M000026655

Quick Snap Guide to

Digital Photography

An Instant Start-Up Manual for New Digital Camera Owners

David D. Busch

ISBN-10: 1-59863-335-X

ISBN-13: 978-1-59863-335-1

Library of Congress Catalog Card Number: 2006906707

Printed in the United States of America

07 08 09 10 11 TW 10 9 8 7 6 5 4 3 2 1

Publisher and General Manager, Thomson Course Technology PTR:
Stacy L. Hiquet

Associate Director of Marketing:
Sarah O'Donnell

Manager of Editorial Services:
Heather Talbot

Marketing Manager:
Heather Hurley

Executive Editor:
Kevin Harreld

Project Editor:
Jenny Davidson

Technical Reviewer:
Michael D. Sullivan

PTR Editorial Services Coordinator:
Erin Johnson

Interior Layout Tech:
Bill Hartman

Cover Designer:
Mike Tanamachi

Indexer:
Katherine Stimson

Proofreader:
Sara Gullion

THOMSON
COURSE TECHNOLOGY
Professional ■ Technical ■ Reference

Thomson Course Technology PTR, a division of Thomson Learning Inc.
25 Thomson Place ■ Boston, MA 02210 ■ http://www.courseptr.com

For Cathy

Acknowledgments

Once again thanks to the folks at Course Technology, who have pioneered publishing digital imaging books in full color at a price anyone can afford. Special thanks to executive editor Kevin Harreld, who always gives me the freedom to let my imagination run free with a topic, as well as my veteran production team including project editor Jenny Davidson and technical editor Mike Sullivan. Also thanks to cover designer, Mike Tanamachi, layout tech, Bill Hartman, and my agent, Carole McClendon, who has the amazing ability to keep both publishers and authors happy.

About the Author

As a roving photojournalist for more than 20 years, **David D. Busch** illustrated his books, magazine articles, and newspaper reports with award-winning images. He's operated his own commercial studio, suffocated in formal dress while shooting weddings-for-hire, and shot sports for a daily newspaper and upstate New York college. His photos have been published in magazines as diverse as *Scientific American* and *Petersen's PhotoGraphic*, and his articles have appeared in *Popular Photography & Imaging*, *The Rangefinder*, *The Professional Photographer*, and hundreds of other publications. He's currently reviewing digital cameras for CNet Networks and *Computer Shopper*.

When About.com named its top five books on Beginning Digital Photography, occupying the #1 and #2 slots were Busch's *Digital Photography All-In-One Desk Reference for Dummies* and *Mastering Digital Photography*. During the past year, he's had as many as five of his books listed in the Top 20 of Amazon.com's Digital Photography Best Seller list—simultaneously! Busch's 90 other books published since 1983 include bestsellers like *Mastering Digital SLR Photography* and *Digital SLR Pro Secrets*.

Busch earned top category honors in the Computer Press Awards the first two years they were given (for *Sorry About The Explosion* and *Secrets of MacWrite, MacPaint and MacDraw*), and later served as Master of Ceremonies for the awards.

Contents

Preface

You're ready to enter the age of digital photography and have purchased your first digital camera. The user manual is an incomprehensible mystery, filled with words and terms you don't understand, like *center-weighted*, *JPEG*, and *image stabilization*. You don't want to spend hours or days studying a comprehensive book on all aspects of digital photography. All you want at this moment is a quick guide that explains the purpose and function of the basic controls, how you should use them, and why. There's plenty of time to learn about file formats, resolution, aperture-priority exposure, and special autofocus modes after you've gone out and taken a few hundred great pictures with your new camera. Why isn't there a book that summarizes whole collections of these concepts in a page or two with lots of illustrations showing what your results will look like when you use this setting or that?

Now there is such a book. If you want a quick introduction to focus zones, electronic flash options, how to use your zoom lens, or which exposure modes are best, this book, written for users of basic to advanced digital cameras, is for you. (A second version, *Quick Snap Guide to Digital SLR Photography* is available for those who own cameras with interchangeable lenses.) If you can't decide on what basic settings to use with your camera because you can't figure out how changing ISO, or white balance, or focus defaults will affect your pictures, you need this *Quick Snap* guide.

I'm not going to tell you everything there is to know about using your digital camera; I'm going to tell you just what you need to get started taking great photos.

Introduction

Here I go again, expanding another niche I helped create. When digital photography began its meteoric rise in popularity and publishers were foisting dozens of "digital camera" books on the public, I insisted on writing about digital *photography*. Then, a host of digital photo books appeared that concentrated on how to get the effects you wanted in Photoshop, when I thought it was a better idea to show you how to get great pictures *in your camera*.

Now I see another niche opening up. There are many photographers who are new to digital photography, and are overwhelmed by their options while underwhelmed by the explanations they receive in their user's manuals. These manuals are great if you already know what you don't know, and can find an answer somewhere in a booklet arranged by menu listings and written by a camera vendor employee who last threw together a manual for a VCR.

While there are a few third-party basic function-oriented how-to books that purport to teach you how to use your camera for a few bucks, they generally deal with certain very popular digital SLR models, such as the Canon Digital Rebel or Nikon D70s/D50. If you own a less advanced or less popular model, you're usually out of luck. There are no books that tell you how to master the controls of your Olympus Stylus, Kodak, Hewlett-Packard, Canon PowerShot, Nikon Coolpix, Pentax Optio, Sony, Samsung, Panasonic, Casio, or Fujifilm digital camera—other than the manual that comes with the camera itself. And those are either too cryptic or too basic to be of much help.

This book doesn't show you exactly which buttons to press to make settings with a digital camera: It tells you *why* you want to make them. You'll learn how to apply various controls, understand where you might find them on your particular camera, and pick up the knowledge you need to visit your camera's manual (if necessary) to locate the exact menu where a setting that does what you want is hidden. No free fish in this book; my goal is to teach you how to fish.

The book is arranged in a browseable layout, so you can thumb through and find the exact information you need quickly. The basics are presented within two-page and four-page spreads, so all the explanations and the illustrations that illuminate them are there for easy viewing. This book should solve many of your problems with a minimum amount of fuss and frustration.

Then, when you're ready to learn more, I hope you pick up one of my other guides to digital photography. Four of them are offered by Thomson Course Technology, each approaching the topic from a different perspective. They include:

The Quick Snap Guide to dSLR Photography.
Once you've mastered your current digital camera, you might decide to move up to a more advanced model with interchangeable lenses. This *Quick Snap* book is the counterpart to the book you're holding in your hands, written for owners of digital SLR cameras. Although most of the illustrations are different, many of the topics are covered in a similar way, so the dSLR *Quick Snap* duplicates much of the coverage of this book. Even so, if you graduate to a dSLR, you might want to have the upgraded version in your camera bag as a reference,

so you can always have the basic knowledge you need with you, even if it doesn't yet reside in your head. (Pass along this book to a friend who is new to digital photography.) The dSLR *Quick Snap* guide, like this book, serves as a refresher that summarizes the basic features of digital cameras, and what settings to use and when, such as continuous autofocus/single autofocus, aperture/shutter priority, EV settings, and so forth. The guide also includes recipes for shooting the most common kinds of pictures, with step-by-step instructions for capturing effective sports photos, portraits, landscapes, and other types of images.

Mastering Digital Photography, Second Edition.

This book is an introduction to digital photography, with nuts-and-bolts explanations of the technology, more in-depth coverage of settings, and whole chapters on the most common types of photography. It delves into some of the topics covered in my *Quick Snap* guides, but in a great deal more detail. Use this

beginner-to-intermediate book to learn additional tips on how to operate your camera and get the most from its capabilities.

Mastering Digital SLR Photography.

This is my dSLR-oriented introduction to digital photography, with more nuts-and-bolts, additional in-depth coverage of settings, and detailed chapters on choosing and using lenses, as well as the most popular types of photography, including close-up and action photography.

Digital SLR Pro Secrets.

This is an even more advanced guide to dSLR photography with greater depth and detail about the topics you're most interested in. It's also filled with fun projects you can tackle to create useful gadgets that will expand your camera's capabilities. If you've already mastered the basics in *Mastering Digital SLR Photography*, this book will take you to the next level.

About This Book

There are easily a hundred books that purport to address the topic of digital photography. I've written a dozen of them myself. Do we really need another book on the topic? Of course we do! An alarming number of the existing

books from other authors cover the topic from *the wrong angle*.

Many of the books on the shelves concentrate on the gee-whiz aspects of the technology and stuff that's only peripherally related to picture taking. Some have as few as three or four chapters actually dealing with digital photography. These were prefaced by chatty chapters explaining the history of digital photography, the pros and cons of digital cameras, and acronym-hobbled discussions of CCD, CMOS, and CIS image sensors. There were thick sections on selecting storage media, and many have perhaps half a dozen

NOTE

Note that this book was written for owners of basic, intermediate, and advanced digital cameras (defined below), and not for those who are wielding digital single lens reflex cameras (dSLRs) with interchangeable lenses. Perhaps you own a pocket-sized camera with few manual controls, and want to use your camera's automatic features most efficiently. Or, you might be working with an intermediate camera with lots of options and a decent allotment of manual controls for shutter speed, metering mode, and focus options. You might reside at the upper reaches of the food chain, with an advanced camera with an electronic viewfinder (EVF), a super zoom lens (usually 8X to 15X zoom range), and other sophisticated options. If you're new to digital photography or to advanced cameras, this book will help you, too. Although this *Quick Snap Guide* isn't written specifically for dSLR cameras, it doesn't ignore their existence, either. From time to time, I'll mention those cameras and their capabilities, usually to differentiate them from the models owned by the typical reader of this book.

chapters on image editing. I'm sick of "digital photography" books that tell you how to get the picture you want after the photo has already been taken, using an image editor like Photoshop or Photoshop Elements. That's not digital photography; that's *picture repair.*

Other books deal with exotic or specialized photographic techniques that can't easily be applied by the average photographer. Most of them assume that you've already mastered your digital camera's controls, and don't require any guidance in why you should select particular settings.

This *Quick Snap* guide makes fewer assumptions. I assume that you're seriously interested in taking better pictures, because you've made the effort to purchase a book that promises to help you achieve this goal. I also assume that you're somewhat new to digital photography and

may not be familiar with all the terms involved in high-tech picture taking. So, I presume that you'll need clear, concise, explanations of most concepts, and provide them within the two- and four-page spreads, and also in the Glossary at the end of this book. Individual spreads, while they are able to stand on their own, build on the material covered in previous sections, so I don't waste a lot of space with numerous cross-references that send you wandering through the book in an endless *Choose Your Own Adventure*-like quest for information. If you encounter a term like *depth-of-field* or *shutter lag*, your best bet is to check the Index first to find the pages that discuss the concept, or read the glossary for a definition.

I also assume that you want lots of illustrations that show the kind of results you can expect if you follow my recommendations. Most of the spreads are dominated by two or three photographs, other artwork, or,

perhaps, a table. This layout will be especially accessible for anyone who falls into one of the following categories:

◆ Individuals who want to get better pictures, or perhaps transform their growing interest in photography into a full-fledged hobby or artistic outlet with digital and advanced techniques.

◆ Those who want to produce more professional-looking images for their personal or business website, and feel that their digital cameras will give them more control and capabilities.

◆ Small business owners with more advanced graphics capabilities who want to use digital photography to document or promote their business.

◆ Corporate workers who may or may not have photographic skills in their job descriptions, but who work regularly with graphics and need to learn how to use images taken with a digital camera for reports, presentations, or other applications.

◆ Professional Webmasters with strong skills in programming (including Java, JavaScript, HTML, Perl, etc.) but little background in photography, but who realize that digitals can be used for sophisticated photography.

◆ Graphic artists and others who already may be adept in image editing with Photoshop or another program, and who may already be using a film camera, but who need to learn more about digital photography.

◆ Trainers, high schools, and colleges, who need a non-threatening introductory textbook for basic digital photography classes.

What Cameras Are Covered

Today, there are four key categories of non-professional digital cameras, and I'll be covering three of them in this book (the fourth type is the digital single lens reflex, or dSLR). The three classes of cameras don't all have the same capabilities, because the range of features is what defines the individual categories in the first place. So, while the

bulk of this book deals with digital photography concepts that apply across the board to any type of camera, you might find sections that cover features that your particular model may not have. To simplify references, I'll refer to the various classes of camera by a generic name: *basic, intermediate, and advanced* digital models, as I mentioned earlier in this introduction. If you're not sure what kind of camera you have, here is a basic description:

◆ **Basic models.** A basic digital camera is one that has the features you need to get good pictures without making a lot of decisions yourself. These cameras generally set the exposure and focus for you automatically with, perhaps, a few options for fine-tuning both. This type of camera is usually small and pocketable, with the most compact models scarcely larger than a stack of credit cards. And, although they might be basic in terms of user controls, such cameras are often rich in features. You might find a dozen or two different "scene" modes which take command of the camera for specific picture-taking situations, such as beach, indoor, or fireworks scenes. Expect to find a 3X to 5X zoom lens. Your basic camera may have interesting in-camera picture trimming capabilities, the ability to collect photos into albums, and to create print orders. There's no reason why you can't have a lot of fun and take great photos with a basic camera, using the guidelines I'll provide in this book.

◆ **Intermediate models.** Cameras that fall into the intermediate category are easy to spot because they provide more user controls for fine-tuning images. You can expect to choose an action-stopping (or creative blur-inducing) shutter speed yourself, with the camera selecting an appropriate aperture. Or, you might want to use the ability to select an aperture to maximize (or minimize) the range of focus in an image. An intermediate camera might have manual exposure and focus, too, along with a selection of more advanced features, such as time-lapse photography, or the ability to stitch several pictures together in a panorama. Look for a 4X to 6X zoom in most of these cameras. Intermediate models are often the same size as more basic cameras, but will have slicker styling, better fit and finish, and, in most cases, a higher price tag. If you own an intermediate camera, you'll be able to apply virtually every technique discussed in this book to improve the quality of your photos.

◆ **Advanced models.** The high end of the cameras discussed in this book are the advanced models, which almost always have either a very long zoom lens range (8X to 15X), an internal LCD viewfinder called an electronic viewfinder (EVF), or both. These cameras are larger in size, often resembling smaller versions of their digital single lens reflex (dSLR) counterparts. They may share many of the performance and shooting features of dSLRs, too, except for interchangeable lenses. Advanced cameras have every capability you can imagine, including the manual exposure/focus controls and fun features found in the basic and intermediate models. Such cameras may actually have *fewer* scene modes (or eschew them altogether), because more advanced users generally like to maintain control over their cameras' settings. If you own one of these little gems, you'll find very few limitations placed on your photography. These cameras are bested only by dSLRs, and can even do a few things that most digital SLRs cannot, such as preview an image on an LCD screen and shoot movie clips.

Who Am I?

You may have seen my photography articles in *Popular Photography & Imaging* magazine. I've also written about 2,000 articles for magazines like (late, lamented) *Petersen's PhotoGraphic*, plus *The Rangefinder, Professional Photographer,* and dozens of other publications. First, and foremost, I'm a photojournalist and made my living in the field until I began devoting most of my time to writing books. Although I love writing, I'm happiest when I'm out taking pictures, which is why I took 10 days off late in 2005 on a solo visit to Toledo, Spain—not as a tourist, because I've been to Toledo no less than a dozen times in the past—but solely to take photographs of the people, landscapes, and monuments that I've grown to love. Since then, I've attended custom car shows, broiled under the sun at professional baseball games, hiked miles through foliage in search of a dramatic waterfall, and stalked animals in wildlife preserves.

Like all my digital photography books, this one was written by someone with an incurable photography bug. I've worked as a sports photographer for an Ohio newspaper and for an upstate New York college. I've operated my own commercial studio and photo lab, cranking out product shots on demand and then printing a few hundred glossy 8 × 10s on a tight deadline for a press kit. I've served as photo-posing instructor for a modeling agency. People have actually paid me to shoot their weddings and immortalize them with portraits. I even prepared press kits and articles on photography as a PR consultant for a large Rochester, N.Y., company which shall remain nameless. My trials and travails with imaging and computer technology have made their way into print in book form an alarming number of times, including a few dozen on scanners and photography.

Like you, I love photography for its own merits, and I view technology as just another tool to help me get the images I see in my mind's eye. But, also like you, I had to master this technology before I could apply it to my work. This book is the result of what I've learned, and I hope it will help you master your digital camera, too.

Chapter Outline

Chapter 1: Exploring Your New Digital Camera

This chapter shows you the main controls, and what they do, and includes a brief discussion of what goes on inside your digital camera. This will get you started.

Chapter 2: Setting Up Your Digital Camera

If you find all the options available in your camera manual confusing, this chapter will help you set up your digital camera, understand battery charging, learn how to format your memory cards, and choose the best resolution and file compression settings.

Chapter 3: Photography: The Basic Controls

Here you'll learn the basics of photography as they apply to a digital camera, including choosing exposure and focus modes, how to adjust ISO for best effect, and selection of an appropriate scene mode.

Chapter 4: Making Light Work for You

Everything you need to know about light to get started, including white balance, electronic flash, and using multiple light sources is included in this chapter.

Chapter 5: Using Your Zoom Lens

This chapter gives you the basics of using the telephoto and wide-angle ranges of your camera's built-in lens, plus suggestions for the use of accessories, such as close-up attachments.

Chapter 6: Creating a Photo

Learn the basics of composition in this chapter, as you master arranging subjects in a pleasing way with interesting angles, orientations, and proportions.

Chapter 7: Exploring Great Themes

Great themes make great photos, and this chapter outlines some of the basic types of photography you may be exploring. You'll learn how to choose the right lens, setup, exposure, and focus method for each of the most popular kinds of picture taking, from architecture to sports to night photography.

Glossary

Want a quick definition of an unfamiliar word? You'll find it here.

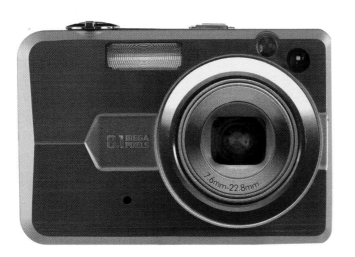

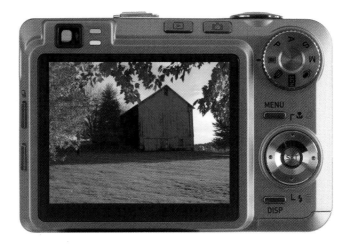

1 Exploring Your New Digital Camera

Let's face it: Digital cameras have *a lot* more buttons and dials than your typical film camera. Even basic point-and-shoot models may have a minimum of a dozen buttons to activate features and navigate menus. Believe it or not, that's a *good* thing, because the ready availability of useful controls lets you access the most-used functions of your camera by pressing a single button and twirling a command dial or thumbing a cursor key. Once you've learned where all the main direct-access buttons reside, this way of working is usually *much* faster than jumping to a menu. The problem, of course, is getting over that hump and learning what all the controls do.

This chapter will introduce you to the key features of your digital camera, with special emphasis on helping you understand the most common features and controls available with virtually every model. Because the controls provided for these cameras differ significantly between basic (compact point-and-shoot), intermediate (pocket-sized models with more features and options), and advanced models (such as super-zoom cameras with electronic viewfinders), I've divided the roadmaps in this chapter into two types. The first set will show you the controls of pocketable basic and intermediate digital cameras, and the second set will illuminate the features of more advanced, EVF cameras.

Although each section includes a photograph of a generic camera, this chapter isn't intended to necessarily serve as an atlas with the location of all the particular features on *your* camera. Although control locations are standardized to a certain extent (that is, you'll *always* find the shutter release button on the top panel at the right side of the camera), some controls are shifted from place to place on the camera body, or, perhaps, relegated to a menu item, depending on a given vendor's design for the camera.

The most important part of the pages that follow is the descriptions of what these particular features *do*. Read the discussions of each control, find its location on your own camera (using my diagrams as a general guide), and then become thoroughly familiar with its use. Once you've mastered the multiple buttons, switches, and keys on your camera, you're well on the way to pixel proficiency.

My example cameras used for the illustrations are drawn from the well-known Nikcasnonlytax 810EXD line, assembled through the magic of an image editor from components scavenged from various camera models, providing a suitably generic base camera that includes most of the common features found in all these models.

Basic-Intermediate Cameras:
Typical Front Controls and What They Do

Here are the main controls found on the front of the basic or inter-mediate-level digital camera, and what they do.

❶ Shutter Release

Pressing the shutter release halfway generally performs several functions. If the metering system has switched itself off, it will revive and begin measuring exposure again. The auto-focus system, if dormant, will again become active. If your camera has been set to fix exposure and focus point when the shutter release is par-tially depressed, those parameters may be locked (See "Automatic Focus Basics" in Chapter 3 for more detail.) Pressing the shutter release down all the way takes the picture.

❷ Electronic Flash

The electronic flash provides illumina-tion when there isn't enough light to take a picture by the existing illumina-tion, and it can also be used to fill in shadows outdoors or in other high-contrast lighting. The flash can be set to fire automatically when needed, flash all the time (useful for fill-flash sit-uations), or can be disabled when you want to avoid using the flash completely, say, for special effects shots such as silhouettes, or in envi-ronments such as museums where flash is forbidden. If your flash is too close to the lens, it can produce red-eye effects in humans (or yellow-eye in animals). This effect is often coun-tered by a pre-flash that causes the subject's pupils to contract, which reduces the effect.

❸ IR Receiver/Focus Assist Lamp/Self-Timer Indicator

This window on the front of many cameras may serve one of several functions. If it is tinted a deep red (almost black), the window may cover an infrared sensor used to trigger the camera with an IR control device. If it is a lighter red or white, the window may instead be used with an LED focus assist lamp that comes on momentarily to provide extra illumina-tion for focusing in low light levels. This lamp might flash during your self-timer's countdown, using a pattern that provides a warning just before the picture is taken. A few cameras have used this lamp as a flasher that causes the subject's irises to shut down just before a flash exposure, reducing red-eye effects. However, it's more common today to have the electronic flash itself provide this pre-flash.

❹ Optical Viewfinder

Many digital cameras have an opti-cal viewfinder window that can be used to compose the photo. This type of viewfinder, which zooms to match the zoom magnification of the lens that takes the picture, is especially useful under dim or very bright light-ing conditions when the back panel LCD is likely to be difficult to view.

The drawback of an optical viewfinder is that it's impossible to judge focus, and, because the win-dow doesn't have the exact same view as the lens/sensor, it's easy to cut off heads or portions of the side of the frame due to a phenomenon called *parallax error*.

❺ Lens/Lens Cover

The lens that takes the photo often retracts behind a protective cover like the one shown in the figure when the digital camera is turned off.

❻ Microphone

Many digital cameras have a micro-phone on the front panel to capture sound when recording movie clips, or to allow the photographer to make voice annotations while shooting.

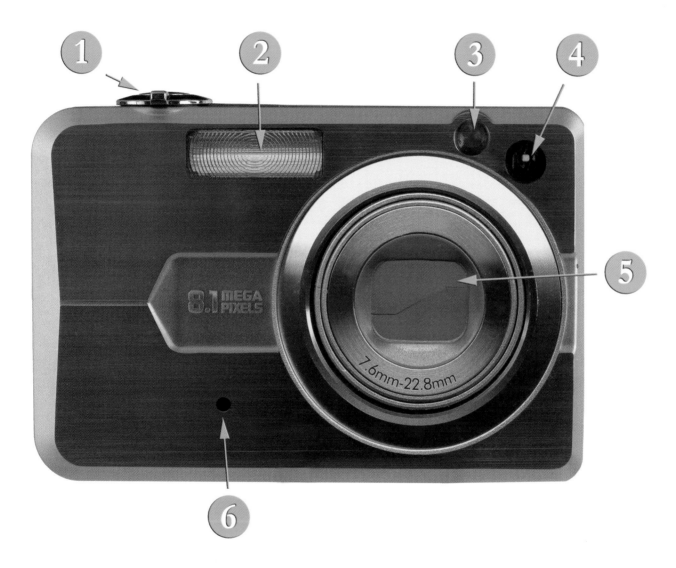

Basic-Intermediate Cameras:
Typical Back Panel Controls and What They Do

The back panel of your digital camera is usually the camera's command center, with most of the important controls and at least one of the key information displays located here. Although it takes a bit of effort to learn the functions of these controls, understanding what each button, dial, or switch does makes operating your camera much faster and more efficient. Note that many cameras assign *several* functions to each button:

① Optical Viewfinder Window
This viewfinder is one way to compose images, although an increasing number of basic and intermediate digital cameras don't include an optical viewfinder at all.

② Status Lights
You'll often find one or two status lights located next to the viewfinder, close enough that you can see them out of one corner of your eye while you look through the viewfinder. These indicators may flash one color (often green) to indicate that the image is in sharp focus, another color (such as yellow) to warn you to wait while the camera saves the current picture to the memory card, and another hue (sometimes a flashing red) to indicate whether the electronic flash is ready to shoot another photo.

③ Hot Shoe
This slide-on connecter accepts an external electronic flash and links it electronically to the camera.

④ Review Button
Press this button to change from recording mode to picture review mode, and back again. Picture review mode is also the mode used to mark images for printing, to view slide shows, and perform other non-picture-taking functions. Digital cameras can usually be set up to display each image for a few seconds after it is shot. If you want to view the image again, or page through multiple images, this button puts your camera into review mode. You can then scroll through your shots with the cursor pad, use the Trash key, and summon the playback menus when the Menu key is pressed.

⑤ Recording Button
Some cameras have a separate button to switch from review mode back to recording mode.

⑥ Shutter Release
Pressing the shutter release halfway generally locks exposure and focus; pressing it down all the way takes the picture.

⑦ Mode Dial
This control is most often a wheel with multiple stops dedicated to individual camera modes. Basic cameras may have only automatic, program, scene, and movie modes. (Review mode is also sometimes located here.) More advanced cameras may have modes for manual exposure, shutter-priority, and aperture-priority. When a camera offers a few scene modes (see Chapter 3 for more information on using scenes), they may all be arrayed on this dial, or there may be a single SCN (Scene) position, with the scenes chosen from a menu or by pressing another button.

⑧ Menu
Your camera's menu system can be activated by pressing this button. Often, a different set of menus will appear depending on whether the camera is in playback or shooting mode. The menus will be laid out in various pages and layers, grouped by type of function. One menu layer might allow you to adjust the current shooting parameters for a session; another might control semi-permanent camera settings and custom features. Some cameras supplement the Menu button with a Func button, which produces a different set of menus for common picture-taking functions.

⑨ Control Pad
The four-way cursor/control pad is the Command Central of most digital cameras. The up, down, left, and right buttons are used to navigate menus, with the central OK/SET button the most common control for selecting a highlighted option. The cursor directional buttons frequently serve double- or triple-duty, with additional functions such as switching in/out of macro mode, choosing flash options, adjusting exposure settings, or manually focusing the lens.

⑩ Display Info

This button lets you control what types of information are displayed on the LCD before exposure and during the review. Perhaps you want only the picture number, date, file format, quality setting, and other basic information to be shown. Or, you might prefer to see what kind of metering mode was used, along with shutter speed and aperture, the focal length of the lens, and so forth. The ISO setting, white balance, informational comments, or even histogram charts showing graphically how well the image is exposed, can also be chosen. Usually, these information options are selected by pressing the Display Info button several times to cycle among them, or by holding down the button and changing the option with a cursor key or command dial.

⑪ LCD

This color LCD, usually measuring 1.5 to 3.0 inches diagonally, is used for viewing images before you take the picture, reviewing images after they've been taken, and for navigating the camera's menu system. It can be used for evaluating pictures, choosing those to be deleted, and for selecting features and settings in the menu. In the sample picture, the information displayed includes the ISO setting, exposure meter pattern, and battery condition.

⑫ USB/DC/AV Ports

Digital cameras include one or more ports used to connect the camera to another device over a USB cable, to provide DC power to run the camera independently of the battery, or to direct the camera's LCD display output to an external monitor. These ports are most often located on the back or left side panels, and are often hidden behind a rubber or plastic cover.

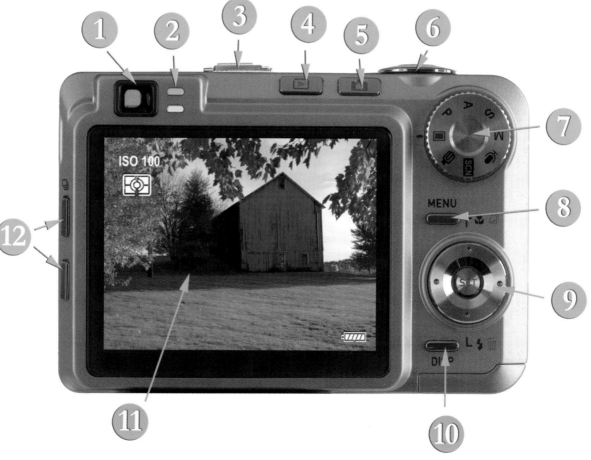

Basic/Intermediate Cameras:
Typical Top Panel Controls and What They Do

The top panel of your digital camera has its own set of controls and features, although they usually aren't numerous or complicated. (Some cameras have nothing more than a power switch and shutter release button on top.) So, learning to use these controls will be a snap!

❶ Lens
When your camera is powered up, the lens, if retracted, will extend from the camera. With some models, the lens also tucks itself away inside during picture review after a period of time (usually a minute or two). Some digital camera lenses are threaded to accept filters or add-on lens attachments. Several Canon models have a removable collar around the base of the lens that can be unsnapped and replaced with a tube that has a filter thread on it, or with optional wide-angle and telephoto lens attachments.

❷ External Flash Hot Shoe
The "foot" of an external electronic flash slides into this shoe, which provides both a mount and electrical connection to the camera. A hot shoe is not usually found on very compact models, nor on very basic cameras of any size; it's a more advanced feature that appears on intermediate and advanced cameras. Speedlights designed to work with a specific camera exchange information with the camera. The camera may report the zoom setting of the lens so the flash can change its coverage angle to suit; the flash delivers information about things like the power setting of the unit. This information exchange allows fully automatic flash exposure with through-the-lens metering. The flash unit can also be used detached from the camera with a special cable plugged into the hot shoe. The shoe also may accept wireless remote control devices and generic, non-dedicated flash units.

❸ On/Off Power Switch
The power switch is usually next to the shutter release, but sometimes it is located concentrically with the shutter release or placed on the mode dial or a separate switch on the back of the camera. It powers your camera on and off.

❹ Zoom Lever
This lever zooms your lens in and out, changing the magnification to enlarge or reduce the apparent size of your subject. Some basic cameras may have a limited number of zoom "stops," so that the zoom goes from one magnification to the next in short jumps, rather than smoothly zooming over the entire focal length range. Many cameras also use the zoom lever to zoom in and out of pictures being reviewed on the LCD.

❺ Shutter Release
Pressing the shutter release halfway generally performs several functions. If the metering system has switched itself off, it will revive and begin measuring exposure again. A picture being reviewed on the rear-panel LCD will vanish as the camera switches from review back to picture-taking mode. The autofocus system, if dormant, will again become active. If your camera has been set to fix exposure and focus point when the shutter release is partially depressed, those parameters may be locked. (See "Automatic Focus Basics" in Chapter 3 for more detail.) Pressing the shutter release down all the way takes the picture.

❻ Speaker
A tiny set of holes may be your only indication of where your camera's audio speaker resides. Most often the speaker is located on top of the camera, but some models place it on the back panel or even the underside. The sound quality of this speaker varies from atrocious to fairly good. A small number of digital cameras (usually those that double as camcorders) have two speakers to accompany a pair of microphones, providing you with tinny, but serviceable stereo playback.

❼ Mode Dial

This control has multiple notches dedicated to individual camera modes. Basic cameras may have only Automatic, Program, Scene, and Movie modes. (Review mode is also sometimes located here.) More advanced cameras may have modes for Manual exposure, Shutter-Priority, and Aperture-Priority. When a camera offers a few scene modes (see Chapter 3 for more information on using scenes), they may all be arrayed on this dial, or there may be a single SCN (Scene) position, with the scenes chosen from a menu or by pressing another button.

❽ Recording Button

Some cameras have a separate button to switch from Review mode back to Recording mode.

❾ Review Button

Press this button to change from Recording mode to Review mode, and back again. Review mode is also the mode used to mark images for printing, to view slide shows, and perform other non-picture-taking functions. Digital cameras can usually be set up to display each image for a few seconds after it is shot. If you want to view the image again, or page through multiple images, this button puts your camera into Review mode. You can then page through your shots on the back panel LCD with the cursor pad, use the Trash key, and summon the playback menus when the Menu key is pressed.

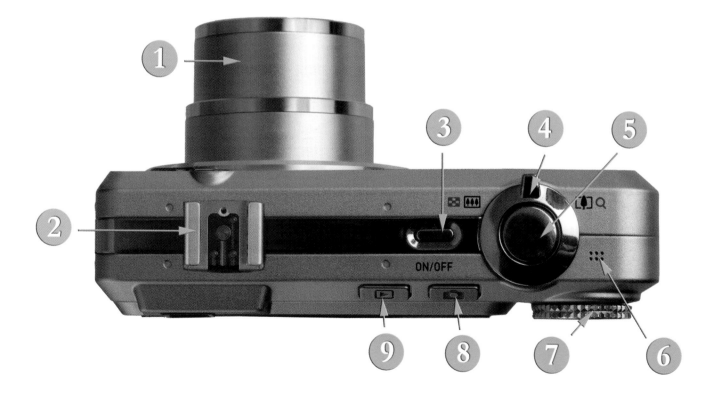

Basic/Intermediate Cameras:
Typical Bottom Panel Controls and What They Do

You won't find many controls on the bottom of most basic/intermediate digital cameras, although some vendors tuck away the speaker here.

❶ Tripod Socket
The tripod connector is a threaded socket that accepts a standard 1/4-inch or 3/8-inch tripod screw or other threaded accessory device, such as a flash bracket, designed to fasten to the underside of the camera. Ideally, the tripod socket will be made of metal rather than plastic to better withstand the rigors of frequent attachment/detachment. It's also better to have the socket centered along the same axis as the lens so that the camera can be rotated more precisely when shooting wide-format panorama shots with the camera mounted on the tripod. A few ultracompact digital cameras have no tripod socket at all, and several require use of a special adapter or mounting the camera in the recharging dock before it can be attached to a tripod.

❷ Cradle/AV/USB Connector
Some digital cameras use a socket on the underside of the camera to con- nect the camera to an external inter- face when it is dropped into a cradle, printer dock, or other accessory made specifically for that camera. The cradled camera can then be con- nected to a computer for picture trans- fer, display, or recharging the battery.

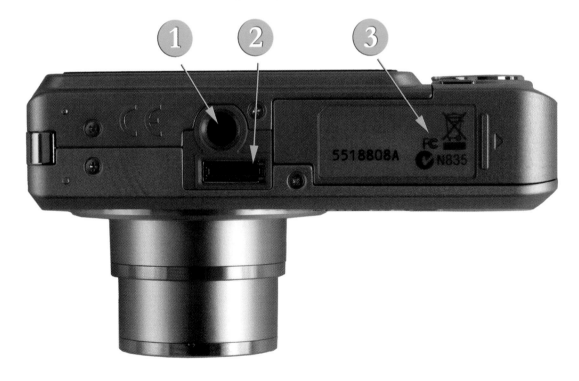

③ **Battery/AV/USB/DC/
Memory Card Cover**
Many digital cameras tuck multiple
access slots inside a large flip-up
cover on the bottom of the camera.
Among the goodies you'll find:

◆ **Battery Compartment.** You'll
find a nest for the camera's
rechargeable battery pack or, per-
haps, two to four AAA or AA cells
of the alkaline or rechargeable
variety.

◆ **Memory Card Slot.** Most com-
pact and intermediate digital cam-
eras use SD, xD, or Memory Stick
media, and there will be a place to
slide the memory in next to the bat-
tery compartment.

◆ **AV/USB/DC Connectors.** If
your digital camera doesn't place
its external connectors elsewhere,
they will probably be found here
under this cover.

Advanced/EVF Cameras:
Typical Front Controls and What They Do

Here are the main controls found on the front of more advanced EVF cameras and what they do. If you're familiar with digital SLRs, you'll see that these more sophisticated cameras have a lot in common with their interchangeable lens counterparts.

❶ Control Wheel/Jog Wheel
This control is usually placed near the shutter release or on the back of the camera so it can be operated easily by the index finger or thumb of the right hand. Some cameras have two control wheels. This dial is used to change settings when the camera is up to your eye just before the photo is taken. For example, one camera puts the control wheel to work changing both shutter speed and aperture set-tings (depending on whether the shut-ter speed or lens opening control but-tons are pressed with the other hand). The same camera uses this wheel to change filter processing effects, flip between various white balance set-tings, and to adjust other parameters.

❷ Shutter Release
Pressing the shutter release partway down locks the exposure and focus settings of most cameras and may trigger a display of information about those settings in the viewfinder. Press the shutter release down all the way to take the photo.

❸ Microphone/Speaker
Many digital cameras have voice annotation capabilities that let you record comments about each photo as it's taken. The microphone can also record sound when the camera is used in Motion Picture mode.

Cameras can also emit sounds, either during playback of annotations/movies, or to simulate the sound a mechanical shutter makes when the picture is taken.

❹ Handgrip
The handgrip gives you something solid to hold and helps position your fingers over the shutter release and other controls on the right side of the camera. In compact cameras, the handgrip may be small, bordering on the vestigial; as cameras grow in sophistication, their handgrips gener-ally grow with them.

❺ Focus Ring
Advanced digital cameras that allow manual focus may place the focusing ring around the lens for convenience and for familiarity—because that's how focusing is done with a film camera—and for design reasons (when the ring physically moves lens elements to achieve sharp focus). Other cameras may provide manual focus using the cursor pad keys or a zoom rocker switch.

❻ Zoom Ring
You'll find one of two common sys-tems used to change the zoom setting of a digital camera. Some cameras have W (Wide) and T (Tele) buttons or a rocker switch on the back sur-face of the camera, or concentric with the shutter release button on top, which operate a motorized zoom fea-ture. Advanced cameras may work more like traditional film cameras with manually operated zoom, often using a ring around the circumference of the lens.

❼ Lens

Every digital camera has a lens of some sort, which will usually be marked with the actual focal length settings of the lens, plus, often, with the equivalent length for a 35mm camera. Our example camera has a 7.2mm to 50.8mm zoom lens, the equivalent of a 28mm to 200mm lens on a full frame film camera. Because sensor size varies, the amount of magnification provided by a lens of a particular focal length varies from camera to camera, so equivalent focal lengths are used to make comparisons easier.

❽ Filter Thread

Most lens accessories attach via a screw-on thread on the front of the lens. These can range from close-up attachments to add-on wide-angle and telephoto converters that enhance the magnification range of your fixed lens. You can also attach various filters, lens hoods, and other accessories to the filter thread. The advantage of a standard screw thread on the front of your lens is that you can attach a wide variety of accessories, including inexpensive add-ons not made by your camera vendor. Note that not all cameras come with this convenient feature, and some require special adapters to attach even the simplest lens accessory.

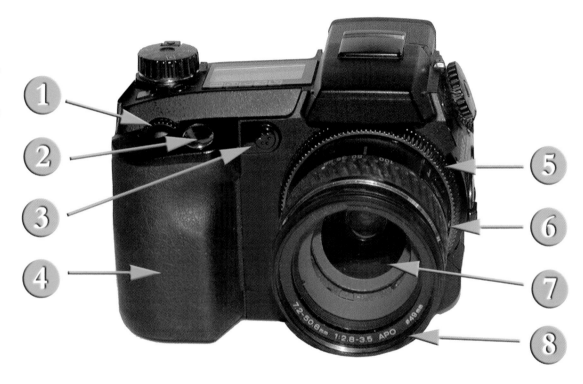

Advanced/EVF Cameras:
Typical Back Panel Controls and What They Do

The back panel of your advanced digital camera is usually the camera's command center, with most of the important controls and at least one of the key information readouts located here. Although it takes a bit of effort to learn the functions of these controls, understanding what each button, dial, or switch does makes operating your camera much faster and more efficient. Note that many cameras assign *several* functions to each button: In playback mode, a button might do one thing, but do something completely different in shooting mode.

❶ Eyepiece
Most digital cameras have an eyepiece for viewing either the optical viewfinder or the internal electronic viewfinder (for through-the-lens view). However, while an increasing number of compact digital cameras have no optical viewfinder at all and rely totally on the back-panel LCD for viewing and reviewing images, more advanced cameras tend to use an electronic viewfinder. The EVF is a small LCD inside the camera. Those with EVFs often have a control for adding plus or minus diopter correction so that photographers with vision problems can view without needing to wear their glasses. This particular camera model also has a sensor to the right of the eyepiece to turn the electronic viewfinder on and off as you move the camera to your eye, saving power. It can also be set to switch from the EVF to the back panel LCD when you move your eye from the viewfinder.

❷ LCD View Screen
This screen can be used to display menus, to frame your compositions, preview images, review images, and to focus (if your camera doesn't have an electronic viewfinder or SLR view). Most cameras also display status information, such as shutter speed, histogram charts that show exposure information, or the number of shots remaining.

❸ Battery Compartment
Most digital cameras use removable rechargeable battery cells or packs. Others may use disposable lithium cells or standard AA batteries. The compartment may open on the back of the camera, the bottom, or one side, depending on your model.

❹ Viewfinder Display Controls
You may be able to adjust the type of information displayed in your camera's viewfinder. Options include a plain view, a view with focus area showing, or a complete view with all status information (such as focus, exposure, shooting mode) displayed. Choose a plain view to declutter your viewfinder or opt for a full display to give you the most information as you shoot. Some cameras have a viewfinder control that sets whether the LCD or electronic viewfinders are used alone or in combination, while others rely on menu controls for these features.

❺ Spot Meter/Spot Focus Control
Digital cameras sometimes have a button that switches metering or focusing into a "spot" mode that reads from a small section of the image shown in the viewfinder. You can use this control to fine-tune exposure or focus to a specific area.

⑥ Menu Button

Pressing this button pops up various setup menus in your LCD display or electronic viewfinder. Many camera functions not controlled by specific buttons and dials can be set through menus.

⑦ Cursor Controls

The cursor movement controls serve multiple functions in most cameras. You might use them to navigate menus, move from picture to picture in Review mode, relocate the focusing "spot," or scroll around enlarged views of images. The button in the center selects the highlighted menu option or performs some other Set/OK/Enter key function.

⑧ Quick View/Delete Button

Automatically trashes the most recent photo you shot or lets you call the image back to the LCD screen for review.

⑨ Ports and Sockets

Digital cameras bristle with various ports and sockets, ranging from DC power jacks to USB connections to audio/video OUT connectors.

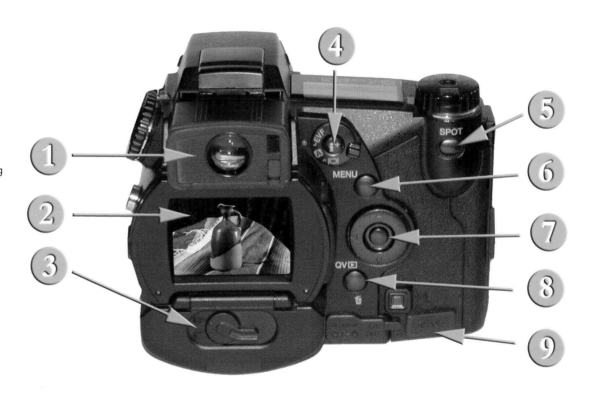

Advanced/EVF Cameras:
Typical Top Panel Controls and What They Do

The top panel of your digital camera has its own set of controls and features, although they usually aren't numerous or complicated to learn. Unlike basic and intermediate cameras, which may have nothing but a power switch and shutter release on top, advanced cameras are likely to have a few more buttons and switches.

❶ Hot Shoe Cover
You may find a mount to hold a more powerful electronic flash unit on top of your digital camera. This "hot shoe" provides electrical contact with the camera and is frequently protected by a plastic cover like the one shown in the illustration.

❷ Viewfinder Swivel
Your electronic or LCD viewfinder may swivel to let you point the camera in one direction and view from another angle. Some models, like our example camera, allow only a small amount of adjustment, from 0 to 90 degrees. Others let you swing the LCD out and twist it to many different angles. Several models let you point both the LCD and lens at yourself (so you can shoot a self-portrait) and automatically invert the LCD display when you've turned the viewscreen 180 degrees (to avoid the need to look at an upside-down view of yourself).

❸ Exposure Program/Scene Modes
Choosing the right combination of shutter speed and lens opening can be tricky, so camera vendors have computerized the process. The example camera has five different program settings or scene modes for (left to right) portraits, action photos, sunsets, night portraits, and text. These are chosen by pressing the button to the immediate right of the program mode strip.

❹ Shutter Release
Pressing the shutter release partway down locks the exposure and focus settings of most cameras, and may display those settings in the viewfinder. Press the shutter release down all the way to take the photo.

❺ Control Wheel/Jog Wheel
This wheel is used in conjunction with another control to change specific settings just before the picture is snapped.

❻ Program Button
Use this button to change program exposure mode or scene mode. On our sample camera, the button marked P resets the camera to normal program exposure mode.

❼ Main Control/Mode Dial
This dial controls the camera's main functions, such as switching the camera on and off, changing from Shooting mode to Playback or Movie modes, or setting up controls and transfering images from your camera to your computer.

❽ LCD Status Screen
This monochrome display shows the number of pictures left, exposure Program mode, and other status information. This data is sometimes repeated in the viewfinder.

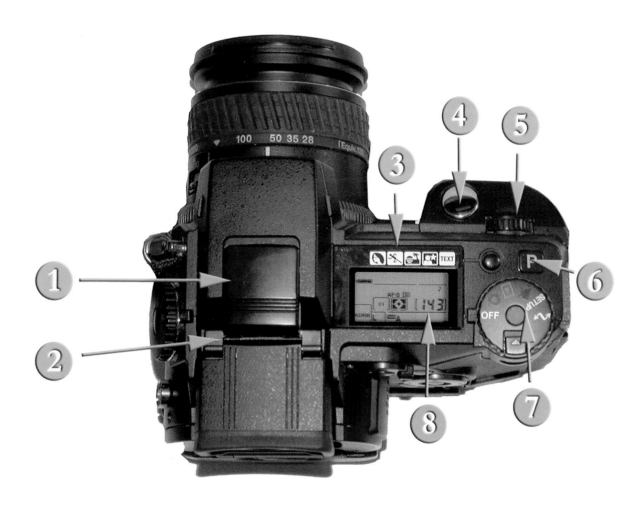

Advanced/EVF Cameras:
Typical Side Panel Controls and What They Do

Many advanced/EVF cameras use the left side of the camera for some controls on the theory that you're holding the camera grip with your right hand, so the left hand is free to fiddle with buttons and knobs.

❶ Flip-Up Electronic Flash

The best electronic flash on digital cameras flip up to raise them as far from the lens as possible to better reduce red-eye effects (which are accentuated when the lens and flash are located close together). Usually, raising the flash also turns it on, unless you've explicitly disabled the flash using your camera's controls.

❷ Zoom Ring

Changing the magnification of a lens manually with a zoom ring is usually faster than the motorized zooms some cameras have. Generally, inexpensive cameras with 3:1 or less zoom ratios use motorized zoom, while more expensive cameras with much longer zoom ratios (like the 7:1 of our example camera) use manual zoom because it's faster for such long stretches.

❸ Macro Button

Digital cameras with close-up capabilities usually have a macro button to switch to close-focusing mode. The button may be on the lens (as in this case) or located elsewhere on the camera. Many cameras let you switch into Macro mode by pressing one of the cursor pad buttons, avoiding a trip to the menus.

❹ Focus Ring

Manual focus, if available, is most convenient when a ring around the lens is used to adjust the focus position.

❺ Filter/Color/Contrast/Exposure Options

Multifunction dials are the norm with digital cameras. This one can be set to four different positions. The user then presses the button in the center of the dial and chooses the option desired with the control/jog wheel. Options for this dial include colored filters, color saturation, contrast, and exposure compensation.

❻ Sensitivity/Program Mode/White Balance/Focus/Sequence Options

In this case the options are MEM (store current camera settings for instant recall); Metering mode (choose from segmented, spot, or center-weighted readings); PASM (select between Programmed exposure, Aperture-Priority or Shutter-Priority, and Manual); Drive (single or multiple exposures, plus self-timer and time-lapse); WB (white balance options); or ISO (sensor "sensitivity" or "speed").

❼ Automatic Focus/Manual Focus Button

I won't use a digital camera that doesn't have this kind of focus control. Press the button to toggle between automatic and manual focus. That's it! Digital SLR cameras may have an AF/M slide switch on the lens or camera body. Some digital cameras force you to switch to manual mode or use menu options to access manual focus. Ack!

❽ External Flash Terminal

While many digital cameras accept detachable flash units, some of them are so sensitive to the voltage used to trip the flash that you must use only electronic flash offered by or recommended by the vendor. A better option is a standard external flash terminal like this one, which allows you to use virtually *any* third-party flash unit. If your digital camera does not have an external PC connection, you may be able to find one that slides into the hot shoe. However, you may have to make some manual settings.

❾ Eyepiece Diopter Correction Control

If you wear glasses, use the diopter control to correct for some kinds of vision problems so you can view your subject without those spectacles, if you so desire.

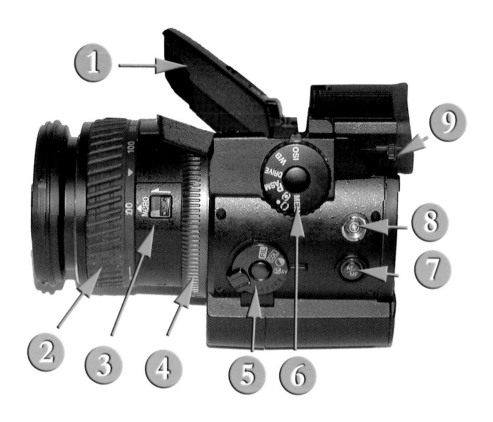

Inserting Media

You don't need to be a veteran digital camera user to know about memory cards. You may have used them to transport tunes to your portable MP3 player, or to archive settings from your PlayStation. Camcorders use them, too. Exchangeable media gives your digital camera virtually limitless shooting capacity. When your digital "film" fills up, just remove it and replace with another memory card. The majority of the latest digital cameras use Secure Digital/SD solid-state memory. Older basic/intermediate digital cameras may use CompactFlash cards, which are also commonly found in digital SLRs. Some of the newest compact digital cameras accept xD Picture Cards or Sony Memory Sticks (usually Memory Stick Pro or Memory Stick Pro Duo varieties). There are a few other formats, such as MMC (Multi Media Card—similar in form factor to the SD card), and mini versions of more common formats. A few advanced cameras have multiple slots for use with several different formats at once, such as CompactFlash and SD, or CompactFlash and xD.

To insert your media just follow these steps:

❶ Open the media slot cover. The cover over your memory card slot can be flipped up when you want to remove or insert a card. Some camera models require pressing a button to open this cover. Because of the delicate electrical contacts inside, your media slot is a potential weak point. Moisture that gets inside can damage

SPEED AND CAPACITY

Your choice of memory cards will generally be limited to two parameters: speed and capacity.

Speed. The faster a memory card is able to accept data from your camera, the faster, in theory, your camera can shoot sequences of pictures. In practice, continuous bursts of images first go into a special area of memory in your camera called a *buffer*, which may be large enough to hold 10–20 pictures. Only when the buffer is full does the speed of the memory card come into play. Vendors use different terminology to represent the relative speed of their cards; some may offer Standard, Ultra, and Extreme versions, while others will sell 15X, 50X, 80X, or even 150X cards (which compare the media's writing speed with a "standard" memory card). If you feel the need for speed, you can compare apples to apples with the figures compiled at http://www.robgalbraith.com.

Capacity. The number of exposures that will fit on your memory card is likely to have a more immediate impact on your shooting. Most digital camera owners purchase memory cards with 1GB, 2GB, or 4GB capacity. An important thing to remember is that your media just may outlive your current digital camera in terms of useful life, and you should purchase cards today with that in mind. Although those 512MB cards work fine with your 6-megapixel camera today, in three or four years when you replace your current model with a $500, 12-megapixel model, those same cards may hold only a few dozen shots. Buying 4GB cards now can end up saving money in the long run.

the camera, so a slot cover with weather seals is a plus. In any case, you should be extra careful when changing media during rainy or snowy weather. Some media covers lack well-designed hinges, so you should also be careful to avoid damaging the door when it's open.

❷ Slide in the removable media.

Your memory card goes in the slot. Pay attention to the proper orientation of the card (usually the label of the card faces the outer edge of the camera) and don't force it when inserting. There may be a button to press to eject a CompactFlash card, but with SD and xD cards, pressing the media inward releases a catch, causing the card to pop out.

❸ Close the compartment cover.

Be sure to close the cover securely, allowing the latch or catch to engage completely. Some digital cameras have a poorly designed cover, so it's worth taking the time to make sure it's closed properly.

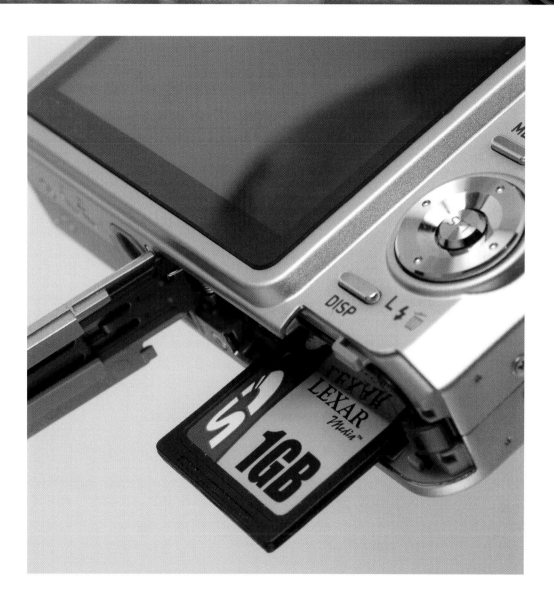

Using Electronic Flash

Electronic flash is a lightning-fast artificial light source built into your camera that provides illumination when the available light is too dim to take a picture. It can also be used to fill in the shadows of scenes with too much contrast. One advantage of electronic flash is that its duration is so brief that it stops action in its tracks if it's the primary source of illumination, often more effectively than all but the briefest of time-slicing shutter speeds. Its key disadvantages are that flash can provide unattractive, glaring lighting, may produce glowing red pupils in humans ("red eye"), and has a range that may be limited to 10-12 feet from the camera.

You'll find out more about flash in Chapter 4.

Some basic, intermediate, and advanced digital cameras can be outfitted with more powerful external flash units, too, but all of them have a built-in electronic flash. Some of the more expensive dSLR models lack this feature on the theory that users of upscale cameras prefer to use more versatile external flash units.

Key components to be aware of when using electronic flash were roadmapped earlier in this chapter. They are:

❶ **Electronic Flash Tube**
The electronic flash tube is tucked behind a plastic window that directs and diffuses the light, providing illumination that covers the angle of view the flash was designed for. Sometimes the internal flash will not cover the image area of particular wide-angle lenses, or may cast a shadow from the lens or lens hood onto your subject area. While convenient, the internal flash might not be positioned well enough to reduce red-eye effects (more on this in Chapter 4), and in such cases you might find an external flash (which is more powerful to boot) will do a better job for you.

❷ **Flash Mode/Flash Compensation Button**
Digital cameras will have one or more buttons used to adjust the flash mode and exposure compensation, often in conjunction with a command

LOOK FOR FLASH MODES

The most common flash setting you'll need to make involves flash mode. Your choices include:

Always flash. Any time you flip up the electronic flash or connect an external flash, the flash will fire as the exposure is made.

Auto flash. The flash fires only when there isn't enough light for an exposure by available light.

Fill flash. The flash fires at a reduced illumination level, providing only enough light to fill in dark shadows caused by the contrasty main light source (which is often daylight).

Red-eye flash. A pre-flash fires before the main flash, contracting the pupils of your subject, reducing the chances of red-eye effects.

Slow synch. Allows using the flash in combination with slow shutter speeds, so that both the ambient illumination and electronic flash contribute to the exposure. This is an especially good option when shooting outdoors at night, particularly if your camera can be mounted on a tripod to avoid blurriness from the long shutter speed. You'll find information about this option in Chapter 4.

dial that's spun while the button is pressed down. Flash mode is one of the modes described in the previous sidebar. Flash exposure compensation is additional or less exposure applied to override the exposure determined by your camera's flash metering system. If you discover that photos of a scene are consistently over- or underexposed, you can add or subtract EV values to increase or decrease the relative exposure. Flash EV settings are typically 2 to 3 EV (each EV doubles or halves the exposure), in 1/2 to 1/3 EV steps.

❸ External Flash Hot Shoe or PC/X Connector

More advanced digital cameras may have a hot shoe to slide in an external flash, or a PC/X connector that can be used to connect an external flash using a cable. These connectors, often located under a protective plastic or rubber cover, accept standard flash accessories for using external flash units. Automated exposure and other features are available only when an appropriate external flash is attached using a connector designed for that purpose, including those that work through the camera's hot shoe. The PC/X connector provides only a triggering mechanism for the flash, and flash output must be controlled at the flash itself.

Setting Up Your Digital Camera

Even point-and-shoot cameras aren't quite ready to go right out of the box. Before you can begin pointing, you'll usually need to set up your camera, make some initial settings, and prepare it for use. If you purchased your digital camera in a full-service retailer, it's likely that the store personnel helped you set up your camera, explained some of the key controls, and gave you a quick tour of the main features. That's one of the best reasons for buying from a local store that specializes in photography and imaging products, even if the price you pay is a little higher. However, the reality is that many digital cameras are bought from "big box" electronics stores and other outlets staffed by sales people rather than photographers, and all you may receive is a box and a handshake. That's okay, too, if you need a handshake more than handholding.

Large numbers of digital cameras are also sold by mail order and over the Internet with very little interaction between you and the vendor. It's very likely that when you open the box and unpack your new digital camera, you're on your own, alone with the camera manufacturer's Quick Start poster and not much more in the way of information. The manual that came with your camera may be fairly helpful, but it probably offers only the basics without any background that explains *why* you're performing the various setup tasks. If you've bought this book, however, you're not entirely without setup help. This chapter provides an overview that you should find helpful when configuring your camera.

Battery Charging and Battery Life

All digital cameras use one or more batteries, which provide electrical power for the camera's various functions. One of these will be the main battery, usually a rechargeable nickel metal hydride (NiMH) or lithium ion (Li-Ion) power pack that can be removed from the camera for recharging or replacement, or which can be charged while it's still in the camera. The disadvantage of in-camera charging, of course, is that you can't use your camera while the internal battery is being recharged. If you have a choice, a camera with removable cells, which can be replaced with another set so you can continue shooting, is the best option.

Your digital camera might also operate using standard AAA or AA batteries (alkalines or rechargeables), non-rechargeable lithium cells, or an AC adapter that can be helpful when using the camera for long periods, such as when you're shooting time-lapse sequences that can last hours or days.

You might not be aware that your digital camera could also have a second "secret" battery, often called a *clock battery* because it powers the memory that retains various settings, including the time and when the main battery has been completely discharged or removed. Without this secondary cell, all the customized settings you've made, as well as the current time and date, would be lost every time you changed the main battery (which is actually the case with a few inexpensive digital cameras).

The clock battery is usually a small button cell that's good for a number of years before it must be replaced. Unfortunately, this cell isn't always as accessible to the user, which means you must send the camera to the vendor when the clock battery needs replacement. If you keep a well-charged main battery in your camera, it can protect the clock battery from discharging, prolonging its useful life. Often, you'll find that a "clock" icon is flashing on your new digital camera when you receive it. That doesn't mean that the battery is already dead; it simply signifies that the time and date need to be set for the first time.

Your camera's main battery is seldom fully charged when you receive the camera. It may have been shipped with a partial charge, or it might have lost some or all of its juice after leaving the factory (rechargeables often lose about 1 percent of their charge each day, even when the camera is not being used). So, it's helpful to recharge your batteries before attempting to use the camera. The process usually takes only an hour or two to rejuvenate a fully depleted battery. Here are some things to consider:

◆ **Separate charger required.** Digital camera batteries are usually recharged outside the camera, using a separate battery charger, like the charger shown in Figure 2.1. Removing the depleted battery gives you the opportunity to plug in a fresh one and continue shooting if you like. It's a better method than that used with cameras that require plugging the whole camera into a

Figure 2.1 Many batteries must be recharged outside the camera.

power source for recharging, or nestling the camera into a separate image transfer/power dock.

◆ **Recharge anytime.** NiMH or Li-Ion batteries can be topped off at any time, regardless of how much of the charge has been used, without danger of suffering from the "memory effect" that plagued earlier types of batteries (particularly nickel cadmium cells) and gradually depleted their capacity. Modern batteries are good for up to 1,000 full charge/recharge cycles in any combination; for example, if you consistently recharge when the battery is half expended, you can reasonably expect to do that about 2,000 times before needing to buy a new one.

◆ **Check remaining power.** Some cameras offer two ways to check the amount of charge remaining. You'll usually find an icon in the shape of a battery on the back panel LCD (or on the status LCD on top of the camera in the case of more advanced cameras). The icon will gradually lose internal segments as the battery is depleted, until an "empty" battery icon represents a fully discharged cell. There may be a battery warning light inside your viewfinder, too. A second, often more accurate way of determining remaining power may be found within your camera's menu system. Some

digital cameras have a Battery Information screen that shows an accurate percentage of power remaining, and the number of photos taken with the current charge (this may be a larger number than the exposures shown on your camera's status display if you've swapped or reformatted memory cards). Some high-end cameras with "intelligent" batteries also measure how many times a battery has been recharged, recommend replacement with a new one when needed, and track the accuracy of their gauge and call for recalibration when there is a difference between the predicted and actual number of shots you should be getting.

◆ **Longer life.** Some kinds of batteries last longer than others, and the number of shots you can get varies from camera to camera, too. A particular camera may give you just 100-150 shots with a set of two alkaline AA batteries, but offer 400 or more exposures with a compatible rechargeable pack. A similarly sized camera from another vendor might provide twice as many shots with each type of battery. Advanced digital cameras with their hefty battery packs can sometimes take 1,000 or more images on a single charge, and 1,500 to 2,000 exposures per cycle is not unusual, depending on a number of factors outlined below.

Why do some digital cameras have relatively more juice than smaller, less fully featured point-and-shoot digicams? Part of the answer comes from the size factor alone: Compact consumer digital cameras may have a tiny battery, like the one shown in Figure 2.2, that offers perhaps 600 to 700 millampere hours (mAh) of power, compared to the 1,500 to 2,000 mAh (or more) ratings of typical advanced digital camera batteries. Snapshooters tend to use their camera's built-in flash units more, power-hungry LCDs are often switched on for long periods to compose or review images, and the camera's battery may have to handle power-gobbling functions like zooming.

More advanced digital cameras, in contrast, may be more efficient in their use of power. Their LCDs may switch off after a minute or two, and remain off until you're ready to take another picture or during picture review or menu access. Autofocus and autoexposure functions consume power, but will typically be switched on only for a few seconds when the

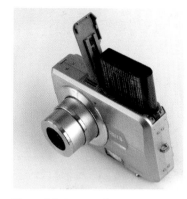

Figure 2.2 Batteries for compact digital cameras are usually good for 150-400 shots.

shutter release button is partially depressed. Serious photographers don't use flash as often as snapshooters. When "idling," a camera uses very little electricity at all, yet is able to spring to life instantly when the shutter release is pushed. Actually taking a picture does cause a spike in battery consumption, but the amount of current drawn isn't all that great. The flash, LCD, and sensor that must remain active to supply an image to the LCD are the most prominent power hogs in your digital camera.

Media Formatting

Your digital camera might not have been furnished with a memory card. Some cameras come with 10MB to 32MB of non-removable, internal memory that can hold a few pictures and may sometimes be used by the camera itself to store photo album setups, special picture frames you can wrap around your images, or other information. Others come with no memory at all: You'll need to buy a card before you can begin taking pictures. That's probably for the best, because there are many variations in capacity and transfer speed (how quickly the media can accept data from your camera), and the vendor probably hasn't a clue about what size or type you might really need. Why pay for a card that doesn't suit you? So, a memory card is an accessory that you either purchased at the same time as your camera, or soon afterwards. You might have already owned a card that you've used with a different camera. In either case, it's a good idea to format your card so it will be ready for use in your new camera.

It's wise to format the card (which removes all the pictures on the card) because there are several different ways of logically arranging information on silicon media, and, as you'll see, it's possible that the card's current format isn't compatible with your camera. You'll know that for sure if you insert the card and receive an error message, often followed by a request on the camera's status LCD to okay an immediate reformat. However, it's also possible that your camera appears to read the card just fine, even though there are potential problems lurking beneath the surface.

Figure 2.3 In general, you shouldn't format your digital film in a memory card reader. Use your camera instead to ensure that the proper format is applied.

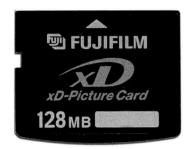

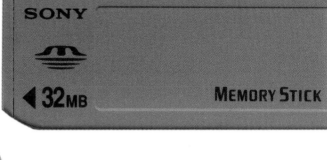

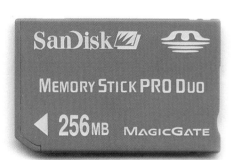

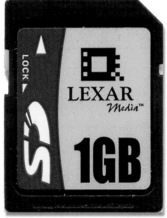

Figure 2.4 Memory cards for digital cameras come in all shapes and sizes.

These include:

◆ **Hidden or protected files.**
Virtually all digital cameras have an option for marking a file as *read only* so that the camera or your computer can view the image, but not erase or remove it. Some allow you to hide a file so that it doesn't readily appear when you access the memory card with your camera or computer. Files created on a memory card by one camera are deposited into a folder created by that camera, and may not be visible to your camera even if they haven't been intentionally hidden. When some previous use has left your media cluttered with hidden or protected files, you'll find yourself with reduced capacity. Extra space might be taken up by files that you don't want and don't even know are there. Reformatting can remove them quickly and easily.

◆ **Bad sectors.** Computers allocate available storage into units called *sectors,* whether the storage is a hard disk drive or a digital camera memory card. These rewritable media eventually develop bad sectors that can't be reliably written to. The reformatting process spots these sectors and locks them out to prevent further use.

◆ **Wrong format.** The device that previously used your memory card might have formatted it using a scheme that's incompatible with your digital camera's internal software. Reformatting the media with your current camera ensures that the correct format will be used.

If you've been paying attention, you've probably drawn two conclusions from the current discussion. First, always format your digital film *in your camera* rather than using the Format command of your computer when the media is inserted into a memory card reader, like the one shown in Figure 2.3. The camera's Format command guarantees that the correct formatting scheme will be used. An exception to this is when you find your camera can't format a card at all for some reason. Performing a format with your computer and *then* reformatting in your camera can sometimes solve the problem.

Second, you probably surmised that *formatting* is almost always a better choice than just *deleting* all your photos. Formatting removes hidden and protected files and locks out bad sectors; deleting files does not do this. The only time you should delete files is when you want to remove some, but not all, of the images on your media. You can delete them one at a time, or use your camera's marking feature and then select Delete Marked (or whatever it is called) using the appropriate menu choice. Of course, if you delete all the files on your card and then immediately discover you erased the wrong files or used the wrong card, you might be able to retrieve the lost files using various utility programs available for your computer. Images removed by formatting are usually gone forever.

FAT Chances

As I've noted, you take your chances if you format a memory card with your computer. That's because there are several different schemes used to lay out the sectors on digital media using a "table of contents" called a File Allocation Table, or FAT. The FAT allocates the smallest individual storage units of your solid-state "disk"—sectors—into easily managed groups called *clusters*. Each cluster is numbered, starting at 0, using a 12-, 16-, or 32-bit number. The maximum number of clusters that can be squeezed onto a digital memory card (or floppy disk or hard disk) is determined by the largest number that can be represented with 12, 16, or 32 bits.

FAT12 (12 bits) limits the capacity of media to no more than 16MB, which is not very useful, so FAT12 is used for Stone Age media like floppy disks. FAT16 allows formatting a memory card with 2GB worth of clusters, while FAT32 allows squeezing 1024GB (a terabyte) onto one card. It will be

quite a while before we see terabyte memory cards, but that upper limit is being approached by hard disk drives—which are already available in 750GB and larger capacities.

The actual conflict for digital camera users comes with memory cards that have more than 2GB of space. Some older cameras use FAT16 formatting and, thus, are unable to use 4GB and larger memory cards. SanDisk pioneered a 4GB CompactFlash card with a three-position switch on one edge that you can use to transform the card from a 4GB/FAT32 card to two separate 2GB/FAT16 volumes. You probably won't have need of this clumsy work-around, because newer digital cameras all use FAT32 and can access memory cards of any size.

However, problems can crop up if your 2GB-plus memory card happens to be formatted using FAT16 in a computer or digital camera. Your larger card will then appear to have no more than 2GB of capacity, which is a tragic waste of valuable silicon. That's the most important reason why you should always format your memory card *in your camera.*

WHAT SIZE?

Your digital camera will use a Sony Memory Stick/Memory Stick Duo, SecureDigital (SD), or xD memory card—or even a CompactFlash (CF) card. Some advanced cameras have several slots and can accommodate more than one type of card. For digital cameras in the 6–8 megapixel range, a 1GB memory card is the smallest size you should consider; shooting 36 exposures or so before changing "film" belongs in the silver halide era, not the age of silicon. That's exactly what can happen if you're using 256MB or 512MB memory cards. You'll find that 2GB cards have become very inexpensive, and may be a better choice. If your digital camera has even more resolution, you probably should consider 4GB cards, especially if they cost about 4X the tariff of a 1GB version.

You can buy 4GB cards for your lower-resolution digital camera today if you expect to upgrade to a higher-res camera in the future and don't want to replace all your 1GB cards when their capacity becomes laughably small with your new machine. This can be false economy, however, because unless your upgrade is planned for the near future, it's very likely that 4GB (or larger) media will cost *less* than you're paying for 1GB cards today.

Using unnecessarily large memory cards today has one downside: Your lower-resolution digital camera can fit so many images on a single card (perhaps thousands of pictures) that you fall into the "all your eggs in one basket" trap. If you have just one basket, it's very, very important to not lose or damage that basket. Of course, it could also be said that using four 1GB cards quadruples your chance of misplacing one of them and losing some of your images—even if you're missing fewer images than if you misplaced a 4GB card.

Transferring Photos

Once you've taken your pictures, the next step is to move them from your camera to your computer so you can put your photos into computerized albums, make prints, send them by e-mail, or upload them to the Internet for online sharing. There are several ways to transfer your images to your computer:

◆ **Built-in card reader.** Of course, the easiest way to transfer photos is to remove the memory card from your digital camera and insert it in a card reader built into your computer. An increasing number of new computers have a memory card reader included. They may be found as slots on the front of a desktop computer, or on one of the edges of a laptop. (For example, many Toshiba laptops have an SD card slot on the left side, adjacent to a PC Card port that can be used with CompactFlash and other types of cards using an adapter.) The card will appear as if just another disk drive to the computer.

Windows and Mac OS will recognize the card and pop up a utility application that offers to transfer the photos for you. Some editing and album programs, such as Photoshop Elements and ACDSee, have their own transfer applications. Your camera might be furnished with such a utility, too.

◆ **External card reader.** If your computer lacks a built-in reader, you can purchase an external device with slots for many different types of memory cards (they're often called 9-in-1 or 12-in-1 readers, depending on the number of card variations they can handle). This reader is connected to your computer's USB 1.1 or USB 2.0 port with a USB cable. Some faster units are available for FireWire connection.

◆ **Camera-to-computer cable.** If you don't have a card reader handy (say, you want to transfer your photos to a friend's computer and your friend does not have a card reader), you can use the USB cable supplied with your camera. Just plug one end into the USB port

on the camera, as shown in Figure 2.5, and connect the other end to a USB slot on the destination computer. The computer's operating system will recognize the camera as a "disk drive" and let you copy files from the camera's memory card or internal memory. (Some basic cameras have 10MB to 32MB of non-removable internal memory for picture storage, with a memory card slot for optional additional space.) You may need to visit your camera's menu system and change the camera's USB connection from PTP to Mass Storage (or vice versa). Usually Mass Storage (which lets your camera mimic a disk drive) will work fine, but PTP is sometimes required with computers that can't recognize your camera when it's set to Mass Storage mode.

◆ **Camera dock.** Another way to transfer pictures is available if your camera comes with a dock, which itself connects to your computer through a USB cable. Indeed, some digital cameras have no direct USB port and *must* be used with their supplied dock to link to your computer.

◆ **Printer linkup.** Most newer printers include a PictBridge connector that mates with a cable supplied with your camera. You can use the PictBridge connection to print picture orders you create in your camera directly with the printer, without first transferring the photos to your computer. This connection might also allow you to transfer photos from the camera to the computer through the printer's connections.

◆ **Wireless transfer.** Look for wireless transfer to become wildly popular in the future. A few pro-quality cameras as well as some point-and-shoot models from vendors like Kodak and Nikon already have the capability of linking your camera with a computer (or some retailers' photo kiosks) over a wireless connection and transferring photos that way. WiFi capabilities are rapidly becoming standard on laptop computers and for home networking, so cameras that include this type of transfer will take advantage of the popularity of wireless communication in the future.

HALf fAST?

The USB 2.0 standard is 40 times faster than USB 1.1 at a maximum of 480 megabits per second, but both your computer and card reader or camera must support the USB 2.0 standard. Otherwise, your pictures will transfer no faster than the top speed of the slower USB 1.1 rate of 12 megabits per second. In practice, your transfer speed will also be affected by the speed of your memory card, which can range from 1 to around 10 mega*bytes* per second (nominally eight times as much data as mega*bits* per second). So, it's likely that a full-fledged USB 2.0 transfer hook-up will be many times faster than your memory card's transfer rate. The lesson here is that if moving photos to your computer is important, buy the fastest memory cards you can, such as those with 40X, 80X, 133X, or 150X ratings.

Figure 2.5 Plug one end of your camera's transfer cable into the camera's USB socket (top), and connect the other end to a USB port in your computer.

Making Optimum Compression and Resolution

Before you start taking pictures, the most important decision you must make is what compression and resolution settings to use. Both settings have an effect on the sharpness of your final image, as well as how many pictures you can fit on your memory card. Here's a quick introduction to each parameter, with some tips on choosing the setting that's appropriate for you.

Compression and File Format

To save space on your memory card, digital cameras usually squeeze down or *compress* the images before they are stored. Compression makes the image file smaller so that more pictures can fit on the card. Various mathematical algorithms are used to squeeze the files down. Some are *lossless*, producing a file that is moderately compressed, but still retains all the basic information that makes up the image. A photo stored with lossless compression can be opened in an image editor and it will be just as sharp and detailed as it was when captured by your camera. To provide smaller files, *lossy* compression is used, typically using the JPEG file format. Some image information is discarded when this kind of compression is applied. The amount can range from very little to a lot. I'll show you how to choose later in this section.

The type of compression available is determined by the file format used. The most common file formats and recommended uses follow:

- **TIFF.** Today, only the most advanced digital cameras, particularly dSLRs, are capable of saving files in the TIFF format. This format is one of the original file formats used for images. It's a lossless format that preserves all the detail of the image, but it typically requires the most space on your memory card, and takes the most time to process. It's not uncommon to wait 15–25 seconds while a mammoth TIFF file is stored on your card. Because TIFF files are compatible with any image editor with no conversion, they are sometimes used when the photographer wants to create high quality image files that will be used as-is, or imported into an image editor for moderate manipulation. Unless you're using an older digital intermediate or advanced non-SLR digital camera, or a digital SLR, you probably won't have to worry about using TIFF in-camera: Your camera probably doesn't offer this option.

However, once you have imported an image into your editor, you can save them in TIFF format to preserve as much detail as possible.

- **RAW.** Some advanced non-SLR digital cameras, almost all of them EVF models, offer the option of saving in a format called RAW. RAW actually isn't a single format; each vendor creates a version that's proprietary to its particular camera model. RAW files (uncompressed and compressed) contain all the information captured by the camera after it has been converted from analog to digital format, without the application of settings such as white balance, tonal changes, or in-camera sharpening. The photographer can then import this relatively unprocessed image into an editing program through a special converter module created for that camera's RAW files, and make the adjustments at that time. Uncompressed RAW files haven't been reduced in size and are slightly larger than the compressed version (but typically half to one-third the size of TIFF files, even though they contain a great deal more editable information).

◆ **JPEG.** All non-SLR digital cameras use the JPEG format as their default file format. This option uses compression to reduce the size of your images by 10X to 15X or more, compared to an unprocessed image. JPEG is definitely a lossy compression method, but your digital camera will offer a choice of low, medium, and high ratios (usually with names like BASIC, NORM, FINE, EXTRA FINE). You can choose the amount of compression based on criteria similar to those applied to selecting a resolution: How sharp and detailed must your image be? Can you afford to give up a little image quality to save space? Most of the time, you'll find that the least compressed JPEG setting (FINE or SUPER/EXTRA FINE) will give you images that are almost as good as you'd get from RAW, but without the ability to manipulate the image as extensively in an image editor. The high compression/low quality ratios are a good choice when you are just taking snapshots, or will route your pictures to a low-res destination, even though you lose some image quality, as you can see in Figure 2.6.

Figure 2.6 Compressing a photo extensively reduces the image quality.

Resolution

In a digital camera, resolution is determined by the dimensions of the image in pixels (picture elements), and represented by the total number of pixels in the image. A digital camera that takes 3008 × 2000-pixel images (a common size) would provide a 6-megapixel image. Cameras commonly provide optional lower resolution formats that can be useful when you don't need the full resolution of the sensor. Quality may suffer, though, as you can see in Figure 2.7.

For example, one digital camera that shoots 3872 × 2592-pixel images (10.2 megapixels), also can be set to produce 2896 × 1944 (5.6 megapixels), or 1936 × 1296 (2.5 megapixels). The available resolutions vary from camera to camera: One model's "medium" resolution mode may be higher than another camera be higher than another camera

can achieve when set at its maximum resolution. Why would you choose a resolution lower than the camera's highest pixel count? There are several situations where this is a smart idea.

◆ **Only low resolution needed.** You're taking photos destined for low-resolution output and don't plan to do much editing of the images. For example, you might be taking pictures for your website, recording construction progress shots, capturing real estate photos, or photographing company employees for ID purposes. In all these cases, you can safely shoot at the lowest resolution your camera allows, then crop or resize them appropriately for your intended use. You might also need low-res photos when you plan on e-mailing your shots, in which case you'll also want to apply JPEG compression to make them as compact as possible.

◆ **Your memory card space is limited.** Perhaps you're on a photo outing and discover that you have only enough space on your card for another dozen photos. Drop down to medium resolution and you might be able to double or triple the number of pictures you can take before the card fills. (You can also increase compression of the images, as I've already explained.)

◆ **A lower resolution adds speed.** Some digital cameras operate faster when resolution is reduced, because they are able to process images and store them to the memory card more quickly. After an image is captured, it resides in a special area of memory called a *buffer* until it can be written to the removable memory card. When the buffer fills, the digital camera is unable to take any more photos until some of the images are offloaded to the card. Inexpensive digital cameras (as well as some older models) may have only a small amount of buffer space available, making it impossible to shoot more than three or four full-resolution photos in a row before it's necessary to wait a second or two as the buffer is gradually emptied. Drop down a notch in resolution, and you might be able to double the number of sequence shots you can take.

Digital cameras typically allow you to change the resolution in one of several ways. The most common method is through a menu setting, which isn't all that inconvenient because most of the time you'll want to use the maximum available resolution and won't be changing that setting very often. Some cameras have a button (sometimes assigning the function to a double-duty cursor pad key) that provides quick access to a Quality menu, or may even let you set the resolution by spinning a command dial or pressing a cursor/multiselector switch.

Figure 2.7 Do you really need a 6-megapixel image (left)—or will a 3.3-megapixel version (right) do?

Making Basic Settings

There are several basic settings you should make or double-check each time you begin shooting. These include ISO (sensitivity), White Balance (color rendition), Autofocus mode (how the camera chooses focus settings), Exposure mode (the scheme used to select the correct combination of shutter speed and f/stop), and Metering mode (how the camera measures exposure). These values generally remain in place from shooting session to shooting session, so if you've made a significant change in the settings you usually use by default, not confirming them when you start can lead to photos that are overexposed, badly focused, or imbued with bad color. This step is a little like the pre-flight checks pilots use to make sure their craft has sufficient fuel, oil, and coolant; the radio is working; and all the doors are closed and latched. A little attention now can avoid unpleasant surprises later.

I'll cover most of the basic settings in more detail on separate pages in Chapter 3, but here are the important checks to make before you begin shooting:

◆ **ISO.** ISO determines the sensitivity of the sensor to light. Lower values require more exposure but often produce better results. Higher values let you take pictures in dimmer conditions but may reduce quality and increase the noise levels in photos. One trap that's easy to fall into is relying on automatic sensitivity adjustments with ISO to Auto. While that's fine for snapshooting, serious photographers often need to make the decision about sensitivity and grain tradeoffs themselves. In bright sunlight, manually select the lowest ISO setting (usually ISO 50 or 100). In dimmer light, you might want to select a mid-range "high" setting, such as ISO 400 or ISO 800 (if your camera offers it), and reserve the highest settings for the most extreme lighting situations.

◆ **White Balance.** Setting white balance to Auto is usually safe. White balance adjusts for the color of the light source you're using: Indoor illumination tends to be warmer or redder, and outdoor illumination is cooler or bluer. Manual settings for a specific type of light, such as daylight, incandescent, or fluorescent illumination can ruin your photos beyond fixing in an image editor if you are shooting JPEG images and select the wrong light source. Your pictures may end up far too blue or too orange to repair. You can even use customized white balance as a creative effect, as in Figure 2.8.

◆ **Autofocus mode.** Select the center focus zone, or allow your camera to choose the focus zone itself. If your camera offers a choice, choose single autofocus, under which the camera locks focus when the shutter release is partially depressed. It's a good choice for subjects that aren't moving rapidly. Continuous autofocus allows the camera to set focus when the shutter release is partially pressed, but continues to refocus if the subject moves or the image is reframed.

REMEMBRANCE OF THINGS PAST

Many basic, intermediate, and advanced digital cameras have a separate menu tab called Memory, which you can use to specify which settings are retained when the camera is switched off. Usually, this tab has a list of settings accompanied by checkboxes. You check off the ones that you want to "stick" and the ones not marked will return to the factory default settings when the camera is powered down. For example, usually it's a good idea to have your white balance and ISO settings returned to Auto when you're finished taking pictures. However, if you plan to take many photos under the same conditions over a period of time, you can mark these settings in the Memory tab so you won't have to reset them each time you turn the camera on. Your preferred Flash setting is another good candidate for memorization, particularly if you prefer to have the camera power up with the flash disabled. Unless you have the camera memorize your preference, you're likely to have the flash firing automatically as needed (which is usually the factory default) every time you turn the camera on.

This mode is better for action and sports photography but does use more battery power.

♦ **Metering mode.** Most digital cameras offer a choice of matrix, center-weighted, or spot metering. Most of the time, matrix metering—which evaluates many different areas of your image to intelligently choose what exposure to set—is best. Center-weighted and spot metering can be used when you want to calculate exposure based on specific areas in an image.

♦ **Exposure mode.** You're safe if you choose Program exposure. The camera will use the Matrix metering mode and match up the exposure results with a built-in database of picture types and arrive at the best combination of shutter speed (to stop action) and aperture (to provide a sufficient zone of sharp focus). Use Shutter-Priority to choose the shutter speed yourself and allow the camera to select the aperture; Aperture-Priority mode gives you control over the f/stop and the camera command of the shutter speed used. Chapter 3 will show you when each is a better choice. Most digital cameras also have scene modes, like the Cuisine mode used to add contrast and richness of color for the picture shown in Figure 2.9. These scene modes are programmed to handle specific shooting situations (such as food, children, portraits, landscapes, museums, or night scenes). These are great when you don't have time to make decisions yourself, but as you learn more about photography, you'll probably use scene modes less and less.

Figure 2.8 Customized white balance can be used as a creative effect, adding a golden glow to this building.

Figure 2.9 Some digital cameras have "scene" modes—such as the flower mode used for this shot—tailored to specific shooting situations.

Changing LCD Brightness and Review Modes

The ability to preview your pictures before they are taken, and to review your images after the shot and make immediate corrections is one of the top advantages of digital cameras over the film variety. By the time you have your film processed and prints made, it's usually too late to go back and re-shoot all those blurry pictures you took with the shutter speed too slow. With a digital camera you can have instant feedback and correct exposures, errant shutter speeds or white balance settings, and fix other potential problems after you've taken only a few pictures. Here are the settings you should be most concerned with:

◆ **LCD brightness.** New digital camera owners may not even be aware that the brightness of the back panel LCD, like the one on the EVF camera shown in Figure 2.10, can be adjusted. (Of course, with an EVF model, you can view the shielded LCD inside the camera by peeping in the viewfinder window.) Outdoors, you might want to

crank up the brightness so you can view the LCD in direct or indirect sunlight (although shading the screen with your hand or an add-on LCD hood is an option). An extra-bright setting can drain your digital camera's battery more quickly, so you won't want to maximize brightness all the time. Indoors, you might want to crank down the brightness below mid-level, particularly when shooting in dark surroundings (say, at a concert). The low level is easier to view and won't distract those close to you (avoiding being a pest at a concert is always a good thing).

◆ **Review period.** You can set your camera to show the most recent picture for a set period (usually about two seconds) or define a longer duration as a default. Or, you can set the display so it doesn't automatically show the image you just captured at all, but instead returns immediately to Preview mode so you can compose your next shot. Turn the review feature off if you won't be checking each shot after it's taken. This will avoid the short delay that occurs when you involuntarily pause to look at your photo, whether you needed to

or not. (With most digital cameras, you can dismiss the reviewed picture and return to Metering mode by partially depressing the shutter release.) You can always summon the most recently taken picture by pressing the Review button on your camera (it's frequently a green triangle pointing to the right).

◆ **Information displayed.** Digital cameras offer a choice of information displayed by default during picture review. Most of the time the information is just the basics: the photo itself and picture number. However, you can elect to have a great deal more info displayed in various combinations, such as file format or compression amount

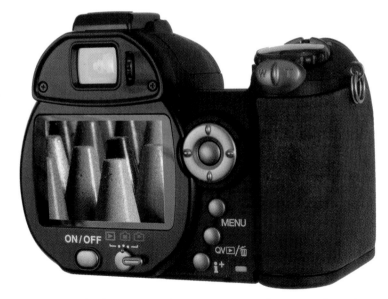

Figure 2.10 A bright LCD can make viewing menus and images easier under bright lighting.

used, time and date, Metering and Exposure mode, shutter speed/aperture, amount of any EV compensation, flash information, ISO, white balance, sharpness, saturation, and other data, such as the display shown in Figure 2.11. Some cameras will even show you the focus zone used for an image and display a histogram that shows the distribution of tones in your picture, as you can see in Figure 2.12. (You can find out more about histograms in Chapter 3.)

◆ **Autorotation.** Digital cameras have a setting called *autorotation* that can be useful if you (as you should) use a healthy mixture of vertically and horizontally oriented shots. Your camera has a little hanging device inside that senses when the camera is tilted between portrait and landscape orientations. The relative position of the camera can be included right in the image file and used by compatible image editing software to determine how the photo should be oriented when loaded. Your camera's software, too, can use this information to display vertically oriented photos upright on the LCD screen. The downside is that a vertical picture shown in its correct orientation on a horizontal LCD looks smaller, and details are more difficult to judge. If you find this to be the case, turn autorotation off in your camera's menu system.

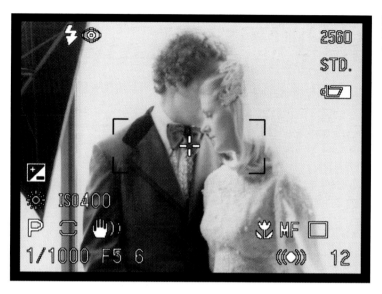

Figure 2.11 Basic information includes the file name and other data.

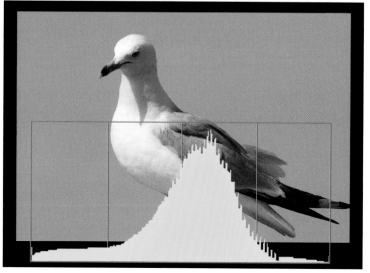

Figure 2.12 A histogram chart, used for judging exposure, can also be included in the picture review display.

Other Shooting Options

There are a number of other options you can set that affect how your pictures are shot. These are fairly specialized choices that must be selected from menus. Here's a checklist of the key items you might want to check before you start shooting.

Noise Reduction

Noise is a pattern of random graininess that infuses your image under a number of different conditions. These include:

◆ **High ISOs.** To increase the apparent sensitivity of a sensor, your camera may amplify the original signal to retrieve information from murky shadows. Unfortunately, the process also magnifies any random electrical interference in the signal, producing noise.

◆ **Long exposures.** The electrical charge that sensitizes your camera's imaging chip also heats it up slightly. As the length of the exposure increases, so does the heat build up, so that any exposure longer than about 1/15th second may suffer from noise induced by interference with the signal due to the excess heat. Long exposure noise can be produced at any ISO setting if the exposure is long enough, but when you combine it with high ISO noise, the speckles become even worse.

Your digital camera has built-in noise reduction (NR) algorithms that can reduce noise somewhat. The most common way to do this is to follow the original exposure with a second, blank exposure, and then compare the two. Any artifacts that appear in the "dark" frame and also in the actual exposure can be assumed to be noise and removed. The process is not 100 percent accurate, so noise reduction can also reduce the amount of detail in your image, and should be used only to the degree necessary. Some digital cameras have only an option for turning NR on or off. Others have normal, high, and low settings, and might allow using NR only for high ISOs, only for long exposures, or for both.

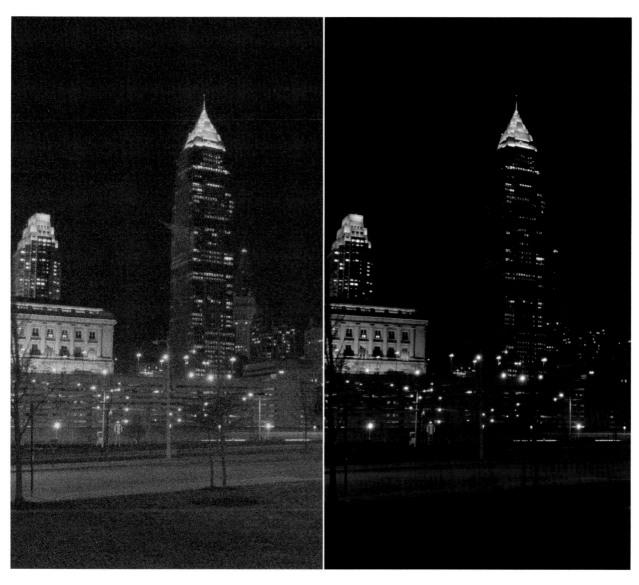

Figure 2.13 Your camera's noise reduction feature can reduce the amount of grain from long exposures and high ISO settings.

Image Optimization

Most digital cameras have an assortment of image tweaks you can turn on or off. It's important to keep track of which enhancements you're using, because no particular adjustment is right for every photograph. Your choices may include:

◆ **Sharpness.** Adjust sharpness when you want to add a little acuity to every image you're shooting, or want to soften images slightly. A sharpness boost might be useful if you need a little extra detail in a group of images and don't want to sharpen each one manually in your image editor. Portraits can sometimes benefit from setting the sharpness level to a softer level.

◆ **Hue.** Some digital cameras let you adjust the hue. This is a different setting than color balance, and it changes all the colors in an image by shifting them in one direction around an imaginary color wheel, like the one shown in Figure 2.14.

◆ **EV.** Exposure Value settings override the setting of your camera's exposure meter, usually to correct for measurements that are "fooled" by the current lighting conditions (such as backlighting or sidelighting), or to deliberately under- or overexpose a photo for a creative effect. It's important to make certain you've "zeroed" the EV settings when beginning a new session, to avoid unintentionally over- or underexposing your pictures. Most digital cameras have an EV indicator in the viewfinder, but it's easy to overlook.

◆ **Saturation.** Saturation is the richness of the color, and can turn, say, an ordinary red into a faded pink or brilliant crimson, or transform a sullen yellow to a brilliant sunny glow, as you can see in Figure 2.15. You can boost saturation as a special effect or to brighten gloomy days outdoors. Reducing saturation produces a subtle pastel look in your photos.

◆ **Color filters.** Some digital cameras have special effects filters, such as sepia, black and white, cyanotype (bluish), or specific colors like red, green, or blue.

Figure 2.14 Hue alters colors by rotating around an imaginary color wheel, shown by the edges of this shape.

Figure 2.15 Boosting saturation enriches the colors of an image.

File Numbers and Folders

You can choose how your digital camera applies file numbers, and designate which folders your files are deposited into on your memory card. Usually, you'll want the camera to continue numbering images consecutively each time existing pictures are copied to your computer and the memory card is reused. That avoids having several pictures with the exact same name. However, you can also direct your camera to start numbering images from zero again each time a new card is used. You might do that if you have your own filing system and want to have each batch of photos numbered consistently. If you were a school photographer, for exam-

ple, you might want to have your photos numbered from 000 to 999 for each school, so you could match the photos with a numbered class list. It would then be up to you to remember to put West Elementary files into one folder on your hard disk, East Elementary photos into another, and North and South Elementary schools' pictures in their own folders.

More advanced cameras may also allow you to choose your own prefix for each file number (say, welemxxxx.jpg instead of imgxxxx.jpg or dscxxxx.jpg) or define the folders on your memory card where the images are deposited.

Custom Settings

Your camera's "memory" feature can allow you to lock in a limited number of current settings at their present values. However, most digital cameras have many more customization options and you can use these options to direct your camera to behave in the way you prefer. Usually, you'll make these settings once and then leave them alone until your preferences change. Here are some of the most important choices you might have to make.

◆ **Beep/no beep.** Your camera may make a sound when it turns on and/or when certain functions are carried out. In some instances, such as at concerts or in museums, you might prefer a more "silent" mode that doesn't draw attention to your camera.

◆ **Digital zoom.** Many digital cameras have an optional feature called *digital zoom* that magnifies a portion of the image frame so that it fills the picture area, simulating a longer zoom lens. Most serious photographers don't care for this bogus zoom, as the results are usually not as good as you could get simply by enlarging the center

of your frame in an image editor. However, there are situations where it can come in handy, as shown in Figure 2.16. Your digital camera will have a menu setting that lets you turn this capability on or off.

◆ **Viewfinder grid.** Many digital cameras have a line grid in the viewfinder that can be used to align images. It's useful for making sure your camera is level and lining up the horizon or architectural images. Some people find the grid distracting and turn it off most of the time. However, if you become used to it, there is no harm in leaving the grid visible at all times. This grid can usually be turned on or off using the DISP or Display button, but some cameras tuck the option away in a menu.

◆ **Drive mode.** "Drive mode" options are so called because they are lumped in with your camera's "motor drive" or continuous shooting mode. In the drive mode menu options you'll find capabilities for turning the self-timer on or off, and for specifying the delay time, usually switchable between 2 and 10 seconds, but sometimes only a 10 second delay is available. Some cameras offer an optional longer

Figure 2.16 Although the quality isn't top-notch, digital zoom can turn your 5X zoom lens into a 20X superzoom.

delay. Other choices will include time-lapse photography, for those times when you want to capture a series of shots of, say, a sunrise or a flower opening. Continuous shooting options may include low-speed bursts (1-2 frames per second), high-speed bursts (2-3 fps or more), as shown in Figure 2.17, and multi-burst, which usually captures around 16 low-resolution images (say 640 × 480 pixels)

and combines them in an array in a single frame so you can analyze your golf stroke or tennis swing. Some cameras have a clever "last shot" mode: They snap pictures continuously until you release the shutter button and then store only the last four or five pictures taken. This capability is useful when you don't know exactly when the action will peak. You can, for example, follow a running back as he tears

across the football field and release the button just as he is tackled and brought to the ground.

◆ **Increments.** Many settings, such as white balance, ISO, and EV adjustments are set in specific whole number or 1/2 or 1/3 step increments. Some photographers prefer the larger increments, which are often faster to set, while others like using smaller increments, which allow more precision.

Your choice. Each type of adjustment may have its own increments setting.

◆ **Control functions.** Many buttons and dials can be user-customized. Some digital cameras have a Func key that can be redefined for a specific function, such as EV setting. Others let you assign a function to one or more of the cursor pad keys. This capability is especially handy when you use a particular feature often and want to access it directly rather than make a trip to menuland.

> ## TIP
>
> Your camera has a way of returning all settings to their factory default values. The method may involve a "hidden" reset button (often on the bottom of the camera with more advanced cameras) or via a menu selection. Learn how to use this option in case you want to start over—either because you just want a fresh start or because you've messed up a few settings and don't want to bother to reset them manually.

Figure 2.17 Continuous shooting, or burst mode, makes it easy to capture action sequences.

3 Photography: The Basic Controls

The number and kind of controls available in a digital camera can vary widely. Some models are true point-and-click cameras that ask you to do little more than simply turn them on and press the shutter release when you see something you'd like to capture. However, even these cameras will have a switch that lets you alternate between normal focus and close-ups, and another that allows you to change your flash from automatic firing to, say, always on and/or always off. The minimal number of controls available make these cameras great for those who just want to take snapshots without being asked to make many decisions.

It's more likely that readers of this book own a model that has more options and controls. Your camera almost certainly has a few scene modes, which are settings that tell the camera what kind of picture taking situation you're immersed in, and have labels to match: Sports, Beach, Portrait, Night Scene, and so forth. The camera can adjust its exposure method and other parameters (such as the richness of the color or sharpness of the image) to suit.

Another step up brings you to a category of cameras that offer a choice of automatic exposure and focusing methods (plus, possibly, manual focus and exposure). Models in this class might let you choose sensor sensitivity (ISO), and adjust to the color of the light the picture is being made under (white balance). Up another notch, and you gain the ability to choose a shutter speed or the size of the lens opening, while the camera selects the other value automatically to optimize exposure. You'll also find more sophisticated continuous shooting (or *burst* modes), motion picture photography that rivals some camcorders, and in-camera special effects and editing features.

Of course, just as it's possible to get a driver's license without knowing how to use a stick shift, you can take great pictures with your digital camera even if you don't know the finer points of using all your camera's individual controls. The digital camera's "automatic transmission" will do a good job of whisking you off to a pretty good picture with little more effort needed on your part other than knowing what to point the camera at and when to push the shutter release.

However, it's likely that you want to have a little more control over what goes into your photograph. If you're new to digital camera photography, having all this control over your images can be daunting. Certainly, you can choose how your camera should react to a particular situation, but do you really know which controls should be used to apply this influence, and how they should be used? This chapter provides the basic information you need to know when it's time to tell your camera who's the boss.

Exposure Controls

In a perfect world, digital cameras would be able to capture all the detail in an image that our eyes can see. The sensor would pull in information from inky shadows and grab detail from the brightest portions of the image (called *highlights*). They'd capture all the rich tones in between with exquisite accuracy, too. But that's not the case with digital imaging, just as it was not true with film. In the case of a digital camera, some exposures will include areas in which an insufficient number of particles of light (*photons*) reach the individual picture elements (*pixels*) that make up an image, so that those areas appear to be black, rather than dark and filled with detail. A particular picture might provide some areas with too much light, causing parts that should be very bright, but still contain detail, to be rendered as a featureless white. Worse, some of the excess photons may spill over to adjacent areas to produce a "blooming" effect.

The job of a camera's exposure controls is to find a compromise exposure that does the best job of preserving as much detail in the shadows and highlights as possible, given the range of tones (called a *dynamic range)* that a particular sensor can capture. Often, it's necessary to sacrifice a little shadow detail to preserve detail in the bright areas, or vice versa, as you can see in Figure 3.1. Your digital camera's auto-exposure system does a commendable job of calculating the optimum exposure. When you're shooting casual snapshots, you might want to use the default exposure system (usually Auto or Program) most of the time. Even so, there are still times when you can provide input so that the areas that are most important to you are captured accurately.

Figure 3.1 The selected exposure allowed some of the detail in the lightest pink feathers of this flamingo to wash out in order to preserve detail in the shadow areas of the bird.

Perhaps you're at a concert, and want to tell the camera to calculate exposure based solely on a small area in the center of the picture where the performer is standing. Maybe you'd like to "weight" the exposure for the area in the middle of the frame, say, a group of children, but you want the subject matter in the rest of the photo—a playground where they are romping—taken into account, too. If you're a more advanced photographer (or are becoming one by reading this book), you may want to use a particular lens opening (f/stop) to optimize sharpness and control the range of the image that is in sharp focus (*depth-of-field*). You may know that your image requires a faster *shutter speed* to freeze action in its tracks and would like the camera to select an exposure that favors those higher speeds.

The basic settings for adjusting exposure are the *shutter speed*, *f/stop*, and *ISO* (sensitivity) controls. Each of these three will be addressed on the following pages. Later on, I'll show you

how you can apply further controls to choose how the three main types of settings are applied by selecting the *exposure mode* (how exposure is measured), *exposure evaluation mode* (how the camera calculates the exposure based on the information collected), *exposure priority* (what parameters are given precedence), and *exposure measurement time* (exactly when the camera takes its exposure readings). Subsequent parts of this chapter cover all of these.

Tonal Range

Digital cameras are *digital* (rather than analog) devices because the continuous range of tones from absolute black to the brightest possible white are

represented by discrete values, just as a digital clock shows whole seconds, minutes, and hours rather than a continuous sweep of time you see on the face of an analog clock. The more individual tones an image is divided into, the more accurately an image can be rendered without needing to convert "in between" tones to some other value.

Although digital cameras typically capture 4,096 different tones (or more) per color, the raw information is preserved only in the camera's native format. Many higher end digital cameras let you save a copy of this information as a "RAW" file. Most of the time, however, your digital camera processes this raw

information to produce the JPEG file that you transfer to your computer. Your original image is usually reduced to a mere 256 different tones per color, or 16.8 million colors (256 × 256 × 256). The darkest tone is assigned a value of 0 (no brightness), while the lightest is assigned a value of 255 (maximum brightness). Every tone in between, from an almost-black dark tone to an almost-white super-light tone, must be represented by one of the other 254 numbers between 0 and 255. In Figure 3.2, I've broken down this scale into ten tones, so you can clearly see the steps between each value. If a sensor is unable to capture all the available tones, some are lost, as in Figure 3.3.

Figure 3.2 When a tonal scale is reduced to only ten tones, the steps between them are clearly seen.

Figure 3.3 A sensor that is unable to capture all the available tones loses some.

Using Scene Modes

One shortcut to capturing all the available tones and getting the right exposure—plus suitable settings for other camera controls—is to use the scene modes available on most digital cameras. Scene modes are the equivalent of those EQ presets on your iPod or other MP3 player. When you set your MP3 player to Electronic, Jazz, R&B, Rock, or some other setting, it adjusts the balance of the frequencies you hear to best suit a particular kind of music. A particular setting may boost the frequencies where electric guitars are their most thrilling; others give you more bottom or bass thump, emphasize the vocals, or provide some

combination that optimizes the sound in other ways. If you have a special group of settings that you prefer, you can even create and save a custom preset.

Scene modes do something similar for photography. A Sports scene mode "knows" that your subjects will be fast-moving, and so chooses a high shutter speed whenever possible while still providing enough depth-of-field (the range of the image that appears in focus) to keep the subject sharp. A Portrait scene mode might emphasize a shallower range of sharpness, because a softer effect often provides a more flattering portrait. The richness of the color (*saturation*)

might be dialed down a notch for portraits to create realistic skin tones that are natural and not garish. A Night Scene mode might favor longer shutter speeds that allow capturing detail in very low light—and would warn you that the camera should be mounted on a tripod to avoid blur from camera movement.

Table 3.1 shows some of the most common scene modes you'll find in digital cameras, along with a description of how these modes *may* adjust the camera for those situations. In practice, what a scene mode actually does varies considerably from manufacturer to manufacturer.

Many other types of scene modes may be included with your camera. Some cameras have as few as four scene modes; others may have nearly three dozen options. Some vendors include Movie or Motion Picture mode as a scene mode. Indeed, some have several different scene modes expressly for movie clips, with special adjustments included for movies taken under various conditions. High Sensitivity is a scene mode offered by some vendors that provides a sensitivity boost (in one case to ISO 1600) even though the camera is limited to no more than ISO 400 outside of this scene mode.

Table 3.1 Common Scene Modes

Scene Mode	What It Does	Scene Mode	What It Does
Auto	Chooses "average" settings for many types of pictures.	Night Scene	Uses long exposures with camera on tripod.
Autumn	Enriches colors.	Night Portrait	Balances flash and available light.
Backlight	Adds exposure to subject with light source behind it.	Old Photo	Enriches colors of faded pictures taken in close-up mode.
Beach/Snow	Reduces contrast and exposure under very bright conditions.	Party	Enriches colors and adds flash for festive occasions.
Business Card	High contrast for text, may correct for pictures taken at slight angle.	Pet	Uses faster shutter speed to capture moving animal.
Candlelight	Uses longer shutter speeds, balances colors for warmer illumination.	Portrait –Single	Softer focus, more muted colors.
Children	Enriches colors, uses faster shutter speed and/or flash.	Portrait – Group	Softer focus but more depth-of-field.
Fireworks	Uses much longer shutter speeds, enriches colors.	Scenery	Enriches colors, particularly greens, and may set focus to infinity.
Food	Enriches colors, sets camera and flash for close-up exposures.	Sports	Uses higher shutter speeds, may set camera to higher sensitivity range.
Macro	Adjusts camera for closer focus.	Sunset/Sunrise	Enriches colors, optimizes exposure for sky.
Museum	Disables flash and camera beeps, uses longer exposures.	Twilight	Uses longer exposures and adjusts color balance for late-in-day tones.
Nature	Enriches colors.	White Board	Higher contrast to capture text, plus may correct image taken at slight angle.

Choosing a Scene Mode

The method your camera uses for selecting a scene mode varies from vendor to vendor, with some methods easier/faster than others. Here are the most common methods:

◆ **Mode dial.** Cameras with only a half-dozen or fewer scene modes may let you select them directly by spinning a mode dial to a notch next to an icon representing a particular scene mode. Several digital cameras have three or four of the most-used scenes on the mode dial, augmented by a SCN setting notch that gives you access to another set of scene modes.

◆ **Mode dial with menu.** With some digital cameras, all scene modes are selected by turning the mode dial to a scene or SCN position, then pressing a button to produce a list of available modes on the LCD. Choose the mode you want by pressing the OK or Set button.

◆ **Scene button.** Several cameras have a dedicated Scene button. Press it, and a list or screen of scene modes appears, which you can browse through and select by pressing the OK or Set button.

◆ **Scene selection menu.** Least convenient are the cameras that send you to menuland every time you want to change scene modes. You might have to page through a Shooting menu or similar list to find the scene modes, then use the cursor keys and OK/Set button to select one.

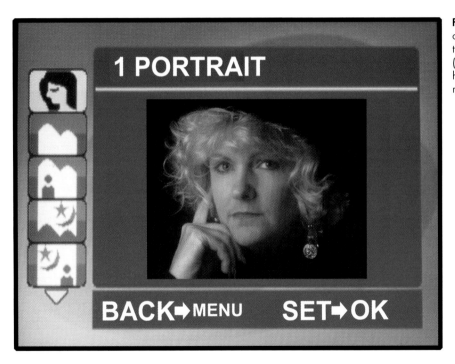

Figure 3.4 Most digital cameras provide a thumbnail image (center) that illustrates how a particular scene mode should be used.

Sometimes it's hard to figure out which scene mode is which. The icons may be cryptic and not very informative and may resemble other icons. If you're fortunate, the camera may offer a line of text describing what the scene mode does when that mode is highlighted. Best of all are the models that use a Help key (with one camera it is the zoom button) to display a full LCD description of the mode, along with a large sample image.

Some cameras allow storing your current settings as a user-definable scene mode. (This feature corresponds to the "custom settings" banks offered in digital SLRs and a few EVF cameras.) Once you have your camera set up the way you want it, select the do-it-yourself scene mode option and store those settings for later recall. Your own photo is often stored as a thumbnail in the scene mode selection screen.

Figure 3.5 Use a Close-Up or Flower scene mode to set focus range and appropriate aperture for photos like this one.

Programmed Exposure Modes

Digital cameras have several programmed (small p) exposure modes, usually consisting of Program (capital P), plus Auto. These both select the shutter speed and aperture for you, but in P mode, you can override the camera's settings. In Auto (automatic) mode, the camera's settings can't be modified. This is the mode you'd use when you ask a stranger on tour with you to take a picture of you and your family posing in front of the Eiffel Tower. Even photographic fumble-fingers won't be able to mess up the settings or press the wrong button.

Both P and Auto use complex mathematical formulas to analyze your scene and compare the information with an internal database derived from thousands of photos. The crunched numbers then suggest appropriate settings, including f/stop and shutter speed, based on current conditions. For example, the camera may decide that you're shooting sports and try to use a relatively high shutter speed to subject motion, but switch to lower shutter speeds only under very low light conditions. Or, the camera may discover that the picture you're shooting very much looks like a landscape, and it will apply the exposure emphasis to the scene itself, rather than the sky or other elements of the photo, as in Figure 3.6. The combinations of best f/stop and shutter settings are built into the camera by the vendor.

Figure 3.6 Programmed metering algorithms can quickly identify this photo as a landscape and expose for the scenery rather than the sky.

Although fully programmed exposures can do a decent job, serious digital photographers might use the A mode only when they first get their digital cameras. Full auto is a good way to get started quickly taking pictures without the need to read a book like this one to learn how to tweak images to get exactly the picture you want.

You'll also use A mode when a picture-taking situation suddenly arises and you don't have time to check any custom settings you might have made to your camera. Instead of worrying whether your current settings are too extreme for the picture at hand, you can set the camera to A and know that the basic factory default settings will be applied to your image, for better or for worse.

Once you have worked your way through this book, you'll know enough to want to have more control over your photos. That's when you'll want to change to Program mode, when you want the camera to make most of the decisions, but you'd like some fine-tuning available at your fingertips. Eventually, you'll find yourself switching to Aperture-Priority or Shutter-Priority, or even Manual mode once you learn exactly how much fun it is to adjust settings.

Figure 3.7 Digital cameras may have only a minimum number of scene modes, although some may have more than 30.

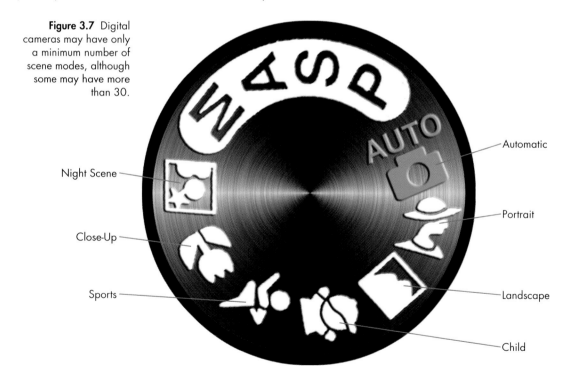

Night Scene

Close-Up

Sports

Automatic

Portrait

Landscape

Child

Aperture-Priority and Shutter-Priority

If your digital camera offers manual or semi-automatic shooting modes, they'll usually be available from a mode dial on the top or back of the camera, labeled with the traditional initials for these modes: MASP for Manual, Aperture-Priority, Shutter-Priority, and Program (which I've already described on the previous pages). Your mode dial may also be marked with the alternate initials favored by some vendors: M Av Tv P. Av stands for Aperture Value (or Aperture-Priority) and Tv represents Time Value (or Shutter-Priority). As photographers gain experience, they usually eschew scene modes as well as a mode called Auto, which may be even more restrictive of options, while not flexible enough to handle common shooting situations.

For most of us, MASP (see Figure 3.8) does the job. We can choose M (Manual) to set exposures (usually based on exposure

information supplied by the camera); Aperture-Priority (you set the f/stop, the camera chooses the shutter speed); Shutter-Priority (you set the shutter speed, the camera selects the f/stop); or

Program (the camera sets shutter speed and f/stop through a sophisticated metering algorithm, but you retain the freedom to customize exposure at your whim).

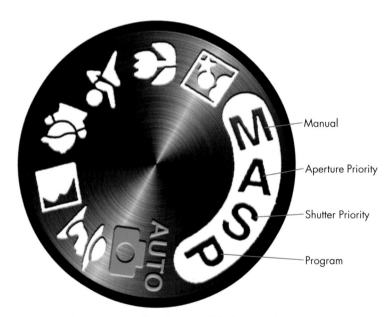

Figure 3.8 If your camera offers them, you'll find settings for Manual, Aperture-Priority, Shutter-Priority, and Program exposures on your mode dial.

Aperture-Priority

This is the mode to choose when you want to use a specific small aperture to maximize depth-of-field, or a large aperture to reduce depth-of-field so you can apply focus only to selected areas of your photo, as shown in Figure 3.9. The shutter speed doesn't matter to you (within reason), so you're content to allow the camera to choose it for you.

Or, you might select Aperture-Priority (usually marked as A or Av on your camera's mode dial) when you *do* want a high shutter speed under changing lighting conditions but prefer to keep the camera from using an aperture that you deem to be *too* wide. So, you set the camera to Aperture-Priority and select an f/stop that allows a shutter speed in the range you're looking for. Your aperture will remain constant at the value you select (say, f/5.6), but the shutter speed will vary a little as the available

illumination allows, perhaps alternating between 1/500th and 1/1,000th second as appropriate. If you were to use Shutter-Priority and set the camera to 1/1,000th second, your f/stop might change from f/5.6 to f/4 or even wider if conditions dictated.

Shutter-Priority

Use Shutter-Priority mode (usually marked S or Tv on your camera's mode dial) when the shutter speed in use is most important to you. This mode is commonly used for sports photography (see Figure 3.10). Set your camera for a high shutter speed and then fire away. The correct f/stop will be selected automatically. The "reverse mode" trick also works for Shutter-Priority: If you want a relatively large or small f-stop for depth-of-field reasons, but don't mind if it varies by a stop in either direction, select Shutter-Priority and set whichever shutter speed corresponds to roughly the

f/stop you prefer. If the light changes a bit more or less, compensate.

With both Aperture-Priority and Shutter-Priority, you may need to adjust the setting selected, or increase/decrease the ISO sensitivity if the aperture or shutter speed you've selected won't allow a good exposure. For example, in Shutter-Priority mode,

if you've chosen 1/500th second, and the exposure system decides there isn't enough light for a shot at that speed with the lens wide open, you can reduce your preferred shutter speed to 1/250th second, or double the ISO to increase the sensitivity so that 1/500th second will be sufficient.

Figure 3.9 Use Aperture-Priority mode when you want to use a specific f/stop to control depth-of-field.

Figure 3.10 Shutter-Priority mode allows you to specify a fast shutter speed for stopping action.

Manual Exposure

More advanced digital cameras—even the pocketable kind—sometimes have full manual exposure, which allows you to set both shutter speed and aperture. A manual exposure mode isn't as retro as you might think. You're far from on your own. Even though you're making the settings yourself, you can still use your camera's built-in exposure meter to determine whether or not the exposure you've selected is within the realm of reason. Your digital camera probably has a flashing LED, or a plus/minus scale in the viewfinder or LCD that tells you when the exposure is right. There are several reasons for using manual exposure:

◆ **Special effects.** Maybe you'd like to underexpose an image deliberately to produce a shadow or silhouette look. The fastest way to do this may be to set exposure manually, review your results on your digital camera's LCD, then shoot again until you have the exact special effect you want.

◆ **External or manual flash.** Perhaps you are shooting in a tricky lighting situation and your internal flash just isn't being measured properly by your camera's exposure system. Or, you're using an external flash without automatic features, or one that isn't compatible with your camera's flash metering system. Set your camera to Manual and choose the exact exposure you want.

◆ **Zoned out.** You love famed photographer Ansel Adams' Zone System of exposure and want to work with a handheld light meter. (There are many books on this system that will bring you up to speed.) Or you need to make some precise exposure calculations. Perhaps you want to work with an incident light meter, a type of light-measuring device that quantifies the incoming light at the subject position, in order to separately assess the shadows and highlights and establish a precise ratio between "main" light and "fill" light. Manual exposure lets you tweak your exposure settings to your heart's content.

◆ **Older lenses.** If you're using a digital SLR camera with interchangeable lenses, it's possible you want to work with older lenses that don't couple with your camera's exposure mechanism. There are some fine manual focus, manual exposure lenses out there at bargain prices. If you switch to Manual exposure, you can use a handheld meter or just guesstimate exposures, fine-tuning your settings after reviewing a few shots on your camera's LCD.

Figure 3.11 Use manual exposure when you want to underexpose significantly to create silhouettes or other special effects.

Figure 3.12 If your automatic electronic flash exposures are incorrect, you may be able to set your f/stop manually to get a properly exposed photo like this one.

Manual exposure is particularly comforting for film camera veterans who are working their way into the highly automated digital photography world. For many years and thousands of photos, I used several film cameras that had *no light meter at all.* A hand-held meter, manual exposure settings, and, perhaps, some judicious bracketing (shooting several pictures at slightly different exposures to get at least one optimum picture) worked just fine. The most important byproduct of this mode of photography was that I learned quite a bit about exposure and lighting, simply because I worked manually. You can learn a lot, too, with your camera set on Manual. Figures 3.11, 3.12, and 3.13 show several examples of situations that work best with manual exposure.

Figure 3.13 If your camera has a T (time exposure) or B (bulb) setting, you can use manual settings to make time exposures of several minutes' duration.

Choosing a Shutter Speed to Stop Action or Create Blur

You can choose a specific shutter speed when working in Manual mode or Shutter-Priority mode. The exact shutter speed you select for a given photo affects two key parts of your image: the overall exposure (when paired with the ISO and f/stop parameters) and the relative sharpness of your image in terms of how well subject or camera motion is stopped. A high shutter speed will freeze fast-moving action in front of your camera, and tend to at least partially negate any shakiness caused by camera movement. If a shutter speed is not high enough to stop this movement, elements in your image will be stretched and blurred. Creatively, you might actually *want* this blur in order to add a feeling of motion to your image. So, it's important to choose the right shutter speed to stop action when you want to freeze a moment in time or to allow your subject to "flow" with a judicious amount of blur when that's what you're looking for.

To maintain the most control over the degree of blur in your photographs, you need to understand that components in your image are subject to this blurring to varying degrees. Indeed, it's possible to have one image with several subjects, each with a different amount of blur.

◆ **Camera movement is an equal opportunity destroyer.** As a practical matter, a shaky camera blurs *all* of your photograph to more or less the same degree. This is the only kind of blur that can be countered, some of the time, by the image stabilization/anti-shake/vibration reduction features built into an increasing number of basic, intermediate, and advanced digital cameras. Lacking a stabilization feature, you'll need to use your choice of shutter speed to counter vibration. Unless you have a creative purpose for camera shake, you'll want to use a high enough shutter speed to stop it, or steady your camera with a tripod, monopod, or other support. Of course, don't discount the possibility of using camera movement in a single direction as a creative element, as in Figure 3.14.

◆ **Motion across the frame is fastest.** Motion that occurs in a plane that's parallel to the plane of the sensor will appear to move more quickly than motion that's headed toward or away from the camera. So, a racecar speeding from one side of the image to the other, or a rocket taking off straight up will appear to be moving the fastest and will require the shortest shutter speed to freeze. You might find yourself using 1/500th or 1/1,000th second in such cases.

◆ **Motion toward the camera is slowest.** Motion coming toward the camera appears to move much more slowly. If that racecar or rocket is headed directly toward you, its motion won't seem nearly as fast (but it's still a good idea to get out of the way). In such cases, you can use a slower shutter speed than you would if the object were traveling across the frame, and still freeze the action. You might be able to stop action with a speed of 1/125th second in that case.

◆ **"Slanted" movement is in between.** If a subject starts out on one side of your frame and approaches you while headed to the other side, it will display blur somewhere between the two extremes. You'll need a shutter speed somewhere between the one you'd use for an object traveling across the frame and one moving towards the camera if you want to freeze the action at, say, 1/250th second.

◆ **Distance reduces apparent speed.** Subjects that are closer to the camera blur more easily than subjects that are farther away, even though they're moving at the same absolute speed, because their motion across the camera frame is more rapid. A vehicle in the foreground might pass in front of the camera in a split second, requiring a shutter speed of 1/1,000th second or even faster, while one hundreds of feet away may require three or four seconds to cross the frame, and can be stopped with a speed of 1/250th second or slower, depending on the zoom setting or magnification of the image.

Figure 3.14 Camera movement during a one-second handheld exposure was used deliberately to add a streak to this photo of a restaurant's neon sign.

◆ **A moving camera emphasizes or compensates for subject motion.** If you happen to be moving the camera in the same direction as a subject's motion (this is called *panning*), the relative speed of the subject will be less, and so will the blur. Should you move the camera in the other direction, the subject's motion on the frame will be relatively greater. An example of partially stopping action with panning and a shutter speed of just 1/60th second is shown in Figure 3.15.

The correct shutter speed will vary based on these factors, combined with the actual velocity of your subject. That is, a tight end racing for a touchdown in an NFL game is very likely moving faster (and would require a faster shutter speed) than, say, a 45-year-old ex-jock with the same goal in a flag football game. The actual speed you choose also varies with the amount of intentional blur you want to impart to your image, as in Figure 3.16.

Figure 3.15 Panning the camera in the direction of movement can stop action at a relatively slow shutter speed of 1/60th second, while imparting a feeling of motion.

For example, if you want to absolutely stop your subject in its tracks, you might need 1/1,000th to 1/2,000th second (or faster) for the speediest humans or speeding automobiles. You might apply 1/500th second to a galloping horse to allow a little blur in the steed's feet or mane. Shutter speeds as slow as 1/125th second can stop some kinds of action, particularly if you catch the movement at its peak, say, when a leaping basketball player reaches the top of his or her jump and unleashes the ball.

Figure 3.16 Because different elements in an image move at different speeds, you can select a shutter speed, such as the 1/250th second used for this photo, that will freeze some parts of your subject, while letting other parts blur in an interesting way.

Selecting the F/Stop to Control Sharpness and Focus

Most point-and-shoot digital cameras have only very basic capabilities for selecting an f/stop. One reason is that many of them have a limited f/stop range, sometimes with only two or three settings available. Many digital cameras have a fixed f/stop that can't be varied at all. A basic camera might have a "wide open" f/stop no larger than f/4.8 at the wide-angle setting (which might be the equivalent of f/5.8 when using the telephoto setting of the lens), and optional f/stops of, say, f/6.3 and/or f/8. Because of the limitations of the short focal lengths used with smaller sensors, even more advanced electronic viewfinder-based cameras might have f/stops only from f/2.8 to f/8 or f/11. If you want a full range of traditional apertures, you'll need to use a digital SLR with interchangeable lenses.

Like shutter speed, the aperture affects both exposure and other important pictorial factors, including *sharpness* and *relative depth-of-field*, or focus range. So, the f/stop you select for a given picture can depend on more than simply how it affects your exposure. You don't want your images to be under- or overexposed, but you don't want to achieve the optimum exposure at the expense of sharpness or focus depth, either.

Here are some things to think about:

Sharpness

Every lens has an optimum aperture that produces its sharpest, best-corrected image. That's generally about two f/stops smaller than the maximum aperture, but the true optimum lens opening can vary depending on the particular lens, especially with lenses for the simplest digital cameras, which are designed to operate at the largest (or *only* f/stop). This ideal f/stop produces the best image in terms of resolution. Subjects at the plane of focus have the most detail, compared to smaller or larger f/stops. The optimum lens opening also provides the best image in terms of correction for some common lens defects, such as chromatic aberration (a tendency for various colors of light in the image to focus at slightly different positions). These defects are often reduced when a lens is stopped down.

So, if you have the option of using a different aperture, you might prefer using an f/stop that's as close as possible to the optimum for your lens. It's not necessary to perform any formal tests: Just close down two f/stops and you'll be near enough to the optimum lens opening. For example, a lens with an f/2.8 maximum aperture would theoretically do its best work at about f/5.6.

Of course, some lenses found on digital cameras are designed to produce good sharpness at certain f/stops. A "fast" (f/2 or f/2.8) lens is intended to provide excellent resolution and correction of distortion wide open, as you can see in Figure 3.17. You probably can gain additional sharpness by reducing the aperture by a stop or two, but will find the performance of such a lens wide open quite acceptable.

Variable F/Stops

Many zoom lenses for digital cameras change their relative aperture as you zoom in or out. This is true for virtually all lenses furnished with basic to intermediate, non-interchangeable lens digital cameras. A lens with an f/4.5 maximum aperture at its wide-angle setting could be an f/5.6 or f/6.3 lens at the telephoto end. Remember that as the maximum aperture shifts, so does the optimum aperture for a given lens and zoom setting: The best f/stop for an f/3.8-f/5.6 lens might range from f/5.6 to f/8 as you zoom out. Lenses that don't change the effective value of their f/stops are generally available only for digital SLRs, and are called *constant aperture* lenses.

Figure 3.17 The lens used for this shot is sharp when used wide open, making it possible to grab a compelling image at 1/125th second and f/2.8.

Depth-of-Field

The aperture of a lens affects depth-of-field, too, although with digital cameras from basic point-and-shoot models up through electronic viewfinder models, the zone of sharp focus is very large because of their wider-angle lenses, regardless of f/stop used. With such cameras, you might be concerned about depth-of-field only when taking close-up photos, where the field of focus is shallow. At those ranges (or with digital SLRs and lenses longer than very wide angles), the larger the lens opening, the less depth-of-field at a particular subject distance. As the aperture is reduced in size, depth-of-field improves.

So, when you want to use selective focus to isolate your subject, a large aperture will help (even if it costs you a bit of sharpness), but when you need to have as much of the image in focus as possible, a smaller f/stop will do the job. (This also can cost you some sharpness, as you'll see shortly.) As with any trade off, you'll need to decide whether sharpness or depth-of-field is most important to you, and choose your aperture accordingly.

For most subjects at ordinary distances, the smallest f/stops available with your digital camera will provide the best combination of sharpness and depth-of-field. If you're shooting close-ups, you might prefer to extend the amount of depth-of-field with the smallest aperture you can muster. Figure 3.18 shows a close-up image taken at f/5.6. Because of the extra depth-of-field offered by the short focal length lens on this digital camera, the part of the image in the foreground is in sharp focus, but there isn't nearly enough depth-of-field to include the blossom in the background.

Diffraction Distraction

Once you stop down more than a couple f/stops smaller than a lens's optimal aperture, another kind of optical malady, called diffraction, strikes. The effect may be small, but the reduction in sharpness is real, so you'll want to avoid using the smallest f/stops available when sharpness is paramount. However, you might need those smaller stops in certain exposure situations (when the light is very bright or you want to use a longer shutter speed), or require the extra depth-of-field the smaller aperture offers. Unless you're using an advanced digital camera, particularly a dSLR, you won't need to worry much about this effect: Basic and intermediate digital cameras don't provide small enough apertures to generate much sharpness loss from diffraction.

Figure 3.18 The blooms in the front are plenty sharp, but f/5.6 simply doesn't offer enough depth-of-field to allow all the flowers to be in focus.

Changing ISO

The third main parameter that controls exposure is the sensitivity of the sensor, as determined by the ISO setting. ISO (which is *not* an acronym, by the way) is the common name for the International Organization for Standardization, a group that determines the basic yardsticks for a host of things (including how to represent its name), ranging from quality standards (ISO 9000, etc.) to the sensitivity of film and digital sensors.

Increasing the ISO setting adjusts the sensitivity upwards, which allows the camera to capture a picture using a briefer shutter speed or a smaller aperture, as shown in Figure 3.19, which shows an ocean scene at dusk that couldn't be captured at a shutter speed fast enough to eliminate camera shake without increasing the ISO setting to ISO 400. Reducing the ISO setting, on the other hand, lets you use a longer shutter speed or a larger aperture, which might be the case when the light is very bright or you want to use a longer shutter speed or a larger lens opening for creative reasons (say, to add blur from movement or reduced depth-of-field).

As with the other two exposure parameters, changing the ISO value has side-effects that can be seen in your images. Boosting ISO provides an increase in the amount of visible grain (called noise) in digital images. Noise is created when blips in the digital signal that do not represent captured photons are mistaken for image data and recorded as such by the sensor. The higher the sensitivity, the more likely that spurious information will show up in your picture as noise. (Noise can also be caused by long exposures, from 1 second to 30 seconds or more, regardless of ISO setting used.)

Noise is random and, as such, may occur at any pixel position, so that noise speckles may be recorded as red, green, or blue spots. Some photographers like the texture that noise adds to an image under certain circumstances, but most of the time it is considered a defect, as in Figure 3.20, and something to be avoided. So, your goal will be to use the lowest ISO setting possible that also lets you use your preferred f/stop and shutter speed combination. In other words, you'll often increase or decrease ISO sensitivity a notch or two to allow you to apply your lens's optimum aperture, or the lens opening that produces the depth-of-field you want. Or, you can adjust ISO to let you use a faster shutter speed to stop action, or you can use a slower shutter speed to generate desired motion blur effects. Note: Many digital cameras have a feature that will adjust ISO for you, if necessary. Use with caution, as it's no fun to think you're shooting creamy-looking photos at ISO 100, and then discover your camera has bumped sensitivity up to ISO 400 or higher with only an indicator on the LCD to inform you of the change.

Figure 3.19 Raising the ISO setting makes it possible to take good photos at night and in other low-light situations.

Figure 3.20 Noise appears as grainy speckles in images shot at increased ISO settings.

Digital cameras have a minimum ISO setting that is usually in the ISO 50 to ISO 100 range. The maximum sensitivity setting is usually ISO 400, but recently, quite a few non-SLR models have been introduced with upper limits of ISO 800 or even ISO 1600-ISO 3200. Olympus achieves its stratospheric high ISO settings using a technique called "pixel pooling," in which a matrix of nine pixels is used to construct a larger superpixel that's more sensitive to light. However, the technique reduces the effective resolution of the camera: One 8.1-megapixel model has an effective resolution of only 3 megapixels at ISO 3200. For truly high ISO settings, only digital SLRs provide sufficient sensitivity.

The rest of us will get the best quality (least noisy) image at ISO 50-200, while grain will often become bothersome at ISO 400, and may make your photos barely usable at ISO 800-1600 and above. A few digital cameras allow changing the ISO setting only in whole "stop" increments (that is, ISO 100, ISO 200, ISO 400, or ISO 800, with no intermediate steps), or in half- or third-stop increments (such as 100/125/160/200, etc.). As a practical matter, there is not much difference in terms of noise levels between ISO settings that are close to each other, so many digital photographers find it convenient to dial in a little less or more sensitivity to fine-tune exposures (particularly in Manual exposure mode) without changing the f/stop or shutter speed. You could, for example, double your exposure in Manual mode by changing the ISO setting from ISO 100 to ISO 200, while leaving the f/stop and shutter speed at their current values.

REDUCING NOISE

Your digital camera probably has a feature called Noise Reduction that can partially compensate for random noise. NR is often activated from a menu option or may only be activated automatically by the camera. Some digital cameras have separate Long Exposure Noise Reduction and High ISO Noise Reduction. The camera compares your image with a blank image of the same scene, so that grainy speckles common to both can be deemed to be noise and thus removed. Some advanced digital cameras let you specify High, Normal, or Off settings for NR.

If you want to customize the amount of noise reduction applied, if your camera allows it, you can turn off noise reduction and do the job with image editors like Adobe Photoshop or use noise zapping programs like Noise Ninja (www.picturecode.com), which is also incorporated into the latest version of Bibble Pro, a file format converter with image manipulation features (www.bibblelabs.com).

Exposure Metering and Evaluation Modes

Exposure metering controls fall into two different categories. Metering mode is the method the camera uses to *gather* the information it uses to make exposure decisions. Evaluation mode determines the rules used to *calculate* the correct exposure from the information that has been collected.

All digital cameras measure and calculate exposure based on light-sensitive sensors inside the camera (using the sensor itself in non-SLR models; or separate sensors that measure the light reaching the optical viewfinder with digital SLRs). This through-the-lens (TTL) metering means that the camera automatically takes into account any filters you've placed over the front of the lens, and any additional exposure that might be required because of close-focusing, which moves the aperture farther from the sensor, decreasing its effective size.

One key option is to specify exactly what portions of the frame should be used to measure exposure. Even the most basic digital cameras today usually offer a menu option for choosing multipoint/matrix, center-weighted, or spot metering.

◆ **Multipoint or Matrix metering.** This is the default metering mode for digital cameras. The camera collects exposure information from many different positions in the frame (from fewer than a dozen to more than 1,000 locations). This method is best for most subjects, which may have the brightest and most important portions of the image anywhere within the frame. (See Figure 3.21.)

◆ **Center-Weighted metering.** The center portion of the frame is afforded 80 percent or more of the emphasis in calculating exposure, although the brightness of the remaining portions of the image is also taken into account. This mode is best suited for compositions in which the most important subject matter is in the center of the frame. (See Figure 3.22.)

◆ **Spot metering.** This method gathers exposure information only from a very small central portion of the frame (sometimes user definable with more advanced cameras). It's the best mode when your main subject is in the center of the frame and surrounded by areas that might mislead a matrix- or center-weighted metering system. A spotlit performer on a stage is a typical subject that lends itself to this kind of metering. (See Figure 3.23.)

After the camera's metering system has measured the amount of illumination passing through the lens, the system uses its evaluation mode to determine the correct exposure. The camera tries to decide what kind of image has been framed, so that the exposure can be determined for the main subject while balancing that exposure for the settings needed to capture other detail in the frame.

Figure 3.21 Matrix metering samples multiple zones within a frame (shown here in yellow) to arrive at the correct exposure.

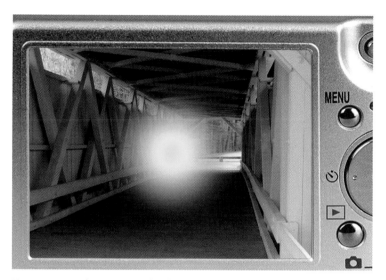

Figure 3.22 With Center-Weighted metering, most of the exposure emphasis is on the center of the frame, shown in yellow, while the rest of the image may count for less than 20 percent of the overall exposure calculation.

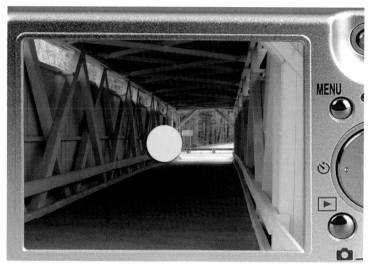

Figure 3.23 Spot metering, indicated by the yellow circle, calculates exposure solely by the information collected from a small area in the center of the frame.

The evaluation system varies from camera to camera. For example, some cameras, when set to Center-Weighted metering, may calculate exposure based on an average of all the light falling on a frame, but with some extra weight given to the center. Others may use a modified spot system with a really large, fuzzy spot, so that light at the periphery of the frame is virtually ignored.

Spot metering, too, can be used in different ways, depending on the camera's design. You might be able to select the size of the spot, or move the metering spot around in the viewfinder to meter the spot of your choice. Some digital cameras couple the metering spot with a user-selectable focus zone, too, so that as you move the zone around on the screen using a cursor key, the camera calculates both exposure and focus based on the spot you've chosen. This metering/focus option can prove to be especially useful for backlit subjects or macro photography.

Matrix or *Evaluative* metering is the most sophisticated metering system. The camera can examine the frame and determine that the upper half is brighter than the bottom half, and then assume from its built-in database that a landscape photo is being shot, and expose appropriately. The same algorithms can determine if you're attempting to shoot a portrait, a snow scene, or other common type of image. More than just the measured amount of light can form the basis for a calculation. For example, a subject that's positioned at infinity (as determined by the autofocus system) is more likely to be a landscape. For pictures taken at closer distances, the camera may safely decide that the object that appears to be closest to the autofocus system is the center of interest, and then base exposure on that subject, even if there are brighter objects elsewhere in the frame.

Overriding Your Camera's Exposure Settings

Sometimes you'll want to modify the exposure your camera would choose, either because the automatic exposure is not quite right or because you want to change the exposure for creative effect, say, to produce a silhouette or extra-bright high key look.

Digital cameras have a number of tools to let you change the exposure from the camera's calculated value to one that better suits your image. These controls include:

◆ **Exposure lock.** You can lock in the current exposure setting so that the camera won't change it. You could, for example, take a reading up close to your subject, then step back to actually frame the photo the way you want. (Zooming in with a zoom lens, then backing off to a wide-angle setting would have the same effect.) One way to lock the exposure is simply to partially depress the shutter release button.

All digital cameras "freeze" the exposure when the shutter release is pressed down halfway. However, that can be clumsy when you're trying to zoom in and out or reframe your image. See if your camera has an AE-L or exposure lock button or switch. When activated, the current exposure is locked in until you take a photo or press the lock button a second time. Some cameras may allow you to lock *both* exposure and focus with this button, or to set it so that only one or the other is locked when the button is pressed.

◆ **Bracketing.** Bracketing is a feature that's usually available only with more advanced digital cameras, especially EVF models and dSLRs, and is usually activated somewhere in the menu system. This feature might be given a "Best Shot" or other nomenclature. You might be able to set up your camera to bracket consecutive exposures for you automatically, changing the exposure each time by an amount you specify, for the number of frames you'd like to include in your bracketed set. It's simple to take three, four, or more shots, each with one-third, one-half, or a full stop more exposure, as quickly as you can press the button (see Figure 3.24). With the most advanced digital cameras, you can combine exposure bracketing with bracketing for white balance, flash exposure, or other parameters, or use them alone.

◆ **Changing combinations.** Some digital cameras let you change exposure combinations without changing the actual exposure. For example, if the camera is set for an exposure of 1/500th second at f/5.6, you can spin a dial or press some other control to change to a preferred equivalent exposure, such as 1/1,000th second at f/4 or 1/250th second at f/8.

◆ **Applying EV compensation.** Exposure Value settings are an easy way to add or subtract exposure. In the camera realm, +1EV means doubling the amount of exposure, while −1EV represents cutting the total exposure in half. In EV terms, it doesn't matter whether the change was accomplished by opening the lens one f/stop or halving the shutter speed (to add 1EV) or by closing down the lens one f/stop or doubling the shutter speed (to subtract 1EV). EV compensation is generally applied by holding down an EV button (either a separate button or as a second function of one of the cursor pad keys) and spinning a dial or using the cursor keys to add or subtract an EV amount. Some models force you to access a menu to set EV. Usually, EV increments are one-third, one-half, or a full EV, and your camera probably allows you to specify the size of the increment. EV compensation can also be used with electronic flash (*flash EV*), and in either case is especially useful when used in conjunction with a graphical representation of tonal values called a *histogram*, discussed next.

Figure 3.24 With bracketing, you can take several consecutive shots at different exposures, automatically, and then choose the one you prefer.

Working with Histograms

Many basic and most intermediate and advanced digital cameras have a feature called a *histogram*, which can be used to evaluate the exposure setting your camera decides on. You can then make an adjustment (generally using EV settings) to fine-tune the exposure. Non-SLR cameras can display this histogram in real time (a *live histogram*), so you can make the adjustment before you take the picture.

A histogram is a graphical display in the form of a bar chart that shows the number of pixels at each of 256 different brightness levels. The chart has both x and y axes. The values in the x axis (horizontal) represent the brightness levels from 0 (black) at the left side to 255 (white) at the right side of the histogram. The y axis (vertical) represents the number of pixels at a particular brightness level. So, a very short

bar at a particular position means that very few pixels have that value; a tall bar means that a larger number of pixels have that brightness.

You don't need to understand much about the distribution of these brightness levels to use a histogram effectively. This exposure aid is a lot easier to use than you might think! Histograms tend to look like a mountain range, as you can see in Figure 3.25. In most images, the majority of the pixels reside in the midtones, producing a tall clump in the middle of the histogram. Fewer tones are present at the darkest and brightest areas, so the histogram "mountain" tends to tail off at either end. Ideally, the histogram should show some tones at every brightness level. That's all you really need to know to get started.

From an exposure and tonal standpoint, problems crop up when some brightness levels are not represented as you might expect. If the "foothills" of the mountain don't extend to both the black (left) and white (right) sides of the graph, some brightness levels are wasted. Worse, if the toes

of the curve run off either side, then the image is probably over- or underexposed. Figure 3.26 shows an image in which the left side of the curve is clipped off, producing an underexposure. Figure 3.27 shows an image in which the right side of the curve is clipped, indicating an overexposure.

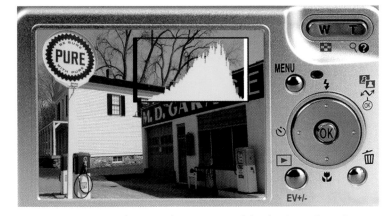

Figure 3.25 In a properly exposed image, most of the detail is in the midtones, trailing off to the highlights on the right and shadows on the left.

When viewing a histogram, you can try to fix the over- or underexposure by adding or subtracting exposure values. If an image is underexposed according to the histogram, add EV; if it is overexposed, use the EV adjustment to subtract exposure. The controls for viewing a histogram and applying EV changes vary from camera to camera. Usually, you can make the histogram appear by pressing the DISP or Display button to change the data that appears on the LCD screen. Then, use your menu system (or press the EV button if present—one is shown at lower right in the example figures), and add or subtract EV values. Often, the left/right or up/down cursor keys are pressed (when the EV indicator is shown on the LCD) to add or subtract exposure.

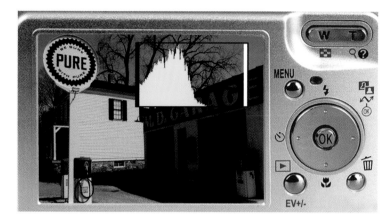

Figure 3.26 With an underexposed image, tones at the left side of the histogram are clipped off.

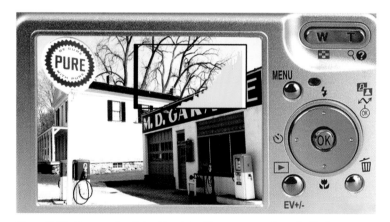

Figure 3.27 Tones at the right side of the histogram are clipped off when an image is overexposed.

Automatic Focus Basics

Owners of non-SLR digital cameras have one significant advantage over dSLR enthusiasts: Their automatic focus systems are much easier to use, without sacrificing much speed or accuracy. The main reason for that edge is that these digital cameras have smaller sensors than dSLRs, and use much shorter focal length lenses (at the wide end of the scale) which have correspondingly more depth-of-field. So, it's easier to achieve sharp focus with a conventional digital camera, and the exact focus point is slightly less critical because of the depth-of-field bonus. Non-SLR digital camera owners have fewer options to worry about, and reduced potential for confusion.

Although high-tech autofocus systems using infrared lights or even ultrasonic pulses have been used in cameras in the past, today digital cameras tend to rely on systems that measure the contrast of

the image as seen by the sensor (or in the viewfinder in the case of dSLRs) of one or more individual focus *zones*. When the portion of an image measured by a particular zone is low in contrast, that zone is out of focus; when the contrast is highest, the zone is properly in focus. Digital cameras have from five to about a dozen focus zones, although very advanced dSLR cameras can have as many as 45 individual focus points.

When the autofocus system is active, the camera adjusts the focus position of the lens and then evaluates the contrast of the zones to determine when correct focus is achieved. At any given time, it's likely that some zones will be in focus, while others are out of focus. It's impossible, of course, for every part of an image to be in sharp focus simultaneously. The key to the success of an autofocus system

is to determine which zones should be sharply focused and which are allowed to be out of focus. In making these decisions, the autofocus mechanism takes into account many different factors:

◆ **Is the subject moving?** The camera can determine, based on the changing state of the image area within the focus zones, whether the subject is moving. Some digital cameras can apply this information to produce *predictive* autofocus; that is, adjust the focus point so that a moving subject is still in focus at the position it's going to be at when the shutter release is finally pressed all the way. This system works best when the subject is heading directly towards or away from the camera.

◆ **Is the subject the closest object to the camera?** As focus information is collected, the camera can determine the relative distance of a subject in any particular focus zone and compare that info with that of the other zones to determine whether a given object

is the closest subject matter to the camera (and, consequently, likely to be the center of interest).

◆ **Which focus zones should take precedence?** The camera can use the focus zone you select manually (which may be a very good idea, because only you know exactly which of several objects in the frame is your main subject). Or, the camera can select a focus zone on its own based on the closest subject or some other parameter. Some cameras can be set to use only a single focus zone in the center of the frame and ignore all others.

◆ **How many zones should be used?** The camera can use a single focus area that doesn't change (useful when your main subject will always be in the center of the frame), or switch among several zones if the subject moves (great for sports or shooting kids). Other cameras work with a group of zones, usually by measuring just one zone, but taking into account the readings from adjacent sensors. This works well when your subject may be moving around

within a limited area of the frame, and you want the autofocus system to track it efficiently. Several digital camera systems use a series of boxes displayed on the LCD to show the available focus zones, with the currently selected zone highlighted. (See Figure 3.28.)

♦ **When should focus be locked in?** It would be an extravagant waste of power to have your camera focus and refocus for as long as the camera was switched on. Instead, your digital camera doesn't begin to seek the correct focus point until you partially depress the shutter release, or press an optional Focus Lock button (see Figure 3.29). At that point, focus can be locked in, or it can change continually as you frame your image or your subject moves while the shutter release is partially depressed.

You'll need to explore your digital camera's manual thoroughly in order to understand the settings you need to apply to change between the various focus zone options.

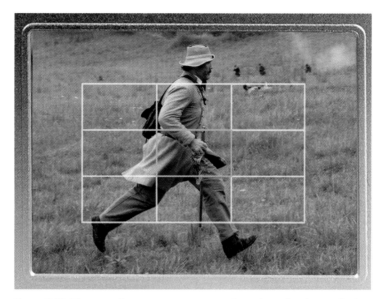

Figure 3.28 The active focus zone or zones can be indicated in the viewfinder.

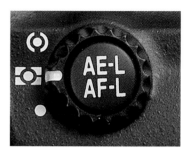

Figure 3.29 More advanced digital cameras sometimes have a Focus/Exposure Lock button.

FOCUS FEATURES

There are several useful autofocus features found in some digital cameras. These include:

♦ **Focus override.** This is a feature that allows fine-tuning an autofocus setting manually, without switching the camera out of Autofocus mode.

♦ **Focus limit lock/lockout.** Some advanced cameras have a provision for locking the lens into or out of close-up focus range. Then, when you're shooting macro photos, your camera won't waste a lot of time seeking focus all the way out to infinity. Or, if you're shooting at normal focus distances, the lens won't try to focus extra close, because the macro range has been locked out. This feature is found in EVF models, although some intermediate cameras also have this capability.

♦ **Autofocus assist lamp.** Many digital cameras have a white or red LED that turns on to provide helpful illumination when attempting to focus in low-light situations. The LED lamp provides enough light to improve contrast sufficiently for the autofocus system, although assist lamps are rarely helpful for subjects farther than a few feet away.

Automatic Focus Modes

Automatic focus modes are an additional option that tell your digital camera that's it's okay or not okay to refocus—even if you have "locked" in focus by pressing the shutter release down halfway. The smartest digital cameras can be set to ignore focus lock and change the focus anyway if the subject in your viewfinder has moved, or you reframe the picture. Most conventional digital cameras don't have these options, called *single auto-focus* and *continuous autofocus*, but more advanced models, especially EVF-based cameras, as well as all digital SLRs, do offer the choice.

Single Autofocus

In Single Autofocus mode, which is more or less the default or only mode for the majority of basic and intermediate digital cameras, when you press the shutter release down halfway, the autofocus system is activated. It then sets the focus and locks it until the shutter release is fully depressed,

taking the picture, or until you release the shutter button without taking a shot. This setting is usually your best choice for non-moving subjects, but it's not always your best option for sports photography. It uses a minimal amount of battery power because the autofocus mechanism is typically active only for a second or two as focus is locked in.

Continuous Autofocus

With Continuous Autofocus mode, when you press the shutter release down halfway, the autofocus system sets the correct focus but remains active and monitors your subject. If your subject moves or you reframe the image, the lens will be refocused as required. This mode is best for action photography (see Figure 3.30), because your subjects won't remain in one place, and the system compensates for that movement or any changes in framing you make. There are disadvantages to this autofocus mode. It uses more battery

power, of course, because the autofocus system is on whenever the shutter release button is partially depressed.

But more importantly, Continuous Autofocus can be "fooled" by a fast-moving object passing momentarily in front of your main subject. If you've focused on, say, the quarterback, Continuous Autofocus will dutifully refocus as

the team's field general moves around the gridiron (which is good). But if a wide receiver 10 yards closer to you than the quarterback suddenly darts into the frame on a passing route, the camera will refocus on the interloper and may not fix back on your original subject quickly after the receiver leaves the frame. Some advanced digital cameras let you dial in a delay so that

Figure 3.30 Continuous Autofocus is best for fast-moving subjects, including most sports.

when you're using continuous aut-ofocus, a momentary diversion won't cause the camera to instantly refocus on the new subject matter.

Both Single and Continuous Autofocus can be "fooled" by low-contrast subjects, or large blank areas that lack details for focusing the image. Large areas of sky, as shown in Figure 3.31, can easily confuse your camera's focus system, unless, as in this case, you manually select a focus zone that includes your subject.

Figure 3.31 Your superzoom camera may let you reach out and photograph a bird in flight, but a cloudless sky can confuse your autofocus system, and if your camera uses focus priority you may not be able to take a picture at all.

WHEN YOUR CAMERA LOCKS YOU OUT

Sometimes you'll find that your digital camera locks up and won't take a picture at all. When that happens, it's very likely that the autofocus system was unable to achieve sharp focus. Rather than let you take an out-of-focus picture, many digital cameras will simply refuse to take one at all. In fancy terms, this is called "focus priority"—the camera assigns sharp focus priority over activating the shutter release. This property comes into play in many different situations, producing what is called *shutter lag*, which is the interval between the time when you press the shutter release all the way, and when the camera actually takes the picture. Because of "focus priority," the camera won't shoot until focus is achieved, producing shutter lag that averages 0.6 seconds to almost 2 seconds (under dim or low-contrast lighting conditions) with some cameras. The latest digital cameras focus very quickly, producing less shutter lag, although few come close to matching the performance of digital SLRs. (Some of which can be set to the equivalent of a "release priority" mode: They'll shoot the picture even if the image is slightly out of focus.)

To reduce the frequency of lockouts, you have three choices:

◆ **Manual Focus.** Turn the autofocus mechanism off, focus the image yourself, and your digital camera will take a picture whether in focus or not.

◆ **Quick Snap.** Some digital cameras have a quick snap option that more or less disables the autofocus system and counts on the extreme depth-of-field of short focal length lenses to provide close-enough focus.

◆ **Pan Focus.** Other digital cameras have a feature that the vendors call "pan focus" but which is really an application of a technique called *hyperfocal distance*. These cameras automatically set the focus distance to the hyperfocal value (which varies by zoom setting and f/stop). At the hyperfocal distance, everything from half that distance to infinity is in relative focus. Usually, that's enough. (Some camera Quick Snap modes actually use pan focus.)

Manual Focus

Once you get the hang of autofocus, you'll probably want to use nothing else. Or will you? There are some situations where manual focus can be very handy. You don't have to worry about the camera understanding exactly what object in your frame is your main subject. Just press the focus buttons (often the cursor keys) or twist the focus ring on the lens (a common feature in EVF cameras) until you visually see that your subject is in sharp focus. You're not entirely on your own, either. With many digital cameras, a focus indicator LED will illuminate when the image within the default focus zone is in sharp focus. Here are some of the pros and cons to manual focus:

♦ **Take your time.** Focusing manually is slower and may not be your best choice for sports or any fast-moving subjects. But if you're shooting things that sit still, manual focus is hardly a handicap. For many close-up shots, I end up switching the autofocus macro to manual focus because I find that focusing close-ups manually allows for more precision in choosing the point of sharpest focus. For these kinds of subjects, manual focus is not a drawback and may even be your best choice. (See Figure 3.32.)

♦ **Focus difficulty.** You may have a bad memory for names, but your brain is even worse in remembering whether your subject was sharper a fraction of a second ago, or is actually sharper right now. That's why you jiggle the focus back and forth a few times when manually focusing. For subjects that lack contrast, manually focusing can be a trial-and-error experience with lots of trial and even more errors.

Figure 3.32 Close-up photography often lends itself to methodical and careful manual focusing techniques.

◆ **Accuracy.** It's easy to focus accurately by manual means if your subject is bright and contrasty. A lens that's easy to focus manually is one with a large maximum aperture (and, thus, little depth-of-field) and a longer focal length (again, because of shallow depth-of-field). More challenging are scenes that are dim and murky, viewed through lenses with smaller maximum apertures (say f/3.5 or smaller), and of the wide-angle zoom range. Focusing under such conditions is challenging for an autofocus system, too, but the extra speed your AF system has and its perfect memory for whether the image contrast is increasing or decreasing means you'll frequently get better results, more quickly, by letting your camera take care of focus.

◆ **Following action.** Your digital camera may be smart enough to use *predictive focus* to track moving subjects and keep them in focus as they traverse the frame. You're not. You might be able to manually focus on a point where you think the action is *going* to be, and then trip the shutter at the perfect moment. But, then again, you might not. (See Figure 3.33.)

Figure 3.33 Prefocus manually on the spot where you anticipate action is going to take place, and you'll be ready for the picture even if your camera's autofocus system is sluggish.

Reviewing and Printing Your Pictures

Reviewing your pictures after you've taken them is one of the joys of digital photography, because you can do it instantly on your camera's LCD screen. You don't have to drop your "film" off at a processing lab and wait an hour or overnight to see your results. Making hard copy prints is easy, too. If you're printing at home, in some cases, you can perform the chore without even transferring your photos from the camera! You can also opt to stop by your neighborhood retailer and have prints made from your memory card on the spot, using specifications that you enter using your camera's picture review/print order facilities.

Picture Review

Many digital cameras are packed with picture review features that make the process a lot of fun. To get the most out of review, move to a semi-darkened area so your camera's LCD won't be washed out by bright lights. Then activate Review mode, which may be a separate setting on the mode dial, or require pressing a button (usually marked with a green right-pointing triangle). Here are some of the things you can do during picture review (some of them depend on special features not available in all cameras):

◆ **Review individual shots on a full screen.** This is usually the default mode, with the left and right cursor keys typically letting you move forward and backward through your collection of photos. Picture scrolling "wraps" around, so you can move from the first picture to the last (and vice versa) by pressing a key.

◆ **View shooting data.** During picture review, your digital camera will usually let you choose whether to show full information about each picture as it is displayed (including scene mode, quality setting, shutter speed/aperture, histogram, and other data) or view an uncluttered image. More advanced cameras may display shooting data in a strip along the bottom of the frame, but it's more common to overlay this data right on the picture itself, which makes judging composition and focus more challenging.

◆ **Review thumbnails.** Most digital cameras let you switch from individual shot full-screen mode to display of four, six, nine, or more reduced-size thumbnails on your LCD screen. This capability allows you to quickly review groups of pictures. You can select one to view full screen, or mark individual thumbnails for deletion or printing. Obviously, this facility works best if your digital camera has an LCD that's 2.5-inches or larger diagonally.

◆ **Zoom in.** Even with a larger LCD screen, sometimes it's difficult to judge focus and picture quality. Many digital cameras let you zoom in 3X to 15X or more and scroll the viewed area around on the screen so you can examine your pictures closely. This zoom capability may also be used to trim or crop your pictures in the camera.

◆ **Trim/Resize/Edit images.** You might have the capability to crop your images right in the camera, create a smaller version for e-mailing, or add special effects such as color filters, picture frames, and sepia toning. These features are handy when you want to share your images and would like to do some simple modifications without bothering to transfer your photos to a computer.

◆ **Erase/Protect/Hide images.** If you want to free up space on your memory card (or just want to eliminate your goods), you can erase individual shots, or page through thumbnails and mark pictures for removal. You can also mark photos to protect them from accidental deletion (formatting the card will remove them anyway) or hide them from view.

◆ **See a slide show.** Most digital cameras let you review all the photos on your memory card and mark them for display in a slide show. Some let you deposit your favorites in a special folder on the memory card and base your slide show on that. There are several intermediate and advanced digital cameras that can apply transitional effects such as wipes or dissolves between individual slides, and play your show with background music using audio clips built into the camera (usually on non-removable 10MB-32MB memory), or clips that you upload to your camera yourself (just copy them to the memory card and follow the instructions in the camera's menus).

◆ **Create an album.** You'll find digital cameras that let you create photo albums. The best implementations of this feature make simple HTML web pages in a special folder on your memory card and produce smaller versions of your images to embed in these pages. You can view the album in your camera, copy it to your computer and view it there, or even upload it to the Internet for sharing with the world at large.

◆ **Create a print order.** Virtually all digital cameras let you create print orders during picture review.

Creating a Print Order

All recent digital cameras are compatible with Digital Print Order Format (DPOF) and PictBridge. With these two standards, you can review your photos and mark them with the number of prints you want, the sizes for each print, and even if you'd like multiple images printed on a single sheet. Then, you can take your memory card to a retailer, plug it into your own printer (as shown in Figure 3.34), or link your camera to a PictBridge/DPOF-compatible printer with a cable, and automatically print out your order.

The print file, stored on your memory card, can even include your name and address so a third-party service can match your print order with you personally. It's even conceivable that if you lose a card and someone turns it into a photo lab somewhere, they will be nice enough to locate you and return it.

Figure 3.34 Output to a printer of this type by plugging in a memory card containing your images and print order, or by connecting the camera and printer through a USB/PictBridge-compatible cable.

Making Light Work for You

Artist Aaron Rose once said, "In the right light, at the right time, everything is extraordinary." As you take photographs, you'll find that even the most mundane subjects can make perfect fodder for great photographs if you cloak them in interesting lighting effects.

James Thurber, another kind of artist, noted, "There are two kinds of light—the glow that illuminates, and the glare that obscures." The cartoonist/humorist knew that illumination can be either friend or foe, both figuratively and, in the case of photography, literally.

Photographers create their images by capturing and manipulating light. Interesting subject matter is all around us, and while angles and timing and other factors are important, what makes the difference between a great photo and a mediocre one is how light is used. The better you understand your raw material, the better you'll be able to use it to shape your photographs.

Light comes in two forms: continuous and electronic flash. Continuous lighting consists of the constant illumination around us, whether it occurs naturally (such as daylight, moonlight, or firelight), or is created by humans in the form of lamps and other kinds of artificial illumination. Electronic flash is a special kind of artificial light, produced by a gas inside a glass tube that glows brightly for a fraction of an instant when given a powerful electrical charge.

For photographers, continuous and electronic flash each has advantages and disadvantages. Continuous lighting allows you to visualize exactly the relationships of the highlights and shadows the light source will produce when the picture is taken. However, you'll need to depend on a fast shutter speed to freeze action, and constant lighting may not be bright enough for the exposure you need.

Electronic flash, on the other hand, makes it more difficult to visualize the lighting effect you'll get, but can be very bright without providing discomfort to your subjects in the form of heat. Electronic flash's very brief duration is excellent for stopping action, too. A flash may illuminate a subject for just a tiny moment in time—as little as 1/50,000th second, which easily freezes all but the very fastest action in its tracks.

This chapter provides a concentrated short course in what you need to understand to work with light in either form.

Quality of Light

Light isn't just a bunch of photons bouncing around aimlessly. In practice, the illumination you use to make photographs has characteristics of its own, including direction, intensity, color, and something you can think of as texture (which is actually a combination of the other factors). You need to understand and manage each of these attributes to shape your images with light. All of these apply both to continuous lighting and electronic flash.

Direction

The direction from which light approaches your subject affects the three-dimensional qualities of your image as well as its mood. You can make some dramatic changes in your images just by altering the direction from which light approaches. When you're shooting subjects that aren't flat—such as people—the direction of light determines how shadows form and how they affect your image. The relative balance between shadows and the lighter areas of your photo is also important.

The directionality of the light you use can affect the mood of the photo. When light comes from behind the subject with very little light falling on the front, you get a backlit or silhouette effect, which can be mysterious—because we can't really see details of the subject on the side facing us. Lighting from the side can be dramatic, because only part of the subject is well-lit, and the rest is either de-emphasized or left to our imaginations. Figure 4.1 shows an image with stage lighting that's coming from high above and to one side of singing cowboy "Ranger Doug" of Riders in the Sky. This lighting provides a dramatic look, which is why I used the available illumination, even though I had to boost the sensitivity (ISO) setting of the camera to capture the image. The bit of extra graininess from noise (caused by the higher ISO setting) was a necessary trade-off.

Figure 4.1 Dramatic lighting can produce interesting shadows and shapes.

A subject lit evenly from the front can be bland because there are no interesting shadows to show shape and form. Light placed very low below the subject can change our perceptions drastically, because, in the natural world, such lighting is not the normal state of affairs. Low lighting of a human face can produce a "monster" look. When shooting photos, you can manage the direction of light by moving your subject or, if the lighting is artificial, by moving the lights themselves.

Intensity

The absolute intensity of the light we use doesn't intrinsically change the appearance of our subjects in the same way that the direction of the light and its texture do. That's because your digital camera can compensate for the relative brightness (or lack of it) by increasing the exposure or boosting the sensor's sensitivity. In practice, the intensity of light has an indirect effect on your photos: If there is too little light, you or your camera's autoexposure system must select a slower shutter speed (which can cause blur), use a larger aperture (affecting depth-of-field and, perhaps, sharpness), or increase the ISO setting (which can add noise or grain to the image). Too much light and you may lose creative control over intentional blur caused by moving subjects or selective application of depth-of-field.

There are a variety of ways of controlling intensity, including adjusting the output of the lights themselves (especially with electronic flash, which may have adjustable power levels), or using light-reducing filters on your lenses. Close-up photos that call for a deep range of focus (depth-of-field) work best with high light levels, even if that light is soft and diffuse.

Color

Although most kinds of photos call for neutral lighting with no color cast, you can often set a mood or create a special look by incorporating the color of your light source into your photograph—or even by changing that hue yourself. Blue tones impart a cool feeling, reds add warmth and passion, greens can represent nature or, in human subjects, a sickly pallor. Figure 4.2 shows a simple mixed-color close-up image made with a digital camera in macro mode and illumination from a pair of high intensity desk lamps—one with a piece of red plastic held in front of it, and the other attenuated by a sheet of blue translucent cellophane. The mixture of color provides an interesting abstract quality to a photograph of a pile of ordinary paperclips.

Figure 4.2 An interesting abstract composition results when contrasting colors are used to illuminate a pile of paperclips.

Texture

Okay, light doesn't really have texture. What I describe as the texture of light is actually another aspect of its directionality and intensity, which, depending on how the light reflects from the subject, reveals or disguises the texture of the subject. This aspect is mostly determined by whether the light appears to come from a small, concentrated point, or from a larger, more diffuse surface. As you can see, this quality of light is actually just another aspect of its directionality. With a point-source light, the illumination arrives at the subject from the same direction, with not much of it spilling into adjacent areas, such as shadows, producing a harsh, glaring look. With a "softer" light source, the light appears to come from slightly different directions, and some of it spreads out to fill in shadows and edges in the subject for a gentler form of illumination. Figure 4.3, which pictures a carving from a Medieval cathedral, shows what I mean.

Texture is also something you can modify as you take photos. With natural illumination and a moveable subject, you can relocate to a place where the light is less harsh or more so, depending on your needs. Sometimes going from direct sunlight to the shade, or vice versa, can do the trick. Light can be modified by using reflectors such as pieces of cardboard or umbrellas. A soft white reflecting surface creates diffused light. A bright, shiny surface can be used to increase the contrast of the light.

Figure 4.3 Notice how the harsh shadows in the lower picture make this a contrasty image; in the upper picture, a more diffused light source fills the shadows with light.

White Balance

The "white" light that we see consists of a continuous spectrum of colors, but, for the purposes of photography, humans have segregated those colors into the same three primaries that our eyes detect: red, green, and blue. Unfortunately, the relative quantities or *balance* of each of those three colors varies, depending on the kind of illumination you're using. That ratio is commonly called *color balance* or *white balance*. For most types of continuous lighting and electronic flash, the white balance is measured in degrees Kelvin, because scientists have a way of equating temperature with the relative warmness and coolness of the light. (That's why white balance is also called *color temperature*.) Common light sources range from about 3200K (warm indoor illumination) to 6000K (daylight and electronic flash). Fluorescent light doesn't have a true color temperature, but its "white balance" can be accounted for nonetheless.

While digital cameras can make some good guesses at the type of lighting being used and its color temperature, it's often a good idea to explicitly tell your camera exactly what kind of light it is working with. Even the most basic digital cameras will have a setting for changing white balance from Auto to presets such as Daylight, Shady, Incandescent, and Fluorescent. Choosing the correct white balance will produce pictures with more accurate colors and less correction required in your image editor. Figure 4.4 shows two sample images with the white balance set manually. The scene was taken at dusk and most of the illumination of the hotel in the foreground was provided by streetlamps. In the version at left, the white balance has been set to Daylight, which provides a warm tone to the picture, because the streetlamps are much more reddish than the daylight balance the camera has been set to. The version at right was exposed with the white balance set to Tungsten. It actually more closely resembles the appearance of the original scene, and its cooler rendition provides an image that is much different from the one at left.

Figure 4.4 With white balance set to Daylight (left), the image, illuminated by streetlamps, has a warmer tone than when white balance is set to Tungsten (right).

Setting White Balance Manually

Your camera's manual white balance controls may be found buried in a setup menu, or may be accessible by holding down a button while changing the setting using a command dial or the cursor pad. In either case, you'll be presented with preset values that you can choose instead of the default, Auto. The number of choices may vary, but you'll have the four basic settings (Daylight, Electronic Flash, Incandescent, Fluorescent), and possibly variations such as Direct Sunlight, Overcast/Cloudy, Open Shade, and one or two flavors of fluorescent illumination, such as Warm White and Cool White. Advanced cameras sometimes have an option to dial in the exact color temperature in degrees Kelvin (assuming you know what that value is for your particular light source; sometimes the lamp is labeled with its color temperature).

It's also common among advanced cameras to have a "fine-tuning" option that allows you to dial in some extra warmth or coolness, usually plus or minus, say 10, from the nominal neutral value.

> **TIP**
>
> If you're in the habit of using your camera's automatic white balance feature, it's especially good idea to take some time now and learn each of the ways you can tweak white balance settings manually. You won't want to take the time to figure it out when you're busy shooting under difficult lighting conditions.

Measuring White Balance

Some intermediate and most advanced cameras let you measure white balance of continuous light sources yourself. The option will be located in one of the setup or shooting menus. Once the camera is ready to measure white balance, you take a photo of a neutral surface (such as a white or gray wall). White balance will be set to render this subject without a color cast.

Creating Your Own Presets

Your advanced digital camera may have an option for storing the measured white balance in a memory slot as a preset. The feature might also include the ability to provide a label or name to the preset (such as Madison Square Garden), so you can retrieve the setting at a later date. Some cameras also allow adopting the white balance of an existing image on your memory card, so that can be applied to your current shooting session or stored as a preset.

> **TIP**
>
> If your camera doesn't allow you to save as many white balance presets as you'd like, dedicate a small capacity memory card for holding sample images with various white balances. When you need one of them, insert that memory card and tell your camera to use the appropriate example as its current white balance setting.

Other Factors

Advanced cameras with the capability of storing unprocessed (RAW) images give you one additional option: specifying the white balance of the image *after* the picture is taken. Your RAW-capable camera was furnished with RAW processing software that will let you make this adjustment. Third-party packages, such as Pixmantec RawShooter Essentials (now bundled with many Corel Corporation applications and recently acquired by Adobe), can do this, too. RawShooter Essentials is shown in Figure 4.5.

If you shoot RAW, you can adjust the white balance when the image is imported into your image editor, changing it from the "as shot" value to any other value available in the conversion program. This may be your best opportunity to tweak electronic flash white balance. Flash color temperature can vary slightly, depending on the duration of the flash.

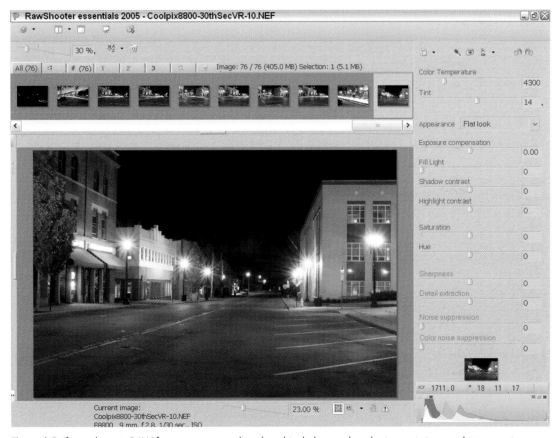

Figure 4.5 If you shoot in RAW format, you can adjust the white balance when the image is imported into your image editor, or by using a third-party tool like RawShooter Essentials.

Electronic Flash

Electronic flash is a convenient form of illumination that can provide the light you need to take a picture in areas where the existing light isn't strong enough for an exposure using a reasonable shutter speed and aperture. All basic, intermediate, and many digital SLRs have a flash unit built in. Some have a fixed flash unit embedded in the front of the camera, while others have a pop-up flash like the one shown on the EVF camera in Figure 4.6.

As with all forms of illumination, electronic flash obeys what photographers (as well as physicists and anyone else who deals with electromagnetic radiation) call the *inverse square law*. This law can be summed up as follows: When the distance between the light source and your subject is doubled (2X), the amount of light needed to provide a correct exposure is quadrupled (4X). In photographic terms, that means you need two extra f-stops worth of light each time you double the distance.

Figure 4.6 A built-in flash pops up ready for use at a moment's notice.

> **TIP**
>
> When using manual flash exposure, keep a clean handkerchief handy. Drape it over the pop-up flash to diffuse the light. You'll reduce its intensity at the same time, which can be important if you've moved in close to your subject. Built-in electronic flash sometimes cannot be reduced in power sufficiently when shooting close-ups.

Fortunately, your digital camera can calculate the correct exposure for you if you use the built-in flash unit or an external dedicated unit designed especially for your camera—usually attached to the shoe mount on top of the camera. Some digital cameras can use a flash (such as the High Power Flash for certain Canon PowerShot models) that clips onto a bracket that connects to the tripod socket on the bottom of the camera, and doesn't require a cable connection to fire.

With most electronic flash units (built-in or external), the appropriate exposure is achieved by reducing the amount of light issued by the flash. When the camera's exposure system determines that sufficient light has been received by the sensor, the camera sends a signal to the unit so the remaining electrical charge in the flash will be "dumped" and not emitted by the flash tube.

Here are some important things to know about using flash:

◆ **Action stopping.** The flash occurs for an instant when the shutter is fully open, so the shutter speed itself has no effect on the flash's action-stopping power. The time of the exposure is determined by the very brief duration of the flash, rather than by the shutter speed itself. So, a flash unit with a duration of 1/1,000th second flash will freeze action in exactly the same manner whether the shutter speed has been set at 1/2 second or 1/250th second.

◆ **Ghost images.** While flash will freeze action even at slower shutter speeds, if there is enough ambient light to produce an image, you'll get a second exposure that can cause a ghost image if your subject is moving. For that reason, it's usually a good idea to use the highest shutter speed that you can when taking flash pictures of moving subjects under high levels of illumination, to avoid ghosts like the one shown in Figure 4.7.

◆ **Hurry up and wait.** The electronic flash must recharge after an exposure, usually 1 to 2 seconds, depending on how much of the charge was used for the last shot. For that reason, your digital camera probably won't let you use its burst/sequence shooting mode with flash.

◆ **Depth of light.** Flash provides optimum exposure at only one distance. Anything in front of that distance will be overexposed; anything behind it will be underexposed. The relative "depth of light" will be shallow. This means that if you want to shoot a group of four people, you're better off with a line-up, at least from a flash perspective. Or alternatively, bounce flash, which serves to increase the effective distance between flash and subject and thereby lengthens the depth of light at the cost of reduced flash power at the subject. Use flash with, say, a couple on a dance floor, and it's likely the background behind them will go completely dark.

Figure 4.7 While the flash freezes your subject, if the other illumination in the scene is bright enough, a second exposure from the ambient light can produce a ghost image.

Flash Modes

Your digital camera has several flash modes that can be used to provide several different flash effects that are useful in particular picture-taking situations, such as when you want to use flash to fill in dark shadows, or want to avoid glowing red eyes in human subjects. With basic and intermediate digital cameras, these modes are most often selected by pressing a cursor key assigned to that function repeatedly until the icon representing the particular mode you want appears on the LCD. With other models, you may find a dedicated Flash button that cycles through each mode, often when you turn a command dial or press a cursor key. The Flash button may also be pressed when adding or subtracting exposure using flash exposure compensation (discussed next). The flash modes can be set individually with most cameras, or may be activated when you choose a particular scene mode. The most common flash modes are:

◆ **Auto.** This mode allows the flash to fire automatically when the camera determines that there isn't enough light for a good exposure without flash. If the camera doesn't have this option, it may resort to long exposures that can cause blur from subject or camera motion, or use a much higher sensitivity (ISO) setting, which can result in grainy noise. Most basic and intermediate digital cameras are designed so the flash is exposed at all times, ready for use, but some intermediate and advanced cameras have a pop-up flash that is hidden when not in use. When the Auto mode is selected, the flash will pop up automatically when required (although a few cameras force you to flip open the flash yourself).

◆ **Auto/Red-Eye.** This mode is similar to Auto, but it will activate the camera's red-eye reduction feature. Usually, a brief pre-flash prior to the actual exposure causes the irises of subjects' eyes to contract, which tends to reduce or eliminate the red-eye effect in humans and yellow eyes found in other animals. Because the pre-flash slows down picture taking for a fraction of a second and uses additional battery power, you might want to avoid the red-eye setting if your picture won't include subjects who are facing the camera. The pre-flash can also be distracting/annoying, so you might want to avoid the red-eye setting if you plan on removing any glowing pupils in your image editor (especially if your camera's red-eye feature does a poor job of canceling red eyes).

◆ **Always On/Fill.** The flash always fires in this mode, regardless of whether or not extra light is needed for the basic exposure. You'll find the Fill flash mode useful in bright sunlight or indoors under glaring light (such as stage lighting) to brighten shadows and produce a more pleasing look. With many cameras, the Fill setting reduces the amount of light the flash emits, so that it doesn't overwhelm the ambient light and create a "flash" look. Completely erasing the shadows is rarely a good idea. With intermediate and advanced cameras you may be able to dial back the power level of the flash to provide a better balance of existing light and flash. In Figure 4.8 (top), you can see that the impressive engine is obscured by murky shadows under the hood of the custom car, but pops out with more contrast and detail when fill flash is used for the version shown at bottom.

◆ **Slow Sync.** This setting couples flash with longer shutter speeds to provide a combined exposure that uses both the flash and existing light. This mode is especially useful outdoors at night, with the camera mounted on a tripod or supported in some other way to avoid blur from camera shake during the longer exposure. The resulting picture includes subjects that are well exposed from the flash, plus background that is brighter (rather than inky black) thanks to the slower shutter speed. Figure 4.9 shows the same image as if it were taken with a normal flash exposure (left), and with slow sync used to allow the background to be illuminated by the stage lighting.

Figure 4.8 Available lighting (top) is a bit murky, but a touch of fill flash (bottom) makes this engine sparkle.

Figure 4.9 Backgrounds are often too dark when flash is the primary source of illumination (left). Using Slow Sync mode allows a longer shutter speed that gives the background additional exposure.

Flash Exposure

With most basic, intermediate, and advanced digital cameras, you'll find only one option for adjusting flash exposure: Flash Exposure Compensation, or Flash Exposure Value (EV) adjustments. This type of tweaking works on the same principle as EV adjustments for continuous lighting: If you find that your picture is over- or underexposed, you can reduce the amount of flash applied by the camera (to compensate for overexposed photos that are too bright) or add a little exposure (to compensate for underexposed pictures that are too dark).

Flash Exposure Compensation is usually dialed in by pressing a button and making an adjustment with a command dial or cursor buttons. You'll usually be able to add or subtract exposure over a range of +3/-3 increments in 1/3 or 1/2 increment steps. There is one big difference between flash and non-flash

exposure compensation: Flash adjustments must be made *after* you've taken a shot to apply correction to your next picture. So, even if your camera provides live histograms before the shot is taken (see Chapter 3 for more information on using histograms), the camera still must "look" at an actual flash exposure to produce the histogram chart you'll use to make your exposure fix.

To use Flash Exposure Values, take a test picture or two and decide whether your images are too light or too dark for your taste. Then press the flash EV button or control (or activate it with a menu choice), and use the command dial/cursor pad, or other adjustment control to add or subtract exposure for the next shot. Adjust by only one increment each time. Some cameras can bracket flash exposures automatically, taking successive pictures at different power levels.

There are several things about electronic flash that are often overlooked. Here are some things to consider:

◆ **Optimized for wide angle.** The electronic flash units built into digital cameras are generally optimized for the *widest-angle setting* of the camera's zoom lens. If that were not true, then the coverage of the flash would be insufficient to illuminate all the corners of the image when using the wide-angle setting. Unfortunately, this optimization also means that when you zoom in on a subject, a lot of the light from the flash is *wasted*. You're taking a photo of a small center section of a scene that's broadly illuminated by your wide-angle flash. So, expect that the "reach" of your camera's electronic flash will be greatest at the wide-angle setting, providing (hopefully) even illumination out to 10-12 feet. When using the telephoto setting, don't be surprised if that same flash has a range of only 8-10 feet,

or less. That might seem counterintuitive (after all, does the flash know whether you're "cropping" the image by using the telephoto zoom?), but that's the way it works in practice.

◆ **ISO used to manage flash range.** Most basic and intermediate digital cameras use automatic ISO adjustments to control flash range, at least in part. So, when your flash is set to Auto exposure, it's very likely your camera will reduce the ISO setting when you're photographing objects that are close to the camera, and increase sensitivity when you're taking photos at the flash's maximum range. With some cameras, this ISO boost can result in excessive noise (depending on how much noise your particular camera produces at higher ISO settings in the first place). Before using your flash extensively, it's a good idea to take some practice pictures of subjects at both close range and distance settings to see how your camera responds.

◆ **Cutting power with manual mode.** Some digital cameras have a manual flash mode, which lets you adjust the output level of the electronic flash (generally from full power to a weaker setting, which can range from 1/8th to 1/128th power). You then set the f/stop of your camera to an appropriate value, determined by guesstimation (and then adjusted after you review your results on your camera's LCD), by calculation (using an archaic system called Guide Numbers), or, if you're using an advanced camera and really dig technology, by use of a handheld flash meter. You can use manual exposure when you're taking photos up close and the full power of your flash is too strong.

You can also use manual exposure when you attach an external flash unit that has no automatic features at all (such as studio flash linked to an advanced digital camera). Manual exposure is also good when you want to calculate flash exposure yourself because the automatic systems are being fooled (say, by a subject that has components that reflect more or less light and throw the auto exposure off, or when you want to use the very lowest power setting to freeze action, as in Figure 4.10). You should also know that reducing power levels manually also makes the flash duration shorter, allowing the flash to do a better job of freezing action.

Figure 4.10 Manual exposure can be used to reduce power to its lowest setting for action-stopping close-ups like this one.

GUIDE NUMBERS

If you want the joy of calculating flash exposures manually (or, more likely, you simply want an indication of how powerful your flash is relative to other units), you can work with Guide Numbers, which are values given in pairs for any particular ISO setting, one for meters and one for feet. To use a Guide Number (GN) to calculate exposure, divide the Guide Number by the distance to produce the f/stop. For example, if the flash's GN at ISO 200 is 110, and your subject is 10 feet away, then 110 divided by 10 is 11, and you'd use f/11. If the subject were 20 feet away, your result would be 5.5, and you'd use f/5.6. Guide Numbers are clumsy to manipulate, and they don't take into account how much light your subject reflects, but they can be useful in a pinch.

Connecting an External Flash

Built-in electronic flash isn't always your best choice. The internal units in your digital camera might not be powerful enough for the job at hand. A built-in or flip-up flash is often so close to the lens that red-eye effects are almost unavoidable, and, with an EVF superzoom camera, you might even find that the lens or lens hood casts shadows on your subject. The flash that comes with your camera might not provide enough coverage for the widest-angle zoom setting. External flash units often solve all these problems, and provide additional capabilities to boot.

Add-on flash units can be attached to a hot shoe on top of many intermediate and most advanced digital cameras, where their extra height helps reduce red eye. They can be swiveled to bounce light off various surfaces, and fitted with color filters, dome diffusers, and other accessories. The most sophisticated models

can "zoom" their coverage automatically to match that of your lens's zoom setting, might have a bright focus assist lamp to replace the one built into the camera, and can wirelessly control other flash units.

But, most importantly, external flash units can be removed from the camera and pointed in any direction you like, so their illumination can come from the side or above your subject. Operated wirelessly or as a slave unit, an add-on flash can be placed anywhere in your scene. But, if the strobe is not mounted on the camera, how does it connect? There are six ways of linking an external flash unit to your camera.

◆ **Proprietary Connector.** Advanced digital cameras sometimes include a proprietary connector that accepts a plug with a half-dozen to a dozen contacts. Electronic flash can be plugged into this connector, as well as remote control units and other accessories. The link is designed to

provide complete communication between dedicated flash units and the camera, again preserving all the features you paid for.

◆ **PC/X Connector.** This is a simple two-conductor connector used to trigger a flash unit. (See Figure 4.11.) The only communication between the camera and the flash occurs when the camera gives the signal to fire. Automatic exposure, if it's possible, must be of the A (Automatic) variety I described earlier, with the electronic flash itself calculating exposure using the ISO and f/stop information you entered

Figure 4.11 A standard PC/X connector is generally found only on advanced digital cameras and digital SLRs.

manually. This kind of connector is useful if you're working with studio flash or other manual strobes.

◆ **Substitute PC/X Connector.** What do you do if you want to connect a flash that is compatible only with a PC/X connection, and your dSLR doesn't have a PC/X socket? If your camera has a hot shoe, you can slide an adapter that has its own PC/X socket into the shoe and then plug your flash into that. Flash units that use a triggering voltage that is too high for your camera's circuitry can be connected to an adapter like the one shown in Figure 4.12 that has its own isolation function, shielding your camera from innards-frying bursts of electricity.

Figure 4.12 Adapters can add a PC/X connector through the hot shoe.

◆ **Wireless Trigger.** Some advanced cameras have a wireless mechanism that can trigger off-camera flash units that are built to sense the signal. There are also third-party wireless or infrared flash triggering devices that connect to your camera (often through a hot shoe) and fire electronic flash units with a compatible receiver when you press the shutter release. You can then place the flash anywhere you like (within its distance limitations) with no need for a wired connection.

◆ **Slave Trigger.** A slave sensor detects the burst from other flash units and triggers its own strobe in response, quickly enough to contribute to the current exposure. External flash units that don't have their own slave sensor can often be fitted with an outboard unit. No camera/flash communication exists. Figure 4.13 shows an inexpensive (less than $80) radio-control slave trigger. The transmitter (upper right) plugs into the PC/X connection of your camera, or substitute PC/X socket. The receiver (lower left) connects to your electronic flash, which is plugged into the PC/X socket on the front. The large plug on the cable can be connected to more advanced flash units that accept "monoplug" connectors.

◆ **Hot Shoe/Hot Shoe Cable.** The basic external flash connector on some intermediate and most advanced digital cameras is the hot shoe, which has contacts that make electrical connections with the flash (as shown in Figure 4.14). For off-camera use, there are also cables that have a fitting that slides into the camera's hot shoe. The external flash slides into a shoe at the other end of the cable. All the electrical connections provided by the hot shoe are conveyed to the flash unit, so all the automated functions of the dedicated flash are retained.

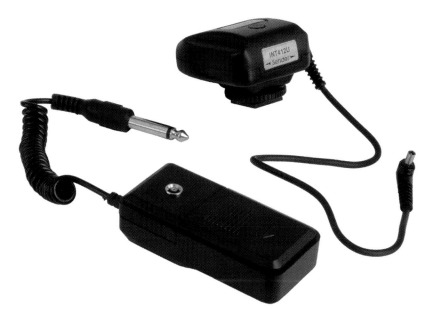

Figure 4.13 Inexpensive radio-control slave devices allow triggering an external flash at a distance from the camera.

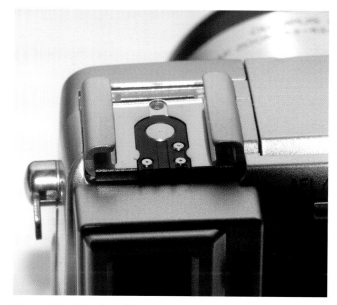

Figure 4.14 A hot shoe allows connecting an external flash, or using a special cable that can control an off-camera flash unit.

Using Your Zoom Lens

A few years ago, the number of megapixels a digital camera boasted was often considered its most important feature. Today, with ample pixel counts found in cameras from $150 to $1,500, the megapixel tally is no longer the most important specification of a digital camera. The focus (ahem) is more likely to be on the features of the camera's lens. The optics attached to your camera determine just how wide a view you can take in, how much magnification you can apply to bring distant objects closer, how close you can focus when shooting subjects like flowers or tiny animals, and, to a certain extent, how much light you must have to get a good picture. Your lens can be one of the most powerful tools associated with your digital camera, or a limiting factor that makes shooting certain types of pictures a challenge.

With non-SLR cameras, the optics can't be swapped out to attach a different lens. You can broaden your camera's perspective or increase its telephoto reach with adapters, and focus closer with filter-like attachments, but, in general, the kinds of photos you take depend, to an extent, on the lens attached to your camera.

The widest angle of your zoom will come in handy when your back is against a wall and you need a wider view. Wide angles are great for interior photos, pictures outdoors in crowded surroundings, and for those times when you want to take advantage of the wide-angle lens's perspective "distortion." Telephoto zoom settings bring things closer, reduce depth-of-field (so you can use selective focus), and compress the relative distance between objects, which are all valid creative tools.

But your zoom lens also has macro capabilities that let you focus as close as an inch or two from the front of the lens, and zooms with larger maximum apertures, relative to their focal lengths, that let you shoot in lower light levels or use faster shutter speeds. Some lenses do an especially good job of providing extra sharpness for critical applications where images will be examined closely or enlarged. This chapter provides a quick overview that will help you choose your optical artillery best suited for common picture-taking opportunities.

Lens Considerations

Unless you're considering an upgrade to a different camera, you'll play your photographic hand with the cards and lens you've been dealt. Even so, it's useful to understand the capabilities of your particular zoom—and those of the one that will be mounted on the camera you buy next. That understanding will help you assess your needs and determine whether zoom range is the most important capability of your lens, or whether you prefer close focusing, an extra wide angle, or simply want a "walking around" lens that covers everything from moderate wide angle to short telephoto. Or perhaps you prefer a compact lens on a compact camera, for easier transport and more discreet shooting than is possible with a superzoom EVF camera with a monstrous lens. Lenses with longer zoom ranges tend to be more difficult under low lighting conditions, too, because they aren't as "fast" as more moderately ambitious optics.

MAGNIFICATION VS. ZOOM RANGE: YOU NEED TO KNOW BOTH

Magnification range tells you how much apparent enlargement you can expect from your lens when zooming from the widest- angle position to the maximum telephoto position. A 10X zoom, for example, makes your subject appear to be 10 times larger when you zoom in. Unfortunately, this zoom "ratio" figure isn't as informative as you might like. To know how useful your lens really is, you need to know the actual focal length range (or its 35mm equivalent). For example, one EVF camera has a 10X zoom that extends from the equivalent of 24mm (a very wide angle view) out to 240mm (which happens to be a useful telephoto range, too). Another vendor's 10X zoom goes from the equivalent of 35mm out to 350mm. If you were shooting architecture, with all other factors equal, you'd probably prefer the 24-240mm zoom. But for sports, the 35-350mm zoom might be more useful. You need to know both zoom range and focal length range to easily evaluate a lens.

- ◆ **Size.** Zooms require additional internal lens elements to provide the zoom factor, correct for optical aberrations, and correct for optical problems introduced by the corrective elements. So, many zoom lenses are considerably larger than others, sometimes even at the same magnification. You'll need to decide whether the extra size or weight is worth the added convenience.

- ◆ **Speed.** Zoom lenses typically have smaller maximum apertures: A camera with an f/2.8 zoom is likely to be expensive. Moreover, regardless of the price, the f/stop is likely to change as the lens is zoomed to the telephoto position, narrowing in the typical lens from, say, f4.5 at the wide-angle position to f/5.6 or f/6.3 at the long end. Cameras equipped with zooms that have an unchanging, *constant* maximum aperture are more expensive.

- ◆ **Sharpness.** Zooms may sacrifice a little sharpness to gain a longer range or a wider aperture. The camera offerings from some vendors may have lenses that vary in sharpness (or even quality of construction) within the same general product line. If you can, test the actual camera you'll be buying before you make your purchase.

- ◆ **Autofocus.** With basic and intermediate cameras, automatic focusing depends more on the camera's capabilities than the properties of the lens. However, with more advanced cameras, automatic focusing can be affected by the design of the zoom lens itself. Some offer slower autofocus than others. Others shift optical focus slightly as you zoom, forcing the camera to refocus constantly.

- ◆ **Zoom Creep.** Watch out for zoom lenses that extend themselves when the camera is pointed downwards. Zoom creep is both inconvenient and annoying. Fortunately, most basic, intermediate, and advanced digital cameras don't suffer from this affliction, particularly those that use a motorized mechanism to zoom. If you own an EVF camera that uses a manual zoom ring on the lens to focus, make sure the mechanism is tight, but works smoothly.

Things to know about zoom lenses:

◆ **Magnification Range.** The most common specification supplied for digital camera zoom lenses is also the most misleading. Although this spec is usually called *zoom ratio*, a more accurate term would be *magnification range*. This range is given as multipliers: 3X, 5X, 10X, or 15X, and represents the amount of apparent magnification of the lens's widest view when set to the extreme telephoto setting. However, all 3X lenses are not alike: One 3X zoom might have a much wider angle view and less of a telephoto effect than another lens.

◆ **Zoom Focal Range.** The focal length range shows the actual field of view of the lens. This specification is usually given as an equivalent of the focal length that would provide the same field of view on a standard full-frame 35mm film camera (or full-frame digital SLR camera).

◆ **Optical vs. Digital Zoom.** Virtually all digital cameras include an optical zoom, which covers the "advertised" range of the lens, such as 3X or 5X, with magnification that's provided exclusively by shifting the optical elements of the lens. Most also include an additional zoom feature called *digital zoom*, which magnifies only the

center pixels of an image to provide additional faux zoom range. For example, if your camera has a 5X optical zoom and a 3X digital zoom, you can magnify your image up to 5 times with the optical zoom, whereupon the digital zoom crops and enlarges the center of the 5X zoom image, producing up to a 15X total "zoom" range (5X times 3X). You'll see an indicator in the LCD, like the one shown in Figure 5.1, with a mark showing where the optical zoom ends and the digital zoom begins. Some cameras with power zoom pause for a moment when that demarcation is reached, providing a helpful visual clue that you're entering digital zoom territory. However, digital zoom rarely provides additional usable magnification, so most people switch it off permanently in the setup menu.

Figure 5.1 When digital zoom is activated, a digital camera's LCD usually uses a bar indicator to show when optical zoom ends and digital zoom begins.

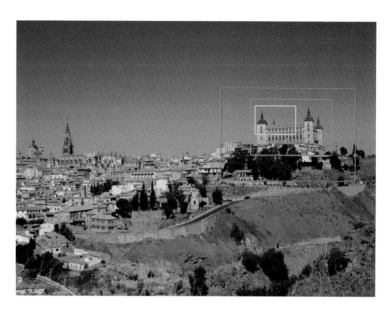

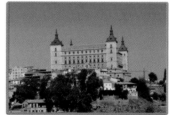
3X

5X

10X

Wide-Angle Views

A wide-angle zoom setting provides a dramatically different perspective compared to normal or telephoto settings, which tend to simply bring things closer. Wide-angle views are so useful that most basic and intermediate digital cameras default to that setting when you turn the camera on. You might have to set a menu preference to have your camera power up using the last zoom setting applied.

Here are the advantages of using the wide-angle capabilities of your zoom lens:

◆ **Increase working space.** If space is tight indoors, you don't want to back up against a wall or go outside and shoot through a window! Outdoors, you might want to include all of a city building without stepping into the street, or you'd like to snap a picture of Lindsay Lohan from a few feet away without giving her fans a chance to crowd around her and

obstruct your view. A wide-angle zoom setting allows you to fit more in the frame from a reduced distance.

◆ **For an interesting angle.** Get down on the ground and shoot up at your subject. Or, climb a ladder or other high vantage point and shoot down. You'll find the perspective refreshing while it sparks your creative viewpoint. Or, try turning your camera sideways and shoot a wide-angle vertical shot, as in Figure 5.2.

◆ **For emphasis or distortion.** A wide-angle setting applied to a landscape subject will emphasize the foreground details while moving the distant scenery farther back from the camera. A snowy slope with distant mountains might look dramatic. Or, you can get extra close to your subject and create a distorted wide-angle look.

◆ **To gain a wider field of view.** The rural field with the barn and scenery behind is wide and dramatic. The only way you can take it all in is with a wide-angle lens, as in Figure 5.3.

Figure 5.2 A wide-angle lens offers an interesting perspective when you get down low below your subject, as in this shot, or up high and shoot down.

Figure 5.3 Wide angles give you a wider field of view, but make it important to watch that the straight lines in your images are properly aligned.

◆ **For added depth-of-field.** As a practical matter, wide-angle views offer more depth-of-field at a given aperture than a telephoto setting. Of course, the fields of view and perspective differ sharply, but if lots of depth-of-field is your goal, a wide-angle lens is your best bet, as in Figure 5.4. Remember that with most digital cameras, which have relatively small sensors and use shorter focal length lenses, your depth-of-field is likely to be abundant at a large range of focal lengths. The wide-angle setting just gives you a little more to work with.

IMAGINARY DEPTH-OF-FIELD?

Of course, pedants will say this added depth-of-field is illusory, because if you photograph the same subject from the same distance with both wide-angle and telephoto settings, then crop and enlarge the wide-angle photo to provide the same subject image size, the depth-of-field will be the same. But who does something insane like that? Most of us happily benefit from the "deception."

Figure 5.4 A wide-angle lens's depth-of-field encompassed everything on this custom auto, along with the background. The size distortion of the close vantage point lifted this photo from the mundane, too.

Wide-angle lenses have a few things to beware of when you use them:

◆ **Watch straight lines.** Your wide-angle shots are likely to have lots of horizontal and vertical lines in the horizon or outlines of structures. If the back of the camera is not parallel to the plane of your subject matter, you can end up with perspective distortion. If the camera is rotated slightly, the vertical and horizontal features won't line up. To help you align your camera properly, consider using the grid that many cameras add to the focusing screen (usually turned on through a menu option or by pressing the Display or DISP key until it appears).

◆ **Avoid unintentional size distortion.** Subjects closer to the camera will appear disproportionately large compared to objects that are farther away. When shooting human subjects up close, you might find that noses look immense and ears look flattened and comical. Unless you're looking for a special effect, back away from such subjects or use a longer lens if you need the same image size—but without distortion.

◆ **Compensate for optical defects.** Wide-angle zooms often suffer from barrel distortion at the edges of their frames, with straight lines seeming to bow outwards. You might even have darkening or vignetting in the corners (make sure it's not your lens hood!) or purple fringing around backlit subjects from chromatic aberration. You can disguise barrel distortion by keeping subject matter with straight lines away from the edges of the frame; and fix vignetting (and sometimes chromatic aberration) in your image editor.

◆ **Avoid uneven flash.** Your camera's built-in flash unit might not cover the full frame of your widest zoom setting, although most vendors deliberately optimize their flash for the widest setting of the camera. You can often fix this by using a diffuser on the flash to spread the light, or by switching to an external flash unit that offers wider coverage, or which can be adjusted to change its coverage angle. Bouncing the external flash off a ceiling can also widen a flash's spread. If all else fails, use a slightly less-wide zoom setting and take a step backwards to capture the same image area using your existing flash.

Using Telephoto Effects

Don't fall into the trap of thinking that the telephoto range of zoom lenses has only one purpose: to magnify distant objects. Although the change in perspective provided by a telephoto end of the zoom range isn't quite as dramatic as that offered by a wide-angle zoom, there are a lot of creative things you can do with these optics. Here are a few of the tools at your disposal:

◆ **Selective focus.** A telephoto lens or zoom setting offers less depth-of-field, even with the relatively shorter focal length used with basic, intermediate, and advanced digital cameras, so you have a better opportunity to use selective focus to make your subjects stand out distinctly from their backgrounds. (See Figure 5.5.)

◆ **Bring distant subjects closer.** Interesting wildlife such as deer, hummingbirds, or tree frogs can become skittish when humans approach, whether the distance is 5 feet (for smaller critters) or 50 yards (for larger creatures). Of course, it's not a good idea to approach animals that aren't particularly frightened of you (wild bears who've had their territory invaded come to mind). You'll often want to photograph inanimate objects up close and personal, too. A telephoto zoom can bring these distant objects nearer to you.

Figure 5.5 The reduced depth-of-field of telephoto lenses lends itself to selective-focus techniques, making it simple to throw a distracting background out of focus.

◆ **Enter the huddle or scrum.**
Telephoto zooms are a valuable tool for getting you into the middle of sports action, too, without the need to don a uniform and attend exhausting practices. Even sports that can be photographed from fairly close, such as basketball or soccer, can benefit from a tele-photo perspective. Other kinds of action, like that shown in Figure 5.6, can be safely photographed from a distance, too.

◆ **Flatter your portrait subjects.**
While wide-angle lenses make humans look their worst, a moder-ate telephoto lens can help your portrait subjects look their best, by providing a flattering perspec-tive with noses, ears, and other body parts portrayed in their best proportions. An 85mm to 105mm lens setting (35mm film camera equivalent) seems to provide the best rendition.

Figure 5.6 A telephoto lens can bring you right into the thick of the action.

Of course, telephoto lenses, like wide angles, have characteristics that must be compensated for. Here's a checklist of the things you must watch out for.

◆ **Boost those shutter speeds.** The magnification provided by telephoto lenses also magnifies any camera shake. A basic rule of thumb says that you should use, as a *minimum*, the reciprocal of the focal length of the lens or zoom setting. So, a 200mm (equivalent) lens would require a shutter speed of 1/200th second—or shorter; a 400mm lens would call for 1/400th second or briefer. Very long, clumsy lenses can set up a rocking action of their own and might require a higher shutter speed. If you plan on enlarging your image, increase the shutter speed, too. A tripod or monopod is often a good idea for telephoto shots.

◆ **Maximize depth-of-field.** Selective focus is a cool tool, but sometimes you want to have more of your subject in focus than your telephoto lens allows at your current f/stop. The solution is to use a smaller aperture, even if it means you have to use a tripod to allow the lower shutter speed required.

◆ **Atmospheric and lighting problems.** Telephoto zooms often exhibit flare when illumination from light sources outside the picture area enters the lens and bounces around within that long tube. Use your lens hood! In addition, photographing distant subjects means the light that makes your image has to pass through a lot more of the atmosphere, which, if it contains dirt or moisture, can reduce the contrast and saturation of your images. A haze filter can sometimes help. Be prepared to brighten up your photo in your image editor.

◆ **Anemic electronic flash.** If you're photographing distant subjects with electronic flash, you'll discover that few built-in units are much good even as far as 15 feet, and more powerful add-on flash seldom is effective much beyond 20 feet. Plan on using multiple flash units with telephoto lenses or eschewing flash photography altogether.

◆ **Compression.** Telephoto lenses aren't free from distortion. Lenses longer than about 200mm (equivalent) tend to flatten human faces, making them appear wider than they really are. Very long lenses can compress the apparent distance between objects, so a line of automobiles will appear to be bumper-to-bumper when they are actually 20 feet apart. Telephoto compression can be a creative effect or a bane, depending on your intention. In Figure 5.7, the effect was used to compress the distance between the columns of the building, enhancing the pattern of the semi-abstract composition.

Figure 5.7 Telephoto lenses compress the apparent distance between objects, such as the columns in this photo, which were actually 20 feet apart.

Using Macro Settings and Accessories

Owners of even the most basic digital cameras can enjoy shooting close-up—or *macro*—photos. All digital cameras have the capability of focusing on subjects 12 inches or less from the camera. That brings macro photography within the reach of anyone looking to capture images of flowers, insects, and other small creatures, or even everyday objects that take on a new perspective when photographed up close and personal.

With basic, intermediate, and advanced digital cameras all offering close-up capabilities, you might wonder just how macro capabilities differ among cameras. Surely, more advanced digital models must offer more sophisticated features for close-ups! That's true, but the differences aren't always overwhelming.

Here are some feature variations you're likely to encounter:

◆ **Focus Distance.** Although in absolute terms *magnification* is more important than how close you can focus (more on that later), digital cameras vary widely in their closest focusing distances. Most focus down to at least 5 inches, and some focus to within an inch or less of the front of the lens. Also important is how *far away* you can focus in Macro mode before you have to switch back to normal focus. A camera that can focus from 1 inch to 12 inches at the macro setting is more useful than one that is able to focus from 1 inch to just 8 inches. The range of subjects you can select in close-up mode is more limited.

◆ **Macro/Super Macro.** A useful feature to have is two complementary Macro modes. Several Olympus models, for example, have a Macro mode that allows you to focus from 8.4 inches to infinity, which is quite a useful range (you might not need to switch out of Macro mode for much of your shooting). The same cameras also have a Super Macro mode that takes you from 3.9 to 23.6 inches: You can't focus on infinity, but you can get much closer.

◆ **Focal Length Range.** It's common for basic and intermediate digital cameras to allow macro focusing *only* when the camera's lens is set to the wide-angle zoom position. More advanced cameras are able to focus close at any zoom position.

◆ **Autofocus/Manual Focus.** Most digital cameras provide automatic focus in Macro mode. However, if you want to use selective focus, as in Figure 5.8, to isolate or highlight a subject, it's helpful if your camera has a manual focus mode, too. Basic and intermediate digital cameras with manual focus often enlarge the center portion of the image on the LCD screen to make it easier to achieve sharp focus. With EVF cameras, you'll often focus using the electronic viewfinder.

Figure 5.8 Depth-of-field is limited in macro photography: Focus on the object in front, and the one behind is likely to be out of focus, unless you use a small f/stop.

KEEP YOUR CAMERA STEADY

Macro photography magnifies camera shake dramatically. The relatively small f/stops used in macro photography (with cameras that provide smaller apertures) to gain depth-of-field forces you to use longer shutter speeds, too. In both cases, a tripod, or your camera's optical image stabilization feature, if available, can help steady your camera to sharpen those close-up images. Use an IR remote available for some digital cameras or the self-timer to trip the shutter to eliminate camera shake caused by your trigger finger.

Here are some things that you should know about macro photography:

- **Magnification.** With non-macro photography, the close-focus specification you're most concerned about is the minimum distance, whether it's 24, 12, or 6 inches. In serious macro work, the magnification is most important. After all, a 50mm zoom setting that can be focused down to four inches from the sensor will give you exactly the same size image you'd get with the same lens at the 100mm zoom setting that is able to focus only eight inches from the sensor. Macro magnification is expressed in ratios, such as 1:2 (half life-size), 1:1 (life size), or 2:1 (twice life-size). A "life-size" magnification will produce the same-size image on the sensor as in real life; that is, a 10mm-wide object will cover 10mm of the sensor width. Macro modes should offer at least 1:2 magnification, and, preferably, 1:1 (1X) magnification. Fortunately, magnification ratios are likely to be most important to you if you're working with an advanced digital camera and need to know or predict the amount of magnification for a technical reason. The average digital camera owner doesn't need to worry about this, but I've included this discussion for the sake of completeness.

- **Focal length.** If your digital camera isn't locked into shooting macro photos only at the wide-angle setting, then the zoom setting of the lens can be important. The longer the focal length of the zoom in Macro mode, the farther you can be from your subject and still achieve the same magnification. So, a 35mm zoom setting might be best for small objects you can conveniently photograph from a few inches away. Objects that are best photographed from more distance (say, skittish insects) might do well with a 100mm to 150mm zoom setting, if you have a more advanced camera that allows shooting close-ups at the telephoto position. Many photographers prefer a camera with a macro zoom that has a longer range because of the flexibility it provides in choosing a shooting distance.

- **Minimum aperture and depth-of-field.** You'll need lots of depth-of-field when shooting close-ups, so the ability to use a small f/stop is key for serious macro work. Basic and intermediate digital cameras rarely have f/stops smaller than f/8, but advanced cameras might give you smaller stops, up to f/22 or f/32.

If your digital camera doesn't focus quite close enough, one way to cut your camera-to-subject distance is with a close-up lens. These aren't stand-alone lenses but, rather, are filter-like attachments that screw onto the front of your camera's lens to enable it to focus closer. Of course, you need a camera that accepts add-on filters. Most advanced digital cameras have *filter threads* on the front rim of the lens. Many basic and intermediate digital cameras can be outfitted with an adapter that accepts filters and other attachments. The close-up lens shown attached to the zoom lens of an EVF camera in Figure 5.9 was too big, so several "step-down" adapter rings were used to make it fit. (Such rings will allow you to use the same filters and other attachments on several different lenses.)

Close-up lenses are inexpensive accessories that change the focal distance of the lens they are mounted on. Their "power" is represented as a relative magnification measured in *diopters*. For example, a 50mm zoom setting focused at 3 feet would focus down to 20 inches with a +1 diopter, 13 inches with a +2 diopter, and 10 inches with a +3 diopter. These lenses can be combined to increase their strength: A +2 and a +3 would yield the same magnification as a +5 diopter attachment. You lose some sharpness with close-up lenses, but they are convenient and don't reduce exposure. Look for better-quality two-element diopter lenses called *achromats*.

Figure 5.9 A close-up lens attachment can improve the close-focusing capabilities of many lenses.

Telephoto and Wide-Angle Lens Attachments

If your digital camera's lens doesn't provide quite enough wide-angle perspective or telephoto reach, you can sometimes augment your lens with a wide-angle or telephoto attachment, like the one shown in Figure 5.10. These converters reduce and magnify

Figure 5.10 Inexpensive telephoto and wide-angle converter lenses may be suitable for moderate telephoto and wide-angle effects.

the image the lens sees, providing a moderate amount of wide-angle and telephoto effect. The converter in Figure 5.10 actually consists of two components: the dark barrel-shaped adapter which allows the Hewlett-Packard digital camera it was designed for to accept filters and other attachments (even though it has a retractable lens), and the wide-angle attachment itself, which screws onto the front of the adapter. A telephoto converter for the same camera uses the same adapter tube.

These attachments don't cost you anything in terms of light loss: The effective f/stop of your lens remains approximately the same with or without the converter. However, converters usually cost you some sharpness. If the optics aren't first rate, you'll lose a little in the extra glass placed in front

of your main lens. Sometimes, using a smaller f/stop can compensate for this loss of sharpness. These accessories are available both from camera vendors and from third-party manufacturers who produce general-purpose converters that work with many different cameras. Unless the converter is designed specifically for your lens, it's possible to experience some darkening in the corners (called vignetting). If you experience this phenomenon, you can sometimes fix it by cropping your photo, which might be acceptable with telephoto attachments, but partially negates the broader perspective you were looking for from your wide-angle converter.

In addition to reduced sharpness and possible vignetting, telephoto and wide-angle converters are less than a perfect solution

because their effects are only moderate. For example, if your digital camera's 3X zoom lens offers the equivalent view of a 35mm lens at its widest position and 105mm at the telephoto setting, as shown in Figure 5.11, a 0.75X wide-angle converter will give you roughly the field of view of a 26mm lens on a full-frame film or digital camera, as shown at top in Figure 5.12. That's a decent amount of coverage, as you can see in Figure 5.12, but hardly an ultrawide look. With a 1.5X telephoto converter, your 105mm zoom will be magnified to resemble the same framing as a 157mm telephoto when you zoom in, as shown at the bottom in Figure 5.12. While the increase in range is useful, it might not be worth the expense.

Figure 5.11 Your 3X zoom lens might provide the same field of view as a 35mm lens on a full-frame camera at the wide-angle position (top) and that of a 105mm lens at the telephoto setting (bottom).

Figure 5.12 With a 0.75X wide-angle attachment, your view is extended to the 26mm range (top), while a 1.5X telephoto add-on brings you as close as a 157mm lens (bottom).

Distortion, Aberrations, and Anomalies

Lenses can be plagued by a variety of optical aberrations, distortion, and anomalies, not all of which are the fault of the lens. They're inherent as a result of the difficult task of designing lenses for digital cameras that meet the needs of compactness, optical quality, zoom range, and other factors. Many of these defects can be fixed up nicely in Photoshop, or worked around with some clever compositional techniques. Here are the most common maladies found in zoom lenses and some tips for countering them.

◆ **Barrel distortion.** This kind of distortion results in lines that are parallel to the edges of the image bowing slightly outward. It's commonly found in wide-angle lenses, and can often be corrected in Photoshop using the Lens Correction filter. (See Figure 5.13.)

Figure 5.13 Barrel distortion in wide-angle lenses causes lines parallel to the edges of the frame to bow outward.

◆ **Pincushion distortion.** This is the opposite of barrel distortion, and appears as lines that are parallel to the edges of the image curving inward towards the center (see Figure 5.14). It's most commonly found in telephoto lenses, and can often be corrected using Photoshop's Lens Correction filter.

◆ **Vignetting.** This is the darkening of the corners of an image, as seen in the pincushioning example (Figure 5.14), and can result from mechanical, optical, and natural causes. Mechanical vignetting most often occurs when a lens hood is used that has too narrow a view for the focal length of the lens, especially if the lens is a zoom. A hood that properly shields the lens from extraneous light at the telephoto setting may intrude on the image when the lens is zoomed out to its wide-angle setting. A filter that is too thick for a lens (particularly a wide-angle lens) can also show up in the frame as vignetting. Optical vignetting is a property of any lens produced by illumination fall-off at the edges of the image. This effect is strongest when the lens is opened up to its maximum aperture, and when the subject matter is relatively contrasty.

Figure 5.14 This image has both pincushion distortion (lines that bow inward) and vignetting (darkening in the corners).

Natural vignetting is also caused by lens design, and afflicts wide-angle lenses, which use a special arrangement of elements to allow them to focus on a sensor placed at a greater distance than their focal length. You can prevent vignetting by using the proper lens attachments, stopping down the lens to a smaller f/stop, and by using a tool like the Lens Correction filter in Photoshop.

- **Perspective distortion.** This is not a lens defect but, rather, an effect produced when the camera is tilted up, down, or to one side to capture all of a tall or wide subject. The portions of the subject closest to the lens appear larger than the portions that the camera is tilted to include. When photographing buildings and other structures, perspective distortion can cause the subject to appear to be falling backwards. (See Figure 5.15.)

- **Chromatic aberration.** This is a kind of distortion caused by the inability of a lens to focus all the colors of light at the same point. This defect produces fringes of color around objects, and is most easily seen around backlit subjects. There are two kinds of chromatic aberration: *axial (or longitudinal)*, in which the colors don't focus in

123

the same plane and produce a colored halo around the subject, and *transverse (or lateral)*, in which the colors are shifted to one side. Preventing this kind of distortion, which is especially noticeable in telephoto lenses, is best tackled by the lens designer, but photographers can sometimes reduce axial chromatic aberration by stopping the lens down. Transverse chromatic aberration can sometimes be fixed by modules included with image editors like Photoshop (you'll find this tool in Adobe Camera RAW as well as the Photoshop Lens Correction filter). (See Figure 5.16.)

Figure 5.15 Perspective distortion can cause buildings or structures to appear to be falling backwards.

Figure 5.16 Lateral chromatic aberration shifts some colors to the sides. In this extreme enlargement, you can see that magenta and cyan fringes have been shifted to one side.

◆ **Bokeh.** This is a term used to describe the aesthetic qualities of the disc-like out-of-focus parts of an image, with some lenses producing "good" bokeh (discs that blend smoothly in the background) and others offering "bad" bokeh (discs that are distinct and obtrusive). (See Figure 5.17.) This characteristic is more of a concern for those with digital SLR cameras. The reduced amount of depth-of-field produced by the relatively longer focal lengths of dSLR lenses makes problems with bokeh more easily seen. However, dSLR owners can do something about it, by changing to a different lens. Advanced users of intermediate and advanced digital cameras might want to be aware of the term, anyway.

MORE THAN YOU WANTED TO KNOW ABOUT BOKEH

Boke is a Japanese word for "blur," and the h was added to keep English speakers from rhyming it with *broke*. Out-of-focus points of light become discs, called the *circle of confusion*. Some lenses produce a uniformly illuminated disc. Others produce a disc that has a bright edge and a dark center, producing a "doughnut" effect, which is the worst from a bokeh standpoint. Lenses that generate a bright center that fades to a darker edge are favored, because their bokeh allows the circle of confusion to blend more smoothly with the surroundings. The bokeh characteristics of a lens are most important when you are using selective focus (say, when shooting a portrait) to deemphasize the background, or when shallow depth-of-field is a given because you're working with a macro lens, long telephoto, or with a wide-open aperture.

Figure 5.17 "Bad" bokeh (top) is intrusive, while "good" bokeh helps the background to blend together.

Creating a Photo

If you're reading this book, you probably are interested in going beyond point-and-click photography. Certainly, it's very cool to whip out your camera and grab a great shot on the spur of the moment without needing to plan anything or fiddle around with settings. That's what the Auto or P settings on digital cameras are for. But there's a big difference between taking a photo and making a photo. Today's technology makes it fairly easy to point a camera at something, press the shutter release, and end up with a decent picture. Going beyond that to get a really *sensational* photograph requires some work and planning.

Of course, it's not really work if you enjoy it, and the planning can be done on the spur of the moment. There's no need to spend hours plotting out exactly how you will photograph your next subject. You don't have to scout a location weeks in advance, decide on the perfect moment when the planets conjoin, and then devote hours to setting up the camera and framing the absolute perfect image. All you really need to do is understand the principles set out in this chapter, and then keep them in mind as you prepare to take your next photograph. As you start on your journey from tyro to guru, you might need to consciously consider each of these guidelines at first. Eventually, they'll become second nature to you and become a regular part of your shooting repertoire. This chapter provides a summary of the key components of a well-thought-out image, and shows you what rules to follow and which rules to break.

Choosing a Theme and Purpose

Every picture tells a story, and you should decide on that story before you shoot. The story can be lighthearted and heartwarming; perhaps you want to show a new puppy getting acquainted with a young child. The tale to be told might be "here's what we did on our vacation" with a concentration on documenting interesting activities and sites. Or, you might have shifted into amateur photojournalist mode and plan to tell a story about how a local woodlands has been devastated by human carelessness. Some of the themes you'll use for your photos are determined when you set out on your shooting expedition.

Other times, a picture's story is determined on the spur of the moment. You're out shooting landscape photos of a majestic mountain, and encounter a family of deer. You're exploring a winding street in a picturesque European town when suddenly the narrow way fills with an impromptu parade of teenagers, their faces painted in support of their local soccer team. You spy two artists-for-hire with their easels set up in a public place, surrounded by the tools of their trade (see Figure 6.1). All these have happened to me, prompting a storytelling photo right on the spot. While it's possible to take photos of interesting subjects in random ways, your results will be better if you have a theme and purpose in mind when you shoot.

Here are some things to think about:

- **What's the story here?** A single subject can be portrayed in many different ways. A sports photo can show a local hero in a solo moment of glory or concentrate on that same individual's confrontation with an opponent. You might want to show two teammates working together, concentrate on the crowd's reaction, or show the coach agonizing over a crucial decision. The officials and team mascots have their own stories, too. You need only choose which story you want to tell.

- **How will your photo be used?** Will this image appear on a webpage, or is it destined for display as a framed print on your wall? Will it be printed in a newspaper or magazine, perhaps, or, more likely, reproduced in your club's newsletter? Perhaps you'll make a few small prints to pass around, or you will be viewing your final shots only as slideshows on your computer screen. Believe it or not, the intended purpose of an image can affect how you shoot it. Figure 6.2 shows an image shot by an old Sony Mavica camera at, believe it or not, 640 × 480 pixels of resolution. Intended for posting

Figure 6.1 The competition between these two artists, who each must display their finest skills to attract customers, makes an interesting story.

on a website, multi-megapixels weren't needed for this charming snapshot. On the other hand, photos intended for display require tight composition so you won't waste any pixels when you enlarge the image, and excellent exposure so details are present in both the highlights and shadows. Pictures that will be printed in publications call for a tonal range suitable for the kind of reproduction you have in mind: Photos that will be printed in slick magazines need different qualities from those that will be printed in a low-budget company newsletter. It you understand the purpose of your final shot, you can make the appropriate adjustments when you create the image.

◆ **Who is your audience?** You'll probably know in advance who will be viewing your images. Perhaps your travel pictures will be seen only by family and friends, in which case you'll want to include yourself and your traveling companions in at least a few shots (see Figure 6.3). You'll also want to make sure all the traditional subjects are included: the Great Pyramid in Egypt, the Taj Mahal in India, or the Great Wall of China in China. Photos taken on the same travels that will be presented to strangers (perhaps you're preparing a travelogue) may have an

entirely different focus. If you accompanied your CEO on a trip to the same countries, you'll want to show the boss doing something CEO-ish, with, perhaps, one of your company's products worked into the photo if appropriate. If you try to put yourself in your viewers' shoes when you take a picture, you can better imagine what they expect and want to see in your photos, and provide that viewpoint.

Figure 6.2 No more than 640 x 480 pixels of resolution were required for this shot, intended for display on a webpage.

Figure 6.3 This photo is intended only for viewing by friends and family, so a quickie shot with electronic flash is perfectly acceptable.

Selecting a Center of Interest

Good photographs capture the eye with a strong main subject, usually called the *center of interest*, which is a person, a group of people, or some other subject that embodies the theme of the image. The center of interest can be a cluster of animals, a mountain, a building, or other obvious focus of the photograph. I say *obvious* because the viewer shouldn't have to search through an image, trying to find some place for the eye to alight. A good picture shouldn't be a "Where's Waldo?" puzzle, cluttered with so many interesting things that it's difficult to decide what the photograph is about.

It's possible to include secondary objects of interest, which add depth and richness to an image, but the other subject matter clearly should be subordinate to the center of interest. One of the worst things you can say about a photograph is to call it "busy." In creating your composition, you'll want to identify the center of interest, and then eliminate or minimize the importance of other portions of the photo that compete for attention. Crop the image to exclude distracting subject matter, or change your angle so it no longer appears in the field of view. If the offending subject is a person, ask him or her to come stand by your side to help take the picture, or send the person on an errand (small bribes sometimes work). It's also possible to take several photographs of the same scene, each featuring a different person vying to be the center of interest, as you lavish the most effort on the one who is your secret goal.

Here are some things to keep in mind when establishing a center of interest in your photos:

◆ **One main subject.** Be sure that your image has one, and only one, center of interest. That center can be more than one object, such as the first baseman, base runner, and umpire in Figure 6.4, but all the components of your main subject should be in close proximity. For example, you can photograph a set of twins together, as long as you avoid having one of them on one side of the picture and the other on the opposite side. While the twins don't have to be dressed identically and posed exactly alike, there should be no outlandish difference between them—unless one or the other is the true center of interest and the additional twin is a secondary subject. A child playing with a puppy is an image with a single center of interest. If there are other puppies elsewhere in the frame behaving in a distracting way, you have a potential for conflicting focus.

◆ **Don't always center your center of interest.** Your most important subject should usually be located a little to one side and toward the top or bottom of the frame in order to keep the photo from becoming too static. There are exceptions to this rule but it's a good idea not to take the "center" concept literally. Conversely, avoid having any subordinate and secondary subject matter smack in the middle of the photo, too: Anything you place in the center is likely to become the center of interest whether you want it to or not.

◆ **Focus.** The center of interest is usually the object that's in sharpest focus, as you can see in Figure 6.5. Other objects that are larger or brighter, or otherwise might command attention become subordinate to a subject that appears sharper and more focused.

◆ **Prominence.** Unless you're using focus or another technique to command attention, your center of interest should be the largest subject or otherwise the most prominent part of the picture. If you want to feature your Uncle Charlie, make sure that an elephant, space alien, any Ferrari automobile, or Brad Pitt aren't also in the picture. Any of these are likely to seize the focus of attention in your photograph, rendering Uncle Charlie as a mere onlooker.

◆ **Color and brightness.** The center of attention doesn't have to be very bright or colored in a gaudy way (which is the case in Figure 6.6), but you must at least be sure that other brighter, more colorful objects don't overpower the real subject of your photograph. Exclude such objects from your image by cropping, moving them behind something, or changing the light that illuminates them (if possible). In a pinch, plan on reducing the power of distracting objects in your image editor.

Figure 6.4 The center of interest can consist of more than one subject, as in this sports shot in which the umpire, first baseman, and base runner are all the focus of the image.

Figure 6.5 The most prominent object in your image should be the center of interest, with the other objects subordinate to it.

Figure 6.6 The covered bridge's bright red color contrasts vividly with the green leaves, so it automatically becomes the center of interest. In a black-and-white version of this shot, however, the bridge doesn't attract the eye quite so dramatically.

Orientation

Another important compositional element that you must decide on is the orientation of the photo—whether you shoot the image "wide" in a landscape arrangement, or "tall," in a vertical configuration. The orientation of an image can have a powerful effect on how the viewer visualizes the photo. Landscape orientation tends to produce a feeling of width and sprawl, or horizontal movement, and it can lend the sensation of a panorama even in compositions that don't depart from the common aspect ratio. Our eyes tend to explore a photo that is wider than it is tall from left to right or right to left, unless there are strong vertical lines within the composition (which may mean the orientation for the picture was incorrect).

Because digital cameras are built using a horizontal orientation as the default, that's the way many beginning photographers instinctively frame all their photos until they learn better. It's usually a simple matter, from an ergonomics standpoint, to rotate the camera to shoot a vertically oriented shot. Most digital cameras are able to sense when the camera is tilted 90 degrees and can embed that information in the image file, so that the photo can be displayed properly rotated when shown on the camera's LCD screen or imported into an image editor.

One feature that's common in basic, intermediate, and advanced digital cameras is the ability to choose from several different aspect ratios, or proportions, for your rectangular image. You might find a menu option that lets you switch from 3:2 (where the image is 1.5X as wide as it is tall, which is the exact proportions found in a 4 x 6-inch snapshot print) to 4:3 proportions (which produces a rectangle that is less elongated). An increasing number of cameras offer the 16:9 proportions of a HDTV display, a "wide-screen" setting that's also found in many laptop and desktop LCD displays with resolutions of 1920 x 1080 pixels. In most cases, these various alternative aspect ratios are produced by cropping the digital camera's

view, reducing the number of pixels used to produce the image. One interesting variation for wide-view fans is cameras like those pioneered by Panasonic with its DMC-LX1, in which the sensor itself conforms to the 16:9 ratio (at 3840 x 2160 pixels), and the optional 4:3 and 3:2 formats are produced by cropping.

Once you've selected the proportions of your picture (or you decide just to go with the camera's default ratio), you should choose horizontal or vertical orientation based on the suitability of your subject. Good horizontal subjects include many landscapes, sports that include horizontal movement (such as football, soccer, and motorboat racing), and many animals (see Figure 6.7).

Figure 6.7 Horizontal orientations work well with subjects that are moving from one side of the frame to the other.

Vertical (or "portrait") orientation is, as you might expect, great for portraits (see Figure 6.8). It's also good for more dynamic subjects, too, as vertical framing provides expectations of height and vertical movement. Our eyes tend to examine such a picture from top to bottom or bottom to top. Vertical orientation tends to be more exciting if used with appropriate subjects, and more frustrating if the orientation was chosen incorrectly, because our eyes will yearn to see what's off to either side of the subject. Typical subjects that lend themselves to vertical compositions are buildings, sports with a vertical component (such as basketball), people, and upright animals.

Figure 6.8 Some subjects just naturally seem to fit best in a portrait orientation.

There is a third possibility, of course: the square composition (see Figure 6.9), which can only be achieved by trimming the edges of a digital photograph composed in one of the other two ways. Circular subjects lend themselves to square compositions, and they often are centered within the image. A subject that contains both vertical and horizontal components, such as a sprawling farmhouse and barn next to a silo, can look good in a square format.

Sometimes the overall orientation of the photo might be dictated by your intended application. Images destined for a projected presentation or display on the computer screen may need to be oriented in a horizontal direction in order to fill up the width of the screen as completely as possible. You may still be able to use a vertical shot, but you will need to mask off the sides of the image and then settle for a photo that is no taller than the short dimension (height) of the screen and which appears to be much smaller than the horizontally composed images in the same presentation.

Figure 6.9 Although square layouts tend to look static, they are suitable for subjects that don't have an inherent horizontal or vertical orientation of their own.

Angles and Distance

Once you've decided whether your image will look best in a vertical or horizontal orientation, you'll need to figure out where to stand. The distance and angle you select can have a powerful effect on your photograph. Choosing your spot is not something you do once and forget about if your goal is to provide thorough coverage of your subject. As you shoot, explore different angles and positions to look for new perspectives and new ways to improve your composition. With a digital camera, your choice of zoom setting has much the same effect as changing the relative distance between you and your subject, too. Here are some guidelines.

◆ **Fill the frame with interest.** To be sure, you don't necessarily have to fill the frame with your main subject matter. But everything in the photo should contribute to the composition. (See Figure 6.10.) If you include extraneous information that you'll only crop out later, you're wasting pixels.

◆ **Move in close to emphasize a person or object or to create a feeling of intimacy.** A close-up view shows details and texture, so when you want to highlight a person, a group of people, or some specific object, move in close or use a telephoto zoom setting.

◆ **Step back to create a feel of distance, space, or depth.** Move a few steps back or use a wide-angle zoom setting to emphasize the foreground area, cause the details in the background to retreat, or to create a feeling of space (see Figure 6.11). Outdoors, this will allow more of the sky to show in your images, enhancing the feeling of depth.

◆ **Don't minimize your main subject.** Your wide-angle lens or steps backward can reduce the size of your main subject so much that it becomes subordinate to its surroundings. Unless that's the feeling you're going for, avoid distant views that reduce the apparent size of your main subject too much.

Figure 6.10 Fill the frame with your center of interest to avoid wasting pixels, and to emphasize texture or details.

◆ **Use high angles to empha-
size the immediate surround-
ings of your subject, and low
angles to create a feeling of
tallness.** Shooting down on your
subject will emphasize those parts
of your subject that are higher off
the ground, while de-emphasizing
parts that are lower. Low angles do
the reverse. For example, shooting
a basketball player dunking the
ball from above the rim will make
the rim, basketball, and the
player's arms dominate the photo.
The same shot taken from near the
floor will emphasize the player's
legs and height. Low angles also
allow a dramatic sky to command
the center of attention of a photo.
(See Figure 6.12.)

Figure 6.11 A wide-angle lens emphasizes the foreground.

Figure 6.12 This low-angle view allows a dramatic sky to dominate the photo.

The Rule of Thirds and Other Guidelines

The Rule of Thirds is something to keep in mind even when you're ignoring it. Briefly stated, this rule says that your main subjects of interest should be located roughly one-third of the way from the top, bottom, or either side of the image. You can visualize this layout by imagining a line located one-third of the way down from the top of the frame, and another line one-third of the way up from the bottom, dividing a landscape-oriented image into three horizontal strips. Then, imagine two vertical lines trisecting the image, as shown in Figure 6.13. Using the Rule of Thirds, the "best" location for your subjects will be at the intersections of these lines.

In practice, the Rule of Thirds works quite well. In landscape photos, the horizon shouldn't be placed in the center of the frame. Moving it up to coincide with the horizontal one-third divider creates a more interesting composition that emphasizes the foreground. Placing the horizon at the lower one-third point is also interesting, but changes the emphasis to the sky. Cover up the top half, and then the bottom half of Figure 6.14 to see what I mean.

Locating other subject matter at the intersections of the dividers also produces pleasing compositions, because such placement keeps important objects from straying too close to the edges, and also ensures that there will be a portion of the frame for your center of interest to "look into" or which can intercept the viewer's gaze and lead the eye to the main subject. Here are some of the ways you can apply these basic compositional guidelines:

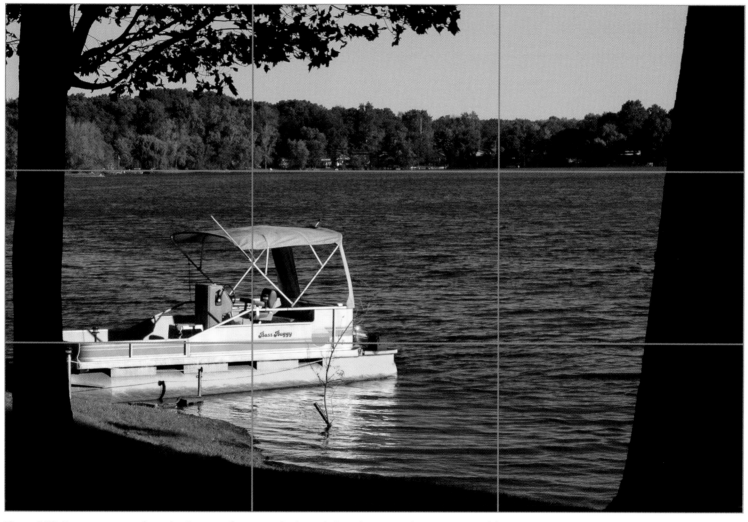

Figure 6.13 Picture imaginary lines dividing your frame into thirds, and place the center of interest at one of the intersections.

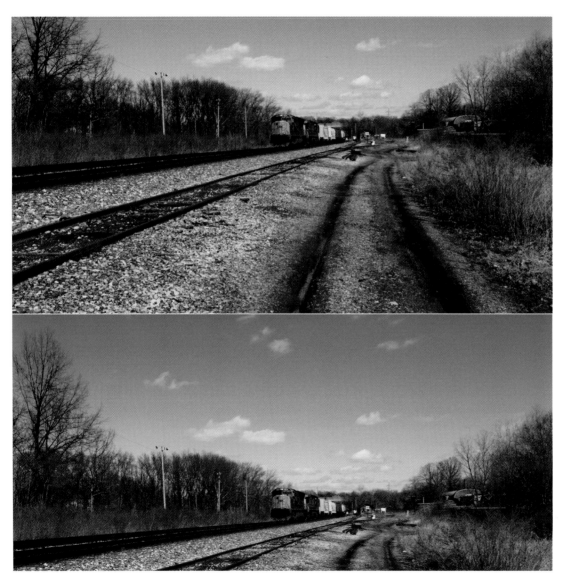

Figure 6.14 Putting the horizon at the upper third of the frame emphasizes the foreground; placing it at the lower third emphasizes the sky.

WHEN TO BREAK THE RULE OF THIRDS

This rule is only a guideline. There are many times when you'll want to ignore it.

◆ **Large subjects.** If your subject is so large that locating it at one of the one-third intersections clips it off at the top, bottom, or side, move it within your composition so the entire object is included comfortably, even if it ends up centered.

◆ **Close-ups and portraits.** By convention, we often expect to see the subjects of close-up pictures and portraits centered in the frame. A photograph you take of a flower, or a picture destined for your passport, might look odd if composed using the Rule of Thirds as a guideline. That's not to say you can't include more space around your close-up photos and people pictures, but these kinds of images often are cropped very tightly with the subject matter centered, as you can see in Figure 6.15.

◆ **To convey a concept.** If you want your subject to appear static, penned in, or surrounded, you might find that centering the center of interest is an effective tool. Putting the subject at one of the intersection points implies motion or direction. When you mean to imply the opposite, ignore the Rule of Thirds.

◆ **To show symmetry.** A centered subject that's more or less bilaterally or radially symmetrical, located in a symmetrical background, can form a pleasing, geometric pattern. Flowers in close-up are a good example of this. The composition may appear to be a bit static, but that might be what you're looking for in addition to geometric harmony.

Figure 6.15 Large objects and portrait subjects can be centered in the frame effectively.

Backgrounds

The background is an important element in most photos, even if it's a featureless expanse of a single color or tone. A flash photo taken at night might have a dead-black background; an exposure on an Arctic snowfield might show nothing in the background but a bright glare. In both cases, these backgrounds still manage to tell you something about your subject's surroundings. More commonly, a background will include more relevant details that you can use to your advantage, or minimize to bring the focus of attention on the subject in front. Here are some considerations to deal with when incorporating backgrounds in your images.

◆ **Avoid making the background the focus of the picture.** The background should not be gaudy, filled with distracting detail, be significantly brighter, or contain anything more interesting than the subject itself (see Figure 6.16). If that's the case, it's time to think of ways to minimize the background.

◆ **Use a plain background for portraits.** A blank, featureless background can work for portraits, as long as it isn't totally bland. Notice how professional photographers who pose subjects against a seamless background still use lights to create an interesting gradient or series of shadows in the background.

◆ **Use natural objects such as trees, grass, skies.** We see these backgrounds as natural accompaniments to outdoor photos, so they are interesting without dominating the photo.

◆ **Be alert for strong lines or shapes that distract from your subject.** Such elements are great when they add to a composition, but they are not good if they distract from the main subject.

Figure 6.16 This shot of a red panda would be much better if the background weren't so distracting. The glass partition behind the animal, even though partially out of focus, is out of place in what should be a more natural-looking environment.

- **Use selective focus to minimize a distracting background.** Lack of depth-of-field can be your friend when selective focus is used to blur the area behind the subject (see Figures 6.17 and 6.18). Selective focus is easiest if you're shooting relatively close to your subject, because basic and intermediate digital cameras (in particular) tend to make everything in a normal scene sharply focused.

- **Darken or clean up the background.** If your digital camera makes achieving a blurry background tricky, you can also make the background darker, or less cluttered. You want the background to appear in such a way that it provides sufficient separation between the subject and itself (they both shouldn't be the same tone, color, or pattern, for example).

Figure 6.17 The field of partially blurred dandelions behind this blossom isn't a terrible background...

Figure 6.18 ...but throwing the background completely out of focus does put more pictorial emphasis on the flower in the foreground.

Using Straight Lines, Curves, and Balance

One of the things that makes a composition pleasing to the eye is the opportunity to discover something new or unexpected as the image is explored by the viewer. We like to see subjects arranged in interesting ways and in ways that are unpredictable, while still maintaining a sense of order. While you can arrange all the objects in an image in a straight horizontal or vertical line, instead provide variety by arranging them in diagonal lines, or converging pairs of lines, or in gentle curves. These lines can lead the eye towards the main subject in a subtle way, or more explicitly for a dramatic effect. Balance within an image is important, too, because you don't want your photo to appear to be lopsided, with all the interesting elements on one side or the other, and nothing of interest elsewhere in the picture. Here are some ideas to work with.

◆ **Straight lines add drama.** Fenceposts, shorelines, the lines of a modern building. Vertical and horizontal lines can provide dramatic compositions and patterns, but they require especially interesting subject matter to overcome the static nature of these shapes.

◆ **Diagonal lines direct the eye to the center of interest.** Like signposts or directional arrows, diagonal lines are more dynamic and interesting and lead the eye naturally through an image (see Figure 6.19).

◆ **Repetitive lines create patterns.** These can be multiple parallel or converging lines in a single object, such as the courses of bricks in a wall or the lines formed by converging objects, such as fences erected on opposite sides of a road. These lines can create a pleasing pattern that reinforces an image's basic composition (see Figure 6.20).

◆ **Curved lines add graceful movement.** Arcs and bends can help the eye explore an image in a gentle, less jarring way. Instead of being directed along a certain path forcibly, as is sometimes the case with strong diagonal lines, the eye can be motivated to explore an image naturally and smoothly with the use of curves.

◆ **Shapes can shape emotions.** Triangles can represent conflict and forcefulness, while squares can provide a more open feeling, and circles are even more open and calm. So, arranging your subjects in a triangular shape causes the eye to follow the lines of the triangle toward the three apexes, where the main components of your images can reside. Squares and rectangles provide a more general arrangement that embraces more of the image, and circles, which point to nowhere in particular, are the least forceful elements of all.

Figure 6.19 Diagonal lines draw the eye to the center of interest.

Figure 6.20 The repetitive parallel curved lines of the neon tubes form an interesting pattern.

◆ **Balance creates a sense of completeness.** Avoid putting all the interesting components of an image on one side or another, or only at the top or bottom of the photo, so that there is nothing to see in the rest of the picture. An imbalanced photo is like a seesaw with a large child at one end, and nothing at all on the other end. You don't need to place another large youngster at the other end of the seesaw, but there should be *something*. That something shouldn't conflict with the center of interest of your photo: You can have a person or mountain or other subject as the focus on one side of the picture, while a less important object, such as a group of trees or a smaller mountain resides on the other half. The center of interest remains the same, but the composition is more balanced. Balance can be symmetrical, with the opposing objects of equal size, but with the main subject brighter or more colorful, in sharper focus, or otherwise more compelling to the viewer. Balance can be asymmetrical, too, with the objects of different size (see Figure 6.21).

Figure 6.21 This image has good asymmetrical balance. While the center of interest is the flower at left, the vase itself provides an interesting, if subdued, contrast.

Framing Your Subject

A frame defines an image's shape and concentrates the viewer's attention on the subject matter within it. The border of an image is more than the physical picture frame and its matte. A frame can also be components of a composition used to provide an informal border around the main subject matter of the photo. Here are some things to think about:

◆ **Foreground frames are best.** Doorways, windows, arches, walls (as in Figure 6.22), and other elements of your picture-taking environment that are a natural part of the foreground make the best frames, because they blend in smoothly with the image within the frame. We naturally think of frames as being "in front of" the subject matter being framed, so the composition appears more natural.

◆ **Frames add depth.** Sometimes it's difficult to judge distances in a photo, but when a frame is used in the foreground, we instantly have a better idea of the scales involved. The foreground is "near" to us, and the scene behind it is "farther," so the image takes on a 3D realism that would not be there if it weren't for the frame (Figure 6.22 illustrates this concept, as well).

◆ **Use telephoto lenses to compress this depth, and wide-angle lenses to expand it.** A tele will reduce the apparent distance between your foreground frame and the image in the background, while a wide angle will increase this separation.

◆ **Change positions constantly as you shoot.** Look for new frames to wrap around your subjects by moving closer or farther away or by changing angles. In Figure 6.23, the trees at right and left and ground cover at the bottom of the picture provide a natural frame for the building.

Figure 6.22 Frames add depth, as you can see in this photo of a narrow European street.

Figure 6.23 A parking lot (at the left) and construction (at the right) have been effectively masked by using trees as a partial frame for this architectural shot, with groundcover and the sky forming the bottom and top of the frame.

7 Exploring Great Themes

You'll probably agree that the broad array of subjects awaiting your exploration is one of the most appealing features of digital photography. Sports photography, portraits of your kids or grandchildren, or perhaps some memorable travel photos all have their own allure. Perhaps you can get some ideas by reviewing some of the great themes showcased in this chapter. Each of these types of photography have been embraced and explored by photographers since the "official" beginning of the art form in 1839, but there's always something new to discover.

If you're a film camera veteran, you'll find that digital cameras offer features that make them an even better choice for creative photography. You can review your pictures instantly and reshoot as necessary, which is a wonderful advantage for travel photography far away from home. Most digital cameras can capture pictures in short bursts of 2-3 frames per second, which is great for fast-moving subjects like sports or children. Digital cameras lend themselves to close-up photography, because you can better see the exact image you're taking on the camera's LCD. Digital photos are easy to stitch together into panoramas and to enhance in an image editor to correct deficiencies in your original shots or to create new effects.

Read through the classic themes illustrated in this chapter, and then go out and show what you can do! Each of these topics is worth an entire chapter on its own, so my goal here is to provide a little taste of many different kinds of photography, offer some examples, and sprinkle in a few tips to get you started.

Action

Although your digital camera's Sports scene mode will do a good job, if you have an intermediate or advanced camera that allows you to set the shutter speed yourself, usually with a Shutter-Priority setting, you can do even better. Truly mastering action photography requires a little technical expertise on several counts. First you'll usually want to stop fast-moving action in its tracks—unless you don't. That's because some of the time you'll want the highest shutter speed possible to freeze motion, and some of the time you'll prefer to use a slower shutter speed to let a bit of blur convey the feeling of movement. Knowing what shutter speed is best for the effect you want is half the battle. There's a summary of how shutter speeds affect different types of motion in Chapter 3, "Photography: The Basic Controls."

Action photography also often works best if your digital camera has a zoom range of 6:1 to 12:1 (or more), offering the kind of telephoto reach that brings you close to your quarry. Of course, a telephoto lens often calls for a higher shutter speed and more careful focus to counter for the telephoto's characteristics. You must be skilled at selecting the right moment, too, to avoid capturing that forgettable instant just *before* or just *after* the decisive moment.

Don't forget that any fast-moving subjects, whether birds in flight, you (or your brave friends) sky-diving, or motoring all lend themselves to action photography. Figures 7.1 and 7.2 illustrate some of the basics of the sports variety of action photography, because many of the action pictures you take will be of spectator or participatory sports.

Both shots were taken with tele-photo lenses at one side of the action. Figure 7.1 shows a decisive moment, just before a game-winning touchdown pass was tossed. While it might have been

nice to show the football leaving the quarterback's hand, this moment of tension as the athlete looks for a receiver while his linemen attempt to quell the oncoming rushers is also dramatic.

Figure 7.1 A shutter speed of 1/125th second was fast enough to stop the action in this memorable football moment.

(It's also an easier shot to take, technically, because the motion is slow enough that a shutter speed of 1/125th second [the fastest I could manage under the stadium lighting conditions] is still fast enough to freeze the players.)

Figure 7.2 shows how a little motion blur can enhance a photo. The batter is being brushed back by an inside pitch, and the blur of the ball as it whizzes past adds to the excitement. In this case, using Shutter-Priority mode with the camera set to 1/1000th second still allowed the 90 mph fastball to blur dramatically. Photos that are *mostly* sharp, but with blurring of the fastest-moving elements of the image can be the most effective.

Figure 7.2 Using a shutter speed just fast enough to freeze the motion of the batter, while allowing the ball to blur, produces a more exciting photo.

Animals

You'll find interesting animals to photograph everywhere you look. Family pets are a good place to start. They're comfortable with you, probably won't be frightened by the camera (even if you need to use flash), and are constantly available for re-shoots. At zoos, you'll find exotic animals you are unlikely to encounter anywhere else. The most challenging animal photography of all is out in the wild, where you not only need to figure out how to take creative photos of your quarry, you have to find them in the first place.

That's why it's often best to start with zoos. The trick there is to take photos that don't look like the animals are in cages. Although zoos do their best to house their creatures in natural-looking environments—fences, fake rocks, moats, doorways that the animals can flee through to

escape for a quick nap indoors—all conspire to add a phony look to your images. Choose your angles carefully, crop tightly, and wait until the animal is doing something interesting to come away with the best pictures.

Here are some tips to keep in mind for zoo photography:

◆ **Visit early in the day.** Some kinds of animals sleep 20 hours of the day. Even the most active creatures spend a lot of time doing nothing. They'll be at their best in the early morning when the first feeding takes place and the animals are busy planning their activities. Arrive at the zoo or animal park as soon as it opens and head directly for some of the most challenging beasts, such as the big cats. You can find out from the zoo when the exact feeding times are, too. By high noon, you'll be ready for your own lunch or a visit to the indoor exhibits with the active smaller animals. (See Figure 7.3.)

Figure 7.3 Early in the morning, this tiger is active and playful. By late afternoon, he'd probably be asleep under a tree.

◆ **Get as close as you can.** That may mean using the longest zoom setting, which, in turn, may call for using a monopod to steady your camera and avoid blur. A camera with image stabilization built-in can be a life saver in these situations, eliminating the need for an external support. (See Figure 7.4.)

◆ **Shoot at an angle.** You can sometimes discover a more attractive background if you shoot at an angle that takes in foliage and ornamental shrubbery at the side of the compound. Angle shots will also allow you to avoid reflections as you shoot through glass or plastic that some zoos use to protect the animals from visitors.

◆ **Look for humorous views.** A polar bear sticking out its tongue, a yawning lion, or some monkeys engaged in playful activities are more interesting than photos of the creature sitting there with a bored look on its face. (See Figure 7.5.)

Figure 7.4 A digital camera with a long telephoto range lets you capture close-up pictures of animals that are shy.

Figure 7.5 This polar bear's expression is priceless. Some of your best animal pictures will involve having the beast looking straight into the camera.

Amusement Parks

Amusement parks, especially the bigger theme parks, have an endless array of fascinating subjects to shoot. Go early and stay late, because the opportunities for creative photography change throughout the day. Of course, you'll want to have fun on the rides, too, so make time for both kinds of activities. I'm fortunate enough to live near a major theme park and generally purchase season passes for my entire family. We visit the park to enjoy the rides during May and June, when the number of visitors is smaller and the lines are shorter. Then, in July and August we wait until evenings for our return visits, because many folks are headed home by then. I'm usually able to fit in a couple trips to the park to do nothing but shoot pictures, too.

In the morning, when crowds are smallest, explore the park and photograph any animal life that populates the place. Even parks that don't feature animals will usually have ducks, hungry pigeons, peacocks, rabbits, or other fauna wandering around. This is a good time to photograph flora, too. You'll find decorative flower plantings worthy of a floral exhibit scattered around many parks.

By mid day you'll be ready to photograph some of the rides and structures in the park. Roller coasters, Ferris wheels, the various rides that go around and round in stomach-jerking ways all lend themselves to dramatic wide-angle shots or close-up telephoto pictures that reveal the stark terror on the faces of the riders. But don't forget to look for interesting abstract patterns and bright colors that make for eye-catching photos on their own. Figure 7.6 shows a giant funnel used to thrill rubber raft riders who cascade down its slopes. The funnel itself made an interesting photo.

Figure 7.6 This support structure for a water ride offered an interesting pattern that's bound to prompt a few "what's that?" queries.

Rides are also fun to photograph late in the day, when dramatic shadows provide interesting patterns, and, after dark when the park is lit with bright bulbs and neon tubes. This is the time to experiment with longer exposures that can create interesting light trails (see Figure 7.7). I usually have no problem bringing a tripod into an amusement park, but you can also use clamps with a tripod screw that fasten to any railing or other support. Don't forget the last moments of the day, when the park vendors are hawking those glow-in-the dark tubes or offering specials on cotton candy. Weary but content park visitors, possibly wearing those silly hats they purchased on a whim, can make some great candid pictures.

Figure 7.8 shows the same Ferris wheel during daylight, photographed from an unusual angle with trees framing the ride (and at the same time masking adjoining attractions so they don't intrude on the photo).

Figure 7.7 A time exposure of several seconds with a tripod-mounted camera produces this interesting light trail of a rotating Ferris wheel.

Figure 7.8 The same Ferris wheel captured earlier in the day, using surrounding trees as a frame, produces another interesting pattern.

Architecture

Architectural photography need-n't be the slick, predictable, or boring illustrations you find in the "house beautiful" publications. You can picture interesting buildings and monuments as you travel, photograph architecturally important buildings in your own town, shoot interior photos of finely appointed rooms, or document the less finely decked-out rooms of your own home. It can all be a lot of fun, and reward-ing, too (especially when it comes time to put the old manse up for sale).

The keys to effective architectural photography include (usually) a digital camera with a good wide-angle lens zoom setting (from 24mm to 35mm equivalent) that helps you capture your subject even when your back is to the wall or up against another build-ing. If your digital camera is less wide-angle-friendly (say, your minimum zoom setting is 39mm), you can investigate adding a

wide-angle adapter to the front of your lens. These are available for many intermediate and advanced digital cameras. Indoors, you might want some supplementary lighting to augment the available illumination. You'll want to use a relatively small aperture, if your digital camera offers one, to max-imize depth-of-field, and because

the light isn't always the best, a tripod can help steady your cam-era for a long exposure.

Another challenge to overcome is *perspective distortion,* which is most often caused when you tilt your camera backwards to take in the top of a tall structure and end up with a "falling backward"

look (see Figure 7.9). This effect is difficult to deal with in the field (sometimes you can find a higher place to shoot from, which can reduce the distortion), but can often be at least partially fixed in Photoshop or Photoshop Elements, using various perspec-tive or lens distortion corrective tools.

Figure 7.9 The "falling back" type of perspective distor-tion in this shot was partially corrected in Photoshop, pro-viding reasonably straight lines for the church tower and the other buildings on the street.

One important aspect of architectural photography is the need to make what might be a staid old building look more interesting. You can do that by shooting from an unusual angle, perhaps even making use of perspective distortion to create strong diagonal lines in your composition, as was done in Figure 7.10 with a staid *new* building. Another trick is to use surrounding buildings or trees to frame the structure (a technique used in Figure 7.9). As you learned in Chapter 6, a frame creates a 3D look that adds depth to the photo.

Indoors, you'll have to contend with one or more of the following lighting situations:

◆ **Insufficient light.** The illumination is so dim you're forced to make a long exposure with the camera mounted on a tripod.

◆ **Uneven illumination.** The light may be strong in one area of the interior and dim in another, making it difficult to evenly expose the entire image.

◆ **Harsh illumination.** Glaring lighting can give an image excessive contrast.

◆ **Mixed illumination.** You may have daylight streaming in the windows, mixing its blue light with the orangeish incandescent illumination of the room, added to a green glow of a fluorescent tube.

◆ **Off-color illumination.** The light in the interior may be distributed evenly, diffuse, and pleasant—and entirely the wrong color, thanks to fluorescent lighting or, worse, colored illumination. Your digital camera's white-balance controls might or might not be able to correct for this problem.

Using a tripod, adding supplementary lights or reflectors, closing the blinds or curtains in an unevenly lit room, or turning off the room lights entirely to eliminate mixed light sources can all be used to fix these predicaments.

Figure 7.10 Horizontal and diagonal lines lead the eye to the main structures on the other side of this plaza.

Auction Photography

Online auction venues like eBay are a great way to sell your old photo gear so you can buy new stuff, or to free up some space in your garage by turning your unwanted trash into treasures that others will pay you to take off your hands. Some folks even make a living from these auctions, selling specialty items like the porcelain figurine shown in Figure 7.11. I've managed to partially fund my photography equipment purchases by selling several old film cameras and some accessories that aren't compatible with my new digital camera. As sellers gain experience on eBay, they learn that a good photo goes a long way towards selling an item for the highest price. But, I'll bet you probably guessed that already.

But isn't the typical 6- to 10-megapixel digital camera overkill for eBay photography, as most of the images will be no larger than about 600 × 400 pixels (in order to fit on the greatest number of browsers within a typical auction page format)? Not at all. If you shoot your auction pictures at a resolution higher than the final size, you can crop the picture freely before shrinking it down to its final size. A larger initial image will frequently have a longer tonal scale (the range of bright to dark tones) and better colors. Your camera's images will almost always look better at smaller sizes than one originally taken with a low-resolution camera.

Figure 7.11 This porcelain figurine was lit with contrasty illumination so that there were plenty of specular highlights to show its texture.

Of course, larger images hold up to retouching and other manipulations better. You can adjust the brightness/contrast or balance the color of your auction pictures more thoroughly to arrive at a better-finished image. Here are some tips for creating small-format images that look good on an auction page.

◆ **Don't waste space.** If your photo is going to end up no larger than 600 pixels wide, make sure that every one of those pixels is devoted to important image information. Arrange your picture setup carefully, choosing an angle that packs the most attractive view of your merchandise into a tightly composed shot. If necessary, crop your photo closely in your image editor to trim away the fat. Figure 7.11 shows a tightly cropped image that wastes very little space.

◆ **Use a plain background.** Many eBay sellers use a plain white background that blends in with the auction page. A busy background distracts viewers from your product. In Figure 7.11 I used a black background, which contrasts with the delicate pale tones of the figurine better than a white

background would. Figure 7.12 uses a more three-dimensional background that shows off the shape of the jug.

◆ **Focus carefully.** A sharply focused image taken at a small f/stop with plenty of depth-of-field makes the most of the available resolution in the final image. A sharp 600 × 400 image will look much better than a blurry or poorly focused 600 × 400 image, even though the resolution is identical.

◆ **Use higher contrast effectively.** Higher-contrast lighting or boosting the contrast in your image editor can make your image look brighter and sharper. For Figure 7.12, I used a pair of high-intensity desk lamps on opposite sides of the piece to provide high-contrast lighting that accentuates the detail.

◆ **Increase color richness.** Digital cameras and image editors have a color saturation or "vividness" setting you can use to make your image look more attractive. If the colors of the merchandise are important (as with clothing or dinnerware, for example) or extra bright colors might be misleading (such as the covers of old faded pulp magazines), use this adjustment sparingly.

◆ **Show all sides of your item.** In addition to the front and top views of an Olympus camera I sold on eBay, I also presented a back view, plus one of the inside of the camera showing the film channel. The more information your buyer has about your product, the more likely he or she is to bid the maximum amount.

Figure 7.12 This piece was shot with a background that gave a more 3D feel to the image.

Candid Photography

The candid camera is a great deal older than the television show of the same name. As long as 60 or 70 years ago, legendary photojournalists were taking advantage of a new invention—the amazingly small 35mm camera—to capture unposed photos of people doing ordinary and extraordinary things. By the 1960s, the candid "look" had spread to other amateur and professional photographic endeavors. For example, during that decade, "candid" wedding photography revolutionized a field that had relied on highly structured poses in studios or onsite, with very little spur-of-the-moment coverage.

Great candid photos are all around you, and can be taken on the spur of the moment. But that doesn't mean that such photos don't require a bit of thought before you press the shutter release. On one hand, having your subjects go about the business of simply being themselves means you don't have to do much in the way of directing the shot. But on the other hand, candid photography is also tricky, because you must avoid disrupting those very activities you want to capture. People can be on guard and not act natural if they are nervous in a photographer's presence, so it's your job to blend in and become part of the activities, taking your candid photos in such a way that it's no big deal, like the photo that resulted in Figure 7.13.

Figure 7.13 Catching your subject in a relaxed moment can yield a memorable candid photo.

Another key to effective candid photography is knowing exactly when the best moment to take the picture is. If you're wandering around at a family reunion and snap a photo or two every 20 seconds or so, you'll soon become annoying and, probably, a person to be avoided. Instead, observe the goings-on and participate in them yourself, and wait until an interesting moment arrives to take your photo. You need to be prepared for the unexpected, as interesting, incongruent, or quirky events may pop up without a moment's notice.

Candid photography requires patience in finding just the right scene and moment, and a bit of luck. I've gotten some of my best shots by sitting down in a public park or square for an hour or two, people-watching and waiting for an interesting photographic moment, like the one in Figure 7.14. You'll find candid photography is a great opportunity to catch people in unguarded moments doing interesting things.

Figure 7.14 A bit of patience and a few hours observing people in a public square is a good technique for grabbing interesting candids.

Child Photography

Everybody loves photographs of their own children or grandchildren. Most of us even tolerate photos of other peoples' kids or grandkids, as long as they aren't too numerous or presented with excessive frequency. So, your job as a digital photographer is to create photographs of children that your family will love and your neighbors and colleagues will find easier to endure.

As subject matter, kids are always good for some interesting photos. Some are painfully shy, but most will turn into natural hams if they know you. Children who are at the "I want to be at the center of attention" phase (which lasts until about age 24), love to be photographed. It's the photographer, not the camera,

that may intimidate them. So, your job is to make them comfortable with you, which is no challenge at all if you happen to be a parent, a bit more of a task if you're a relative (especially one who doesn't see the kid regularly), and downright difficult if you're a stranger who wants to photograph somebody else's cute kids.

Here are some tips for successful child photography:

◆ **Use props.** A favored toy the child can hold as you're taking his or her photograph can put the child at ease, plus it gives you something to talk about as the kid explains to you what he likes about that particular toy.

◆ **Three's company.** If the child is not your own, he or she will be more comfortable if Mom or Dad or a sibling is around. The trick is to make sure the child talks to you most of the time, rather than the other members of the family. You want the child to be at ease, but not busy looking away from the camera while chattering with another person.

◆ **No new clothing.** Avoid the temptation to dress the child in brand new clothing just for the photo shoot. Find something nice, clean, and well pressed so the kid will look good but not feel like he's dressed up in a "monkey suit" for the picture. Similarly, a recent haircut properly combed or brushed will look better than having every hair in place from that morning's trip to the stylist.

◆ **Shoot from the child's level.** There's a tendency for adults to shoot children from a slightly elevated level. Getting down on the floor at the child's perspective can yield much more natural-looking photographs. Try out new poses, too, for a different look (see Figure 7.15).

◆ **Don't say cheese!** Teenagers, in particular, may be self-conscious about their smiles, especially if they are wearing braces. If they prefer to smile rather than grin, don't force the issue. Otherwise, your subject will end up being uncomfortable and that will show in your photos.

◆ **Catch the child in an unguarded moment.** In Figure 7.16, the toddler was enrapt watching his dad taking a picture, so it was the perfect moment to capture both of them in a snapshot.

Figure 7.15 Try new poses in addition to the standard ones. It never hurts to let the child suggest a few.

Figure 7.16 Younger children are sometimes easier to capture in photos if you just follow them around and snap a picture when they are engaged in something interesting.

Concerts—Live!

Nothing beats the enthusiasm and interaction of an audience with live music, and concerts are an opportunity to capture the visual excitement that doesn't begin to show up in audio recordings of even the most dynamic performance. Whether you're photographing an internationally known recording artist, or an up-and-coming act that may—or may not—make headlines some day, you'll find that concerts are a great way to take creative photographs.

There's one overriding challenge to this kind of photography: getting close enough to take pictures in which the performers are more than a rumor. Most of the time, stadium shows are a waste of time, even if you have primo seats, and in such venues you're likely to get jostled so much that your photography will suffer. Your best bet is at smaller theaters and clubs where getting up close is not a problem. For the five or six concerts I photographed in the last year, I specifically tried for a second- or third-row aisle seat, because it was far enough to the side that I could get a good view of the performers and not so close that all the photographs were of the underside of their chins. To get those seats I had to order far in advance or, for general admission shows, arrive a couple hours early so I'd be first in line for the mad dash to the front. Here are some other things to watch out for:

◆ **Microphones.** It's odd, but you don't notice the microphones on stands much when you're watching a concert, but they intrude quite awkwardly when you take photos. At general admission shows I've actually switched seats, as I did to get a clear view of folksinger Loudin Wainright III, for Figure 7.17.

Figure 7.17 It's difficult to get a clear view of some performers. Getting up close can let you maneuver so the microphones and other paraphernalia aren't a major part of the photograph.

◆ **Metering.** You'll probably want to switch your camera from Matrix or Center-Weighted metering to Spot metering, and then lock in the correct exposure as you frame your pictures. It's often a good idea to use your camera's exposure meter to determine the correct exposure, but set it manually to avoid slight changes as your subject moves around in the frame.

◆ **Changing light.** It's very common for the light to change dramatically during the course of a show, from bright white spotlights to blue or red key lights to set a mood. Each individual performer may be lit differently, too, perhaps with a stronger light on a musician performing a solo, and lights at a lower level or of a different color on the other performers. Even if you're using automatic exposure, be prepared to adjust your settings as the evening goes on.

◆ **Available light.** If your digital camera has a good quality lens, don't be afraid to use it wide open. The large f/stop and shallow depth-of-field concentrates attention on the soloist (in Figure 7.18, the guitar player), while allowing the other musicians to be part of the composition even though they are softly blurred. As a bonus, the large f/stop may let you shoot at a fast enough shutter speed (1/125th second in this case) to provide a reasonably sharp image without the need to resort to a high, noise-inducing ISO setting. (Notice that the drummer's drumstick is the only object significantly blurred by subject motion in Figure 7.18.)

Figure 7.18 Shooting wide open puts all the emphasis on the guitarist, while the other players are in softer focus.

Events

Events happen. By definition, events are activities of limited duration, whether they are World Cup soccer tournaments, car shows, Civil War re-enactments, local celebrations, or even a wedding or two. They're great photo opportunities, because they often involve festivals, costumes, pageantry, fighting among contentious fans, and things you just don't see everyday. That's why they are "events."

The important thing for shooting pictures at events is to plan ahead. You might want to scout parade routes in advance, see what kind of lighting might be in use, and understand any restrictions that will limit your access to the subjects that interest you most. I've been at events where no tripods were allowed, where finding a shooting position was subject to "first come, first served" mandates (there was no special shooting area for photographers), and where time limitations made getting a variety of pictures tricky.

Figure 7.19 Hot air balloon lift-offs are often part of the festivities at many events. If staged in late afternoon, they can be thrilling and full of photo opportunities.

You'll absolutely want a copy of the event schedule. Many events have their own website where you can peruse the schedule in advance, which can be helpful for multi-day events like Renaissance Faires or Civil War re-enactments. You might want to attend only on a specific day, perhaps to catch a jousting tournament in full regalia, or to witness (and photograph) a climactic battle.

If you're going to be at an event for a full day or the duration, arrive early. Introduce yourself to the security staff (or write in advance) so they'll know you're not a whack-o and will be more likely to tolerate your presence. Sometimes I show up while equipment is still being unloaded from trucks, mixing with the staff, but staying out of the way, so I became just another member of the crew. On one occasion, I even had to vouch for the local newspaper photographer, who arrived late, went to the wrong entrance, and forgot his credentials!

Figure 7.20 Car shows are great for photography, even if you're not a car buff, because there are always magnificently restored vehicles and some astounding customized automobiles to photograph.

Figure 7.21 Civil War re-enactments always have exciting battle scenes that make for an interesting trip back in time.

Fireworks and Aerial Pyrotechnics

Fireworks aren't just for July 4th anymore! You can expect to find fireworks and aerial pyrotechnics on Independence Day, of course, but many sports organizations, particularly baseball teams, offer fireworks nights after special games, as a promotion to get families to come out to the ballpark. Some amusement parks have fireworks shows as entertainment at the end of the park's day, in this case as an inducement to stay longer and buy more of those refreshments and souvenirs.

Fireworks are fun to shoot, and it's easy to get spectacular results. The biggest challenge when capturing fireworks with a digital camera is getting to actually see the fireworks yourself. The show is likely to be of limited duration—perhaps 10 or 15 minutes—so you'll be busy trying to take the maximum number of shots in the minimum amount of time. It's easy to become engrossed in the operation of your camera and miss the big show yourself. If you plan ahead and have your camera set up properly, you can usually relax and press the shutter release at appropriate times and actually view the show. Here are some tips for photographing fireworks.

◆ **Take your tripod.** Fireworks exposures usually require at least a second or two, and nobody can handhold a camera for that long. Set up the tripod and point the camera with your lens set at a normal or wide-angle zoom setting (depending on how much of the sky will be filled with pyrotechnics), and be ready to trip the shutter.

◆ **Timing is everything.** Watch as the skyrockets shoot up in the sky; you can usually time the start of the exposure for the moment just before they reach the top of their arc. With the camera set on time exposure, trip the shutter using a remote release (or a steady finger) and let the shutter remain open for all or part of the burst. Usually an exposure of one to four seconds works. (See the sidebar for specific tips.)

◆ **Review and adjust.** Look at your shots on your camera's LCD and, if necessary, adjust your f/stop so you don't overexpose the image. Washed-out fireworks are the pits. At ISO 100, you'll be working with an f/stop of about f/5.6 to f/11.

◆ **Use extra-long exposures.** Try leaving your shutter open for several sets of displays. Cover the lens with your hand between displays to capture several in one exposure, as shown in Figure 7.22.

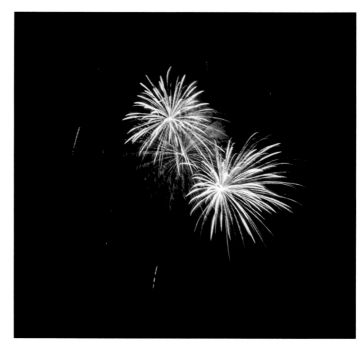

Figure 7.22 Long exposures allow capturing more than one burst in a single photo.

◆ **Experiment with color filters.** I held some color filters in front of the lens for part of the exposure shown in Figure 7.23, adding a purple tone to the white-tinted blasts.

◆ **Don't fret over noise.** Even if you're using a relatively low ISO, you can end up with some visual noise because of the long exposures required. Fortunately, noise in fireworks really doesn't distract much from the picture. Don't use your camera's noise-reduction feature, either, as the extra processing time may cause you to miss the next display.

◆ **Take a penlight.** A handheld light source can help you check your camera settings and make manual adjustments, even if your camera has backlighting for the monochrome LCD status displays, and the back panel LCD is big and bright. You still might need some light for other tasks, such as mounting your camera on the tripod or changing digital memory cards.

◆ **Use your image editor to combine displays.** Figure 7.24 was assembled in Photoshop using bursts from several different images (note that the display in the lower-left corner is the same as the one at left in Figure 7.23). You can create a more exciting picture by filling up the sky with bursts.

EXPOSING FIREWORKS

Use your digital camera's long exposure capabilities set to one to four seconds or longer, specified either in Manual mode, or by using your camera's special fireworks scene mode. Or, your camera might have a Bulb or Time exposure setting. The former keeps the shutter open for as long as you hold down the shutter release, while the latter opens the shutter with one press, and closes it again when you press the button a second time. If your camera allows you to specify f/stops, use f/5.6 to f/11. Focus on infinity.

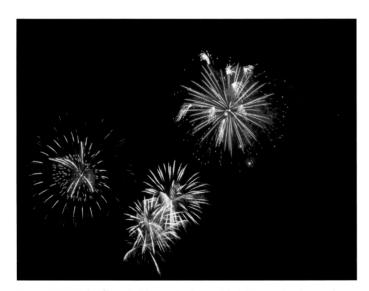

Figure 7.23 Color filters held over the lens added this purple glow to the fireworks.

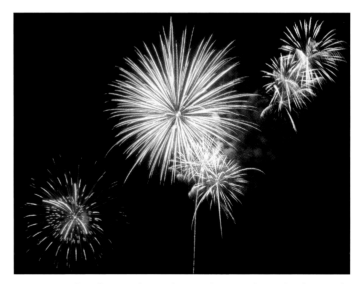

Figure 7.24 Photoshop can be used to populate your fireworks photos with displays from several different images.

Lush Landscapes

You may love sports photography, be enamored of pictures of animals, and fairly fond of taking pictures at night, but it's the landscapes that you probably blow up to huge sizes and hang on your walls. With the exception of portraits of people (of all ages), and pictures of personal pets, perhaps no other type of photography gets printed up and proudly displayed. Your travel pictures of the Eiffel Tower or Statue of Liberty make it into albums, and you show your sports photos around to your friends, but you're probably proud enough of your landscape photos to hang them on the wall.

There are good reasons for that. Nothing beats Mother Nature for natural beauty. Most scenes have charm, unless humans have intruded to spoil the landscape. Scenic photos have a kind of neutrality to them, too. Unless you have extraordinarily cute children or a spouse who could be employed as a model, most folks will enjoy your portraits of them

in direct proportion to how well they know them. As much as you love your portrait subjects, unless the photography itself is extraordinary, viewers might actually find them boring.

Not so with landscape photos. There are fewer personal feelings about the subject matter to interfere with your viewer's response to your scenic pictures. Everybody loves the Grand Canyon, or purple mountain

majesties, or a well-presented photo of trees dressed in their Fall colors (see Figure 7.25). If you shoot landscapes, you've got a ready audience for your work anywhere you go.

Figure 7.25 Autumn is a great time to capture lush landscapes of trees as they change their colors.

Any digital camera can do a good job with landscape photography. It's not complicated. Just find yourself a suitable subject, use a lens or zoom setting suitable for capturing it (wide angles often work best), and choose an exposure that provides a good combination of f/stop for a healthy amount of depth-of-field (if foreground objects are to be included) and a shutter speed that will stop camera shakiness from spoiling your shot.

You don't need a lot of gadgets or tools, other than a sturdy tripod, which can let you frame your images more carefully, maximize sharpness (useful when you decide to make 16 × 20 or larger prints from your photos), and take longer exposures in dim lighting, at dusk or dawn, or at night. If your intermediate or advanced digital camera accepts filter attachments, you've got a definite advantage.

Here are some of the things you can do with filters:

◆ **Polarizing filter.** A filter of this type can remove reflections from any water in your landscape photos and deepen the color of the sky, providing an overall more satisfying image. However, a polarizer can be a two-edged sword, as you can see in Figure 7.26. The unfiltered image is shown at the top. In the bottom version, the polarizer has darkened the sky and made the colors more vivid, while removing reflections from the inlet. However, in this case, the reflections in the water were part of the charm; removing them makes the water look muddy and uninteresting. A better choice for this photo might have been a split-density filter.

◆ **Split-density filter.** One problem with landscape photos like the scene in Figure 7.26 is that it is difficult to get a good balance between the bright sky and darker foreground. There are special split neutral density filters that are dark on one half and clear on the other. You can orient the filter so the dark half covers the sky and reduces its intensity, while the lower, clear half lets the terrestrial part of your photo show through in all its glory.

Figure 7.26 The unfiltered version lacks contrast in the sky; the polarizing filter used for the bottom photo darkened the sky and enriched the colors of this scene.

◆ **Neutral-density filter.** Snow or beach scenics can be excessively bright even when you use the smallest f/stop and fastest shutter speed. If your digital camera has a super-fast speed like 1/2000th second and a low-sensitivity setting like ISO 50 or ISO 100, you probably won't have this problem. But, there are digital cameras with a 1/1,000th second top speed and ISO 200 minimum sensitivity setting which, when coupled with a zoom lens that has an f/stop no smaller than f/8, your exposure choices may be limited. In addition, there are times when you don't want to use such a high shutter speed or small f/stop for technical or creative reasons. A 2X or 4X neutral density filter will cut down on the light by 1 or 2 f/stops (respectively). Figure 7.27 shows a waterfall shot handheld at ISO 400 and 1/400th second at f/10. The relatively high shutter speed wasn't fast enough to freeze the water, which is still slightly blurred.

Figure 7.27 A handheld photo of this waterfall at a high shutter speed allows the falls to blur only slightly.

Figure 7.28 shows another photo of the same waterfall taken from a slightly more distant vantage point using an 8X (three stop) neutral density filter, at ISO 100, with an exposure of 1/4 second at f/16 with the camera mounted on a tripod. This slower shutter speed transforms the churning water into a silky stream.

◆ **Haze filter.** Distant subjects force you to shoot through more layers of atmosphere, and the intervening haze might not be to your taste. A haze or skylight filter can be useful for cutting through the "fog" (in some cases it probably *is* fog) and restoring contrast to your image.

Figure 7.28
Mounting the camera on a tripod and shooting a longer exposure through a neutral density filter transforms the falls into a silky cascade.

Macro Photography

Close-up or *macro* photography is a year-round activity that enthralls many photographers because of the unique opportunities it provides to explore new techniques and to find subjects even in commonplace objects. In Spring, you can venture outside and shoot close-ups of flower buds as they emerge, or take macro pictures of insects and small animals as they build homes for the Summer. Then, during the hot months, you can find whole worlds of tiny objects to shoot at the seashore or in your own backyard. When Fall arrives, interesting photos can be captured in close-ups of leaves as they change color, tight shots of pumpkin carvings, or maybe in those decorated sugar skulls you or your kids prepared for Día de los Muertes (Day of the Dead) festivities that have grown popular as schoolchildren of all backgrounds study Mexican culture.

And, of course, in the Winter you can explore photography of your hobby collections or find interesting subjects in common household objects. Indoor macro photography is possible during the rest of the year, too, but those of us who live in chilly climes find it especially rewarding when the weather is cold.

When shooting close-ups with a basic, intermediate, or advanced digital camera, the only equipment you need is a tripod to hold the camera steady. A rock-solid tripod is essential for two reasons. Focus is critical with macro shots, and it's easy to shift the camera slightly and throw your picture completely out of focus if the camera isn't mounted on a tripod. In addition, many macro photos require a long exposure (often because the smallest f/stop available must be used to provide a sufficient range of sharpness), and your image will be blurry from camera shake if you don't steady the camera by mounting it on a tripod.

Admittedly, a tripod is a pain in the neck when you're outdoors photographing flowers or insects. If your camera has image stabilization, you can sometimes get good images even without a tripod at the shutter speeds required for close-up shooting at small apertures. You still must be careful not to move the camera enough to throw your subject out of focus, though.

When taking close-up photos, you'll want to use your digital camera's Macro or Super Macro modes, which allow the lens to focus very close to your subject.

With some cameras, Super Macro allows you to get to within a few millimeters of a tiny object, as shown in Figure 7.29. In that case, your problem will be lighting your target. There won't be much room between your lens and your subject, so light must come from the side or behind the object, as in the illustration.

Close-up photography allows you to find new and interesting subjects in common everyday items, such as the tripod screw shown in Figure 7.30. From half an inch away, this machined hunk of metal is transformed into a shiny, nicked-up, art object. Macro photos can be taken indoors or out, all year long. A tiny icicle suspended from a pine tree branch can be the subject of an eye-catching photo, as you can see in Figure 7.31.

Figure 7.29 The Super Macro mode found in some digital cameras allows you to focus to within a few millimeters of your subject.

Figure 7.30 Even common objects can make good macro subjects.

Figure 7.31 Macro photography can be successfully pursued all year round. You can find subjects outdoors in the middle of winter.

Nature Photography

There's a lot of overlap among the categories discussed in this chapter. Under the heading of "nature" photography you can include macro photography if you're shooting a spider, animal photography should capturing deer strike your fancy, and you can include scenics under this umbrella. It's all nature. I included this catch-all grouping because I wanted to show you a few more things that couldn't be squeezed into one of the other categories.

An example of macro/nature photography is close-ups of small creatures like the spider shown in Figure 7.32. You'll need to be careful not to disturb the spider (if she moves much the web will vibrate), so if your digital camera can focus close at a telephoto zoom setting, you'll be able to back up a little when you take your shot. Indeed, the biggest problem with macro photography of natural subjects outdoors (after scaring away the ones that have

Figure 7.32 Getting a photo of this nervous spider can be tricky, as sudden movements (by you or her) can start the web shaking, ruining your close-up.

legs) is avoiding or damping vibration that can make accurate focus and sharp photos impossible. If you're shooting flowers and other subjects that won't be frightened by the activity, it's often a good idea to set up wind shields to block gusts. They can be something as simple as a few pieces of cardboard and have the added benefit of reflecting additional light on your subject. Sometimes you can shield your subject with your body. Dedicated outdoor close-up shooters often buy or make moveable blinds that can isolate delicate plants from errant breezes.

An even more challenging pursuit is capturing living creatures in flight. Hummingbirds are especially popular, as all you need is a feeder to attract the little creatures, a digital camera with a telephoto lens that allows you to photograph them from a non-threatening distance, and a great deal of patience. A hiding place where you can wait unobserved can also be useful to avoid fright-

ening the birds away before you get a good picture. A fast shutter speed is necessary to grab a shot in which nothing blurs but their wings.

Those with less patience can try photographing bees and other insects as they flit around, as shown in Figure 7.33. Let your digital camera's autofocus system zero in on the flowers that will be the destination of the bee, and then snap your picture as the insect moves from blossom to blossom.

Figure 7.33 Capturing a flying insect on the wing takes patience.

Night Photography

Photography at night is challenging because there's so little light to work with. Subjects that look familiar in the daytime become dark and mysterious at night. You can photograph these subjects using the light that is there, or supplement that with electronic flash, extra lamps, or even a flashlight. You might need high ISO settings to capture an image at all, or you might require a tripod so you can use longer exposures. Night photographs can look moody and foreboding or include streaks of light that give them a Las Vegas or Great White Way excitement.

There are lots of different techniques you can use to shoot at night. Figure 7.34 relied on nothing more than the existing light and a long exposure with a tripod. This can be an interesting way to go on several counts. One by-product of long exposures like this is that pedestrians

Figure 7.34 A long exposure at night yielded this photo of a Medieval cathedral, illuminated only by the spotlights on the structure itself.

walking through your photo won't remain in one place long enough to even register in the image. There actually were people passing in front of this cathedral when I took the picture—you just can't see them.

Another technique is to "paint" with light, as shown in Figure 7.35. The tripod-mounted camera and long exposure is the same, but during the exposure you, or an assistant, race around with an electronic flash (popping it off manually) or a broad-beam flashlight, illuminating your subject as if painting. If the painter keeps moving and keeps his or her back between the light source and the camera, only the results of the painting will show up; the artist will be invisible.

Add some vehicles with headlights and taillights into the mix, and you end up with a photo like Figure 7.36. Its another tripod shot, with the headlights of the automobiles leaving a trail of streaks behind at the left side of the picture.

Figure 7.35 This courthouse was photographed using a camera on a tripod and a long exposure, with an external electronic flash triggered three or four times to illuminate the darker left and right sides of the edifice.

Figure 7.36 If the streets in your town are as quiet as this one, you may need a long exposure of several minutes to get any tail light streaks.

Panoramas

Many digital cameras—even the most basic models—have facilities built-in for creating great-looking panorama photos. All you need to do is activate the feature, and (sometimes) tell the camera whether you're taking a series of pictures from left to right or right to left. After you've snapped off a picture, one of its edges appears on the LCD so you can compose the next one with the proper degree of overlap. With simple cameras you may end up with three or more photos that you combine yourself in your image editor. (Photoshop and Photoshop Elements have a Photomerge dialog box that makes this easy.) More advanced cameras may stitch the images together for you, right in the camera. Models that do this often take each of the individual pictures at a lower resolution, so you might end up with three 3.3-megapixel images combined into one, rather than a humongous trio of 6- or 8-megapixel shots.

Panoramas are a wonderful effect that give you wide-screen views of your subjects. They're usually used for scenic photographs, but can be applied to any kind of picture. For example, you could shoot the interior of a room in your home, showing all four walls smoothly merged into a single picture. It's usually easiest to shoot panoramas of landscape scenes, because your subject will remain fixed in place while you fool around taking the photo.

Panoramas can simply be "wide" photos, showing, say 100 degrees of a scene in a narrow strip, or can include 180 degrees or even a full 360-degree view if you have the inclination and technical wherewithal to accomplish such a feat. If your camera doesn't have a panorama option, you'll need to manually shoot several pictures and stitch them together to create one wide view.

When shooting panoramas, many find it useful to mount the camera on a tripod so the camera can be smoothly panned from one shot to the next overlapping picture. You also must watch for the varying levels of illumination between individual pictures. Not only can the light change, but it's very likely that even if the light doesn't change during your series of exposure, not all angles of view will be lit in the same way. In either case, you may have problems matching up the individual pictures.

There are several ways to shoot panoramas with a digital camera that won't do this for you automatically. The simplest way is to simply crop the top and bottom of an ordinary photo so you end up with a panoramic shot like the one extracted from the full-frame picture in Figure 7.37. You'll get even better results if you plan ahead and shoot your original image so that no important image information appears in the upper and lower portions. By planning ahead of time, you can crop your image as shown in Figure 7.38, and get a more natural-looking panorama.

If your camera doesn't have a built-in panorama feature, you can still shoot and stitch together several photos manually. You take the first picture and then pivot the camera to take the next, overlapping frames (without benefit of a special panorama feature's ghost overlap, described earlier) so you can match them to each other in an image editor. If you don't have Photoshop or Photoshop Elements, there are many other utilities like ACDSee (or an equivalent program for Macs), as well as some stitching programs furnished with digital cameras.

Figure 7.37 This image was created by trimming the top and bottom from an ordinary wide-angle photo.

Figure 7.38 If you plan your picture ahead of time, you can create a panorama in which no important information appears in the top and bottom of the frame.

Portraiture

Portraits are a way of documenting our lives as we change and grow, showing us as friendly, glamorous, adventuresome, hopeful, or even sinister, depending on our whims and those of the photographer. Photographing people is certainly challenging, because everybody's a critic. You as the photographer not only have to please yourself with your results, you have to please the person you've photographed as well as everybody who knows that person. The photograph can't show your subject as they really are but, rather, as they see themselves.

There are dozens of different kinds of portraits and people pictures: formal or candid; individuals, couples, or groups; family portraits; and fashion photography. Portraits can be photographed in a studio or shot on location for "environmental" portraits. But all have one thing in common: The arrangement and lighting (whether natural or arranged by the photographer) tell us that this is a portrait, a deliberate representation of one or more persons.

You don't need a fancy digital SLR to shoot effective portraits with your digital camera, although, if you're using an advanced digital camera you might want to experiment with using supplemental lighting (either flash or incandescent lamps). You do need certain basics, however:

◆ **Lots of megapixels.** The higher the resolution of your camera, the larger you can make your prints and the more editing you can do on your photos. If you're hoping to make 20 × 30-inch prints to hang over the mantle, you'd better have an 8-10 megapixel digital camera, or better!

◆ **A short to intermediate telephoto zoom setting.** Individual humans look their best when photographed with a moderate telephoto zoom setting, in the 85mm to 100mm range , as shown in Figure 7.39. If you're shooting a full-length portrait, or picturing several people in one shot, the shorter end of the range, or even a "normal" (50mm equivalent) focal length setting can be used. Anything wider can distort the features of your subjects, especially when used up close. Noses look larger compared to the ears, and faces may look too thin. Longer focal lengths can compress the features, causing a face to look wider.

◆ **A light source. Or two. Or three.** You can shoot great portraits with any digital camera using the light that's already available, as long as you study the lighting and arrange your subject so they are illuminated in a flattering way. However, for more advanced photographers, multiple light sources are often used in portraiture to more easily control how the light provides shape and texture to the face. One "main" light will illuminate part of the face, with a "fill" light used to brighten shadows, as you can see in Figure 7.40, in which a light was placed off to the side of the woman to provide what is called (naturally) *side lighting*, while another light near the camera filled in the shadows on the side of her face facing the lens. Additional lights can add some sparkle to the hair or light up the background. Learning to use light sources effectively can be half the challenge of learning how to shoot portraits.

◆ **A background.** Portraits work best if the background isn't busy, cluttered, or distracting. Outdoors, you can often find a background in nature, such as trees, the sky, or a cliff. Indoors, the background can be a blank wall, a shelf of books, or a special background designed especially for portraiture. You'll find that simply adjusting the amount and type of light that falls on your background can change its appearance. Make it lighter to provide separation between a dark-toned subject and his or her surroundings, or darker for a lighter subject. You can purchase backgrounds for use in a studio, buy rolls of seamless paper, or make a background yourself.

Figure 7.39 A zoom setting in the 85mm to 100mm range (equivalent) produces the most flattering portraits.

Figure 7.40 Three lights were used for this portrait: a main light off to the left, a fill light at the camera position, and a background light to brighten the backdrop.

Still Lifes

Still-life photography is a little like macro photography, but from farther away and, perhaps, with a bit of specialization towards bowls of fruit and the like. Artists love to create still-life paintings because they cherish the chance to paint infinitely patient three-dimensional subjects that will challenge their skills and give them a chance to try out various techniques, without worrying that the "model" will get tired and leave. Georgia O'Keefe was a master of the still life, and even Andy Warhol's soup can paintings are based on the concept.

Photographers can use the same kind of subjects to demonstrate that they are masters of arrangement and light, and the other components of successful still-life imaging. Of course, your models aren't limited to bowls of fruit flowers, or food (see Figure 7.41). Any collection of objects can be used effectively in a still-

Figure 7.41 Your dinner or snack can make a good photographic subject.

life arrangement. You can grab a box of crayons and play with lighting and color and framing until you get the exact effect you want. Or, you can array a collection of peppers (see Figure 7.42) and adjust them until the colors or curve of the stems provides a pleasing composition.

I placed the peppers on a black velour background and lit them with electronic flash bounced off umbrellas. I tried various angles and lighting effects to arrive at this shot. Replace the peppers with lemons and limes, change the lighting a little, and you have an entirely new still-life arrangement. These kinds of photos combine the intimate shooting distances of macro photography with the careful lighting and "posing" techniques of portraiture. Indeed, still-life photography is excellent training and practice for both.

Figure 7.42 Still lifes traditionally consist of flowers or fruit, often in a basket, but there's a whole cornucopia of possibilities to explore.

Sunrises and Sunsets

Sunsets and sunrises are beautiful, colorful, and often appear to have been carefully planned, even though that's not usually the case. Most of the time, we happen to be in a particular location at the right time of day, look over at the setting (or rising) sun, and realize that the view is stunning. We snap away, and end up with a dramatic photo that makes us look like better photographers than we really are. That's why some photographers actually specialize in them.

Sunrises and sunsets can look almost identical; although, depending on the weather conditions, they often are not. Sunrises, like the one shown in Figure 7.43, take place after the cool of the night, when the Earth and its creatures are just waking up and becoming active again. There's often a light fog or haze as the sun warms and evaporates the dew.

Figure 7.43
Photos at dawn have a special quality, often quite different from photos taken at dusk.

Sunsets, on the other hand, often occur after a hot day. The air can be warmer and dryer and the sky clearer. As a practical matter, sunsets are easier to prepare for, as you have at least a modicum of light to work with in setting your camera until the actual sunset takes place. Here are some tips for shooting sunrises and sunsets.

◆ **Experiment with white balance and exposure.** Experiment to see what white balance you want to use and bracket your exposures. You'll want a warm tone that isn't neutralized by the white-balance control and an exposure that will let you take advantage of the backlighting provided by the sun. With sunset photos, you generally *want* a dark, silhouette effect punctuated by the bright orb of the sun.

◆ **Don't stare at the sun, even through the viewfinder.** I usually compose my sunset photos with the sun slightly out of the frame, then recompose just before taking the photo. Often, I'll set the camera on a tripod and just press the shutter release when I see a composition I like.

◆ **Avoid splitting your photo in half with the horizon in the middle.** Your picture will be more interesting if the horizon is about one-third up from the bottom (to emphasize the sky) or one-third down from the top (to emphasize the foreground) (see Figure 7.44). Remember the Rule of Thirds.

◆ **Sunsets don't have to be composed horizontally!** Vertically oriented shots can be interesting.

◆ **Experiment with filters.** Star filters, gradients, or other add-ons can enhance your sunset pictures. You don't even need a star filter if you use a small enough lens aperture. At tiny f/stops, bright light sources burst into star effects all by themselves.

◆ **Shoot silhouettes.** They're more dramatic (see Figure 7.44 again).

◆ **Focus at infinity.** Sunsets can fool the autofocus mechanisms of some cameras. Use manual focus if you can't get the autofocus to focus at infinity.

◆ **Have your tripod handy.** The closer you are to actual sunrise or sunset, the longer the exposure. If your camera is mounted on a tripod, you can still get a good shot when the sun is behind some trees or buildings or below the horizon.

Figure 7.44 Place the horizon about one-third down from the top of the frame to emphasize the foreground.

Travel Photography

Vacations are a great time to take pictures. You're relaxed, ready to have fun, and have brought your digital camera along to document every moment of your trip. When you get home, after spending thousands of dollars, all you'll have left are some treasured memories, a pile of souvenirs, and hundreds of photographs you can share with others.

In some ways, travel photography is an interesting blend of other kinds of photography in this chapter. It has elements of landscape and architectural photography. If you include family members in your photos, you can exercise your candid and portrait skills. There's lots of Nature's wonder to picture, and urban life to capture.

But given all those opportunities, you should resist the urge to take along every possible piece of equipment you own. If you get weighed down by a ton of gear, you'll spend more time fiddling with gadgets than actually taking pictures. Once, I traveled to Europe carrying just a single camera and its lens—but that was pretty stupid. On my last trip to Spain, I took *two* digital cameras, plus a tripod and monopod and a clutch of filters, and a portable hard disk to copy my pictures for safekeeping and to free memory cards. I was still traveling light, but I had backups in case something bad happened to one piece of gear.

Figure 7.45 The telephoto setting on your zoom lens is great for capturing details and close-up looks at interesting sites while you travel.

In addition to your camera(s), here are some other things to take with you:

◆ **Lots of memory cards.** You'll want to have enough memory cards for at least a day or two's shooting. Plan on shooting twice as many pictures as you expect to. Your digital camera makes it easy to snap photos, review them on the LCD, and then take more pictures. You'll end up shooting more photos from more angles than you expected, and your memory cards will quickly fill up. In a pinch, you can switch to a higher JPEG compression ratio (Standard instead of Fine, or whatever terminology your camera uses) to stretch your cards farther. But the best solution is to have lots of memory cards and some way of offloading photos from the cards you have at intervals so they can be re-used.

◆ **A portable storage device.** Because you'll probably fill up your memory cards quickly, a lightweight, battery-operated standalone storage device might be easier to carry and more practical than a huge complement of expensive memory cards or a laptop computer. Your best choice might be a portable DVD/CD burner so you can create several copies of each photo, but hard-drive based portable storage devices can work,

too. If you already own a 20GB to 60GB Apple iPod, you can buy a card reader that plugs right in. Of course, hard-drive storage devices can crash, too, so this solution isn't perfect.

◆ **A listing of cyber cafés along your route.** It's difficult to find a city of any size that doesn't have a cyber café nearby. If you know in advance where you can find one of these handy rent-a-computer sites, you can leave your own computer at home and log onto one at the café to read your e-mail (if you must) or upload your photos (if you're smart). Just remember to take along your camera's USB cable or a USB card reader so you can link your camera or memory card to the café's computer. There are a couple drawbacks to this option. Although cafés are everywhere, there is no guarantee you can find one when you absolutely must have one. It's a better idea to compile a list before you leave. Nor can you guarantee that the establishment will have a fast, broadband connection. You might have a dial-up connection that's great for e-mail, but not so great for sending multi-megabyte picture files. Finally, these outlets generally charge by the minute or hour, so uploading all your photos might prove expensive.

Figure 7.46 When visiting new places, capture images of strange and exotic things. In Europe, the narrow streets and even the automobiles will be interesting and different.

Glossary

additive primary colors The red, green, and blue hues which are used alone or in combinations to create all other colors you capture with a digital camera, view on a computer monitor, or work with in an image-editing program like Photoshop.

ambient lighting Diffuse nondirectional lighting that doesn't appear to come from a specific source but, rather, bounces off walls, ceilings, and other objects in the scene when a picture is taken.

analog/digital converter In digital imaging, the electronics built into a camera or scanner that convert the analog information captured by the sensor into digital bits that can be stored as an image bitmap.

angle of view The area of a scene that a lens can capture, determined by the focal length of the lens. Lenses with a shorter focal length have a wider angle of view than lenses with a longer focal length.

Aperture-Priority A camera setting that allows you to specify the lens opening or f/stop that you want to use, with the camera selecting the required shutter speed automatically based on its light-meter reading. See also *Shutter-Priority*.

autofocus A camera setting that allows the camera to choose the correct focus distance for you, usually based on the contrast of an image (the image will be at maximum contrast when in sharp focus) or a mechanism such as an infrared sensor that measures the actual distance to the subject. Some advanced cameras can be set for *single autofocus* (the lens locks focus as soon as the shutter release is partially depressed) or *continuous autofocus* (the lens locks focus when the shutter release is partially depressed, but then refocuses constantly as you frame and reframe the image or the subject moves).

autofocus assist lamp A light source built into a digital camera that provides extra illumination that the autofocus system can use to focus dimly lit subjects.

averaging meter A light-measuring device that calculates exposure based on the overall brightness of the entire image area. Averaging tends to produce the best exposure when a scene is evenly lit or contains equal amounts of bright and dark areas that contain detail. Most digital cameras use much more sophisticated exposure measuring systems based in center-weighting, spot-reading, or calculating exposure from a matrix of many different picture areas. See also *spot meter*.

B (bulb) A camera setting found in some models for making long exposures. Press down the shutter button and the shutter remains open until the shutter button is released. Bulb exposures can also be made using a camera's electronic remote control (available for some models), or a cable release cord that fits to some cameras. See also *T (Time)*.

back lighting A lighting effect produced when the main light source is located behind the subject. Back lighting can be used to create a silhouette effect, or to illuminate translucent objects. See also *front lighting, fill lighting,* and *ambient lighting*. Back lighting is also a technology for illuminating an LCD display from the rear, making it easier to view under high ambient lighting conditions.

ball head A type of tripod camera mount with a ball-and-socket mechanism that allows greater freedom of movement than simple pan and tilt heads.

barrel distortion A defect found in some wide-angle lenses or zoom settings that causes straight lines at the top or side edges of an image to bow outward into a barrel shape. See also *pincushion distortion*.

blooming An image distortion caused when a photosite in an image sensor has absorbed all the photons it can handle, so that additional photons reaching that pixel overflow to affect surrounding pixels producing unwanted brightness and overexposure around the edges of objects.

blur In photography, to soften an image or part of an image by throwing it out of focus, or by allowing it to become soft due to subject or camera motion. In image editing, blurring is the softening of an area by reducing the contrast between pixels that form the edges.

bokeh A buzzword used to describe the aesthetic qualities of the out-of-focus parts of an image, with some lenses producing "good" bokeh and others offering "bad" bokeh. *Boke* is a Japanese word for "blur," and the h was added to keep English speakers from rhyming it with *broke*.

Out-of-focus points of light become discs, called the *circle of confusion*. Some lenses produce a uniformly illuminated disc. Others, most notably *mirror* or *catadioptic* lenses (for digital SLR cameras), produce a disc that has a bright edge and a dark center, producing a "doughnut" effect, which is the worst from a bokeh standpoint. Lenses that generate a bright center that fades to a darker edge are favored, because their bokeh allows the circle of confusion to blend more smoothly with the surroundings. The bokeh characteristics of a lens are most important when you are using selective focus (say, when shooting a portrait) to deemphasize the background, or when shallow

depth-of-field is a given because you're working at macro settings, a long telephoto zoom setting, or with a wide-open aperture. See also *circle of confusion*.

bounce lighting Light bounced off a reflector, including ceiling and walls, to provide a soft, natural-looking light.

bracketing Taking a series of photographs of the same subject at different settings to help ensure that one setting will be the correct one. Many digital cameras will automatically snap off a series of bracketed exposures for you. Other settings, such as color and white balance, can also be "bracketed" with some models. Digital SLRs may even allow you to choose the order in which bracketed settings are applied.

brightness The amount of light and dark shades in an image, usually represented as a percentage from 0 percent (black) to 100 percent (white).

buffer A digital camera's internal memory that stores an image immediately after it is taken until the image can be written to the camera's non-volatile (semi-permanent) memory or a memory card.

burn A darkroom technique, mimicked in image editing, which involves exposing part of a print for a longer period, making it darker than it would be with a straight exposure.

burst mode The digital camera's equivalent of the film camera's "motor drive," used to take multiple shots within a short period of time.

calibration A process used to correct for the differences in the output of a printer or monitor when compared to the original image. Once you've calibrated your scanner, monitor, and/or your image editor, the images you see on the screen more closely represent what you'll get from your printer, even though calibration is never perfect.

camera shake Movement of the camera, aggravated by slower shutter speeds, which produces a blurred image. Some of the latest digital cameras have *image stabilization* features that correct for camera shake, while a few high-end interchangeable lenses have a similar vibration correction or reduction feature. See also *image stabilization*.

candid pictures Unposed photographs, often taken at a wedding or other event at which (often) formal, posed images are also taken.

cast An undesirable tinge of color in an image.

CCD Charge-Coupled Device. A type of solid-state sensor that captures the image, used in scanners and digital cameras. See also *CMOS*.

center-weighted meter A light-measuring device that emphasizes the area in the middle of the frame when calculating the correct exposure for an image. See also *averaging meter* and *spot meter*.

chromatic aberration An image defect, often seen as green or purple fringing around the edges of an object, caused by a lens failing to focus all colors of a light source at the same point. See also *fringing*.

circle of confusion A term applied to the fuzzy discs produced when a point of light is out of focus. The circle of confusion is not a fixed size. The viewing distance and amount of enlargement of the image determine whether we see a particular spot on the image as a point or as a disc.

close-up lens A lens add-on, available in several different magnifications that can be used alone or combined, which looks like a filter attachment. It allows you to take pictures at a distance that is less than the closest-focusing distance of the lens alone.

CMOS Complementary Metal-Oxide Semiconductor. A method for manufacturing a type of solid-state sensor that captures the image, used in scanners and digital cameras. See also *CCD*.

CMY(K) color model A way of defining all possible colors in percentages of cyan, magenta, yellow, and frequently, black. Black is added to improve rendition of shadow detail. CMYK is commonly used for printing (both on press and with your inkjet or laser color printer). Photoshop can work with images using the CMYK model, but converts any images in that mode back to RGB for display on your computer monitor.

color correction Changing the relative amounts of color in an image to produce a desired effect, typically a more accurate representation of those colors. Color correction can fix faulty color balance in the original image, or compensate for the deficiencies of the inks used to reproduce the image.

CompactFlash A type of memory card used in many digital cameras, although today they are most often used in advanced models. See also *Secure Digital, xD Card,* and *Memory Stick*.

composition The arrangement of the main subject, other objects in a scene, and/or the foreground and background.

compression Reducing the size of a file by encoding using fewer bits of information to represent the original. Some compression schemes, such as JPEG, operate by discarding some image information, while others, such as TIF, preserve all the detail in the original, discarding only redundant data.

continuous autofocus An automatic focusing setting in which the camera constantly refocuses the image as you frame the picture. This setting is often the best choice for moving subjects. See also *single autofocus*.

continuous tone Images that contain tones from the darkest to the lightest, with a theoretically infinite range of variations in between.

contrast The range between the lightest and darkest tones in an image. A high-contrast image is one in which the shades fall at the extremes of the range between white and black. In a low-contrast image, the tones are closer together.

crop To trim an image or page by adjusting its boundaries.

dedicated flash An external electronic flash unit designed to work with the automatic exposure features of a specific camera.

depth-of-field (DOF) A distance range in a photograph in which all included portions of an image are at least acceptably sharp. Most non-dSLR cameras have enormous depth-of-field, rendering most subjects more than a few feet from the camera in good focus. DOF becomes most important when shooting close-up pictures.

desaturate To reduce the purity or vividness of a color, making a color appear to be washed out or diluted.

diaphragm An adjustable aperture, similar to the iris in the human eye, which can open and close to provide specific sized lens openings, or f/stops, and control the amount of light reaching the sensor. See also *f/stop* and *iris*.

diffuse lighting Soft, low-contrast lighting.

diffusion Softening or blurring of detail in an image by randomly distributing gray tones in an area of an image to produce a fuzzy effect. Diffusion can be added when the picture is taken, often through the use of diffusion filters, or in post-processing with an image editor. Diffusion can be beneficial to disguise defects in an image and is particularly useful for portraits of women.

diopter A value used to represent the magnification power of a lens, calculated as the reciprocal of a lens's focal length (in meters). Diopters are most often used to represent the optical correction used in a viewfinder to adjust for limitations of the photographer's eyesight, and to describe the magnification of a close-up lens attachment.

dodging A darkroom term for blocking part of an image as it is exposed, lightening its tones. Image editors can mimic this effect by lightening portions of an image using a brush-like tool. See also *Burn*.

dots per inch (dpi) The resolution of a printed image, expressed in the number of printer dots in an inch. You'll often see dpi used to refer to monitor screen resolution, or the resolution of scanners. However, neither of these uses dots; the correct term for a monitor is pixels per inch (ppi), whereas a scanner captures a particular number of samples per inch (spi).

electronic viewfinder (EVF) An LCD located inside a digital camera and used to provide a view of the subject based on the image generated by the camera's sensor.

Exif Exchangeable Image File Format. Developed to standardize the exchange of image data between hardware devices and software. A variation on JPEG, Exif is used by most digital cameras, and includes information such as the date and time a photo was taken, the camera settings, resolution, amount of compression, and other data.

existing light In photography, the illumination that is already present in a scene. Existing light can include daylight or the artificial lighting currently being used, but it is not considered to be electronic flash or additional lamps set up by the photographer.

exposure The amount of light allowed to reach the film or sensor, determined by the intensity of the light, the amount admitted by the iris of the lens, and the length of time determined by the shutter speed.

exposure program An automatic setting in a digital camera that provides the optimum combination of shutter speed and f/stop at a given level of illumination. For example a "sports" exposure program would use a faster, action-stopping shutter speed and larger lens opening instead of the smaller, depth-of-field-enhancing lens opening and slower shutter speed that might be favored by a "close-up" program at exactly the same light level.

exposure values (EV) EV settings are a way of adding or decreasing exposure without the need to reference f/stops or shutter speeds. For example, if you tell your camera to add +1EV, it will provide twice as much exposure, either by using a larger f/stop, slower shutter speed, or both.

fill lighting In photography, lighting used to illuminate shadows. Reflectors or additional incandescent lighting or electronic flash can be used to brighten shadows. One common technique outdoors is to use the camera's flash as a fill.

filter In photography, a device that fits over the lens, changing the light in some way. In image editing, a software special effect feature that changes the pixels in an image to produce blurring, sharpening, and other transformations.

FireWire (IEEE-1394) A fast serial interface used by scanners, digital cameras, printers, and other devices.

focal length The distance between the film and the optical center of the lens when the lens is focused on infinity, usually measured in millimeters.

focal plane An imaginary line, perpendicular to the optical access, which passes through the focal point forming a plane of sharp focus when the lens is set at infinity.

focus To adjust the lens to produce a sharp image.

focus lock A camera feature that lets you freeze the automatic focus of the lens at a certain point, when the subject you want to capture is in sharp focus.

focus range The minimum and maximum distances within which a camera is able to produce a sharp image, such as two inches to infinity.

focus tracking The ability of the automatic focus feature of a camera to change focus as the distance between the subject and the camera changes. One type of focus tracking is *predictive*, in which the mechanism anticipates the motion of the object being focused on, and adjusts the focus to suit.

framing In photography, composing your image in the viewfinder. In composition, using elements of an image to form a sort of picture frame around an important subject.

fringing A chromatic aberration that produces fringes of color around the edges of subjects, caused by a lens's inability to focus the various wavelengths of light onto the same spot. *Purple fringing* is especially troublesome with backlit images.

front lighting Illumination that comes from the direction of the camera. See also *back lighting* and *side lighting*.

f/stop The relative size of the lens aperture, which helps determine both exposure and depth-of-field. The larger the f/stop number, the smaller the f/stop itself. It helps to think of f/stops as denominators of fractions, so that f/2 is larger than f/4, which is larger than f/8, just as 1/2, 1/4, and 1/8 represent ever-smaller fractions. In photography,

a given f/stop number is multiplied by 1.4 to arrive at the next number that admits exactly half as much light. So, f/1.4 is twice as large as f/2.0 (1.4 × 1.4), which is twice as large as f/2.8 (2 × 1.4), which is twice as large as f/4 (2.8 × 1.4). The f/stops which follow are f/5.6, f/8, f/11, f/16, f/22, f/32, and so on. See also *diaphragm*.

full-color image An image that uses 24-bit color, 16.8 million possible hues. Images are sometimes captured in a scanner with more colors, but the colors are reduced to the best 16.8 million shades for manipulation in image editing.

gamma A numerical way of representing the contrast of an image. Devices such as monitors typically don't reproduce the tones in an image in straight-line fashion (all colors represented in exactly the same way as they appear in the original). Instead, some tones may be favored over others, and gamma provides a method of tonal correction that takes the human eye's perception of neighboring values into account. Gamma values range from 1.0 to about 2.5. The Macintosh has traditionally used a gamma of 1.8, which is relatively flat compared to television. Windows PCs use a 2.2 gamma value, which has more contrast and is more saturated.

gamma correction A method for changing the brightness, contrast, or color balance of an image by assigning new values to the gray or color tones of an image to more closely represent the original shades. Gamma correction can be either linear or nonlinear. Linear correction applies the same amount of change to all the tones. Nonlinear correction varies the changes tone-by-tone, or in highlight, midtone, and shadow areas separately to produce a more accurate or improved appearance.

gamut The range of viewable and printable colors for a particular color model, such as RGB (used for monitors) or CMYK (used for printing).

Gaussian blur A method of diffusing an image using a bell-shaped curve to calculate the pixels which will be blurred, rather than blurring all pixels, producing a more random, less "processed" look.

graduated filter A lens attachment with variable density or color from one edge to another. A graduated neutral density filter, for example, can be oriented so the neutral density portion is concentrated at the top of the lens's view with the less dense or clear portion at the bottom, thus reducing the amount of light from a very bright sky while not interfering with the exposure of the landscape in the foreground. Graduated filters can also be split into several color sections to provide a color gradient between portions of the image.

grain The metallic silver in film which forms the photographic image. The term is often applied to the seemingly random noise in an image (both conventional and digital) that provides an overall texture.

gray card A piece of cardboard or other material with a standardized 18-percent reflectance. Gray cards can be used as a reference for determining correct exposure.

grayscale image An image represented using 256 shades of gray. Scanners often capture grayscale images with 1,024 or more tones, but reduce them to 256 grays for manipulation by an image editor.

highlights The brightest parts of an image containing detail.

histogram A kind of chart showing the relationship of tones in an image using a series of 256 vertical "bars," one for each brightness level. A histogram chart typically looks like a curve with one or more slopes and

peaks, depending on how many highlight, midtone, and shadow tones are present in the image.

hot shoe A mount on top of a camera used to hold an electronic flash, while providing an electrical connection between the flash and the camera.

hyperfocal distance A point of focus where everything from half that distance to infinity appears to be acceptably sharp. For example, if your lens has a hyperfocal distance of four feet, everything from two feet to infinity would be sharp. The hyperfocal distance varies by the lens and the aperture in use. If you know you'll be making a "grab" shot without warning, sometimes it is useful to turn off your camera's automatic focus and set the lens to infinity, or, better yet, the hyperfocal distance. Then, you can snap off a quick picture without having to wait for the lag that occurs with most digital cameras as their autofocus locks in.

image rotation A feature found in some digital cameras, which senses whether a picture was taken in horizontal or vertical orientation. That information is embedded in the picture file so that the camera and compatible software applications can automatically display the image in the correct orientation.

image stabilization A technology, also called vibration reduction and anti-shake, that compensates for camera shake, usually by adjusting the position of the camera sensor or lens elements *(optical image stabilization)* in response to movements of the camera. Some models, such as specific cameras from Olympus, use *digital image stabilization*, in which camera shake is countered by processing the image in the camera (either before or after the picture is taken) to reduce the effects of blur.

incident light Light falling on a surface.

infinity A distance so great that any object at that distance will be reproduced sharply if the lens is focused at the infinity position.

infrared illumination The non-visible part of the electromagnetic spectrum with wavelengths between 700 and 1,200 nanometers, which can be used for infrared photography when the lens is filtered to remove visible light.

interchangeable lens Lens designed to be readily attached to and detached from a camera; a feature found in more sophisticated digital cameras.

International Organization for Standardization (ISO) A governing body that provides standards such as those used to represent film speed, or the equivalent sensitivity of a digital camera's sensor. Digital camera sensitivity is expressed in ISO settings.

interpolation A technique digital cameras, scanners, and image editors use to create new pixels required whenever you resize or change the resolution of an image based on the values of surrounding pixels. Devices such as scanners and digital cameras can also use interpolation to create pixels in addition to those actually captured, thereby increasing the apparent resolution or color information in an image.

invert In image editing, to change an image into its negative; black becomes white, white becomes black, dark gray becomes light gray, and so forth. Colors are also changed to the complementary color; green becomes magenta, blue turns to yellow, and red is changed to cyan.

iris A set of thin overlapping metal leaves in a camera lens, also called a diaphragm, that pivots outwards to form a circular opening of variable size to control the amount of light that can pass through a lens.

jaggies Staircasing effect of lines that are not perfectly horizontal or vertical, caused by pixels that are too large to represent the line accurately. See also *anti-alias.*

JPEG (Joint Photographic Experts Group) A file format that supports 24-bit color and reduces file sizes by selectively discarding image data. Digital cameras generally use JPEG compression to pack more images onto memory cards. You can select how much compression is used (and therefore how much information is thrown away) by selecting from among the Standard, Fine, Super Fine, or other quality settings offered by your camera. See also *GIF* and *TIF.*

Kelvin (K) A unit of measurement based on the absolute temperature scale in which absolute zero is zero; used to describe the color of continuous spectrum light sources, such as tungsten illumination (3200 to 3400K) and daylight (5500 to 6000K).

lagtime The interval between when the shutter is pressed and when the picture is actually taken. During that span, the camera may be automatically focusing and calculating exposure. With digital SLRs, lagtime is generally very short; with non-dSLRs, the elapsed time easily can be one second or more.

landscape The orientation of a page in which the longest dimension is horizontal, also called wide orientation.

latitude The range of camera exposures that produces acceptable images with a particular digital sensor or film.

lens One or more elements of optical glass or similar material designed to collect and focus rays of light to form a sharp image on the film, paper, sensor, or a screen.

lens aperture The lens opening, or iris, that admits light to the film or sensor. The size of the lens aperture is usually measured in f/stops. See also *f/stop* and *iris.*

lens flare A feature of conventional photography that is both a bane and creative outlet. It is an effect produced by the reflection of light internally among elements of an optical lens. Bright light sources within or just outside the field of view cause lens flare. Flare can be reduced by the use of coatings on the lens elements or with the use of lens hoods. Photographers sometimes use the effect as a creative technique, and Photoshop and Photoshop Elements include a filter that lets you add lens flare at your whim.

lens hood A device that shades the lens, protecting it from extraneous light outside the actual picture area which can reduce the contrast of the image, or allow lens flare.

lighting ratio The proportional relationship between the amount of light falling on the subject from the main light and other lights, expressed in a ratio, such as 3:1.

lossless compression An image-compression scheme, such as TIFF, that preserves all image detail. When the image is decompressed, it is identical to the original version.

lossy compression An image-compression scheme, such as JPEG, that creates smaller files by discarding image information, which can affect image quality.

luminance The brightness or intensity of an image, determined by the amount of gray in a hue.

macro A camera setting (or interchangeable lens) that provides continuous focusing for extreme close-ups, often to a reproduction ratio of 1:2 (half life-size) or 1:1 (life-size).

magnification ratio A relationship that represents the amount of enlargement provided by the macro setting of the zoom lens, macro lens, or with other close-up devices.

matrix metering A system of exposure calculation that looks at many different segments of an image to determine the brightest and darkest portions.

maximum aperture The largest lens opening or f/stop available with a particular lens, or with a zoom lens at a particular magnification.

Memory Stick A proprietary Sony memory card used in the company's digital cameras, as well as other devices, including PlayStation video game consoles, camcorders, and music players. The original Memory Stick format was limited to 128 MB capacities; the company has since introduced the Memory Stick Pro, and smaller Memory Stick Pro Duo (which includes an adapter that allows the Pro Duo to be used in devices that accept the standard Memory Stick).

microdrive A tiny hard disk drive in the CompactFlash form factor, which can be used in most digital cameras that take CompactFlash memory.

midtones Parts of an image with tones of an intermediate value, usually in the 25 to 75 percent range. Many image-editing features allow you to manipulate midtones independently from the highlights and shadows.

moiré An objectionable pattern caused by the interference of halftone screens, frequently generated by rescanning an image that has already been halftoned. An image editor can frequently minimize these effects by blurring the patterns.

monochrome Having a single color, plus white. Grayscale images are monochrome (shades of gray and white only).

monopod A one-legged support used to steady the camera. See also *tripod.*

neutral density filter A gray camera filter reduces the amount of light entering the camera without affecting the colors.

noise In an image, pixels with randomly distributed color values. Noise in digital photographs tends to be the product of low-light conditions and long exposures, particularly when you have set your camera to a higher ISO rating than normal.

noise reduction A technology used to cut down on the amount of random information in a digital picture, usually caused by long exposures at increased sensitivity ratings. Noise reduction sometimes involves the camera automatically taking a second blank/dark exposure at the same settings that contain only noise, and then using the blank photo's information to cancel out the noise in the original picture. With cameras using this technique, the process is very quick, but can increase the amount of time required to take the photo. Noise reduction can also be performed within image editors and stand-alone noise reduction applications.

normal lens A lens focal length that makes the image in a photograph appear in a perspective that is like that of the original scene, typically with a field of view of roughly 45 degrees. A quick way to calculate the focal length of a normal lens is to measure the diagonal of the sensor or film frame used to capture the image, usually ranging from around 7mm to 45mm.

overexposure A condition in which too much light reaches the film or sensor, producing a dense negative or a very bright/light print, slide, or digital image.

pan-and-tilt head A tripod head allowing a camera to be tilted up or down or rotated 360 degrees.

panning Moving the camera so that the image of a moving object remains in the same relative position in the viewfinder as you take a picture. The eventual effect creates a strong sense of movement, especially if a relatively slow shutter speed is used to allow the background to blur.

panorama A broad view, usually scenic. Photoshop's new Photomerge feature helps you create panoramas from several photos. Many digital cameras have a panorama assist mode that makes it easier to shoot several overlapping photos that can be stitched together later.

parallax compensation An adjustment made by the camera or photographer to account for the difference in views between the taking lens and the external viewfinder.

PC/X terminal A connector for attaching standard electronic flash cords, named after the Prontor-Compur shutter companies that developed this connection. This connector is found on some EVF and digital SLR cameras.

perspective The rendition of apparent space in a photograph, such as how far the foreground and background appear to be separated from each other. Perspective is determined by the distance of the camera to the subject. Objects that are close appear large, while distant objects appear to be far away.

pincushion distortion A type of distortion, most often seen in telephoto prime lenses and zooms, in which lines at the top and side edges of an image are bent inward, producing an effect that looks like a pincushion.

pixel The smallest element of a screen display that can be assigned a color. The term is a contraction of "picture element."

pixels per inch (ppi) The number of pixels that can be displayed per inch, usually used to refer to pixel resolution from a scanned image or on a monitor.

polarizing filter A filter that forces light, which normally vibrates in all directions, to vibrate only in a single plane, reducing or removing the specular reflections from the surface of objects and emphasizing the blue of skies in color images.

portrait The orientation of a page in which the longest dimension is vertical, also called tall orientation. In photography, a formal picture of an individual or, sometimes, a group.

positive The opposite of a negative, an image with the same tonal relationships as those in the original scenes—for example, a finished print or a slide.

RAW An image file format offered by some advanced digital cameras that includes all the unprocessed information captured by the camera. RAW files are very large, and must be processed by a special program supplied by camera makers, image editors, or third parties, after being downloaded from the camera.

red eye An effect from flash photography that appears to make a person's eyes glow red, or an animal's yellow or green. It's caused by light bouncing from the retina of the eye, and is most pronounced in dim illumination (when the irises are wide open) and when the electronic flash is close to the lens and therefore prone to reflect directly back. Image editors can fix red eye through cloning other pixels over the offending red or orange ones.

red-eye reduction A way of reducing or eliminating the red-eye phenomenon. Some cameras offer a red-eye reduction mode that uses a preflash that causes the irises of the subjects' eyes to close down just prior to a second, stronger flash used to take the picture.

reflector Any device used to reflect light onto a subject to improve balance of exposure (contrast). Another way is to use fill-in flash.

reproduction ratio Used in macrophotography to indicate the magnification of a subject.

resample To change the size or resolution of an image. Resampling down discards pixel information in an image; resampling up adds pixel information through interpolation.

resolution In image editing, the number of pixels per inch used to determine the size of the image when printed. That is, an 8 × 10-inch image that is saved with 300 pixels per inch resolution will print in an 8 × 10-inch size on a 300 dpi printer, or 4 × 5-inches on a 600 dpi printer. In digital photography, resolution is the number of pixels a camera or scanner can capture.

retouch To edit an image, most often to remove flaws or to create a new effect.

RGB color mode A color mode that represents the three colors—red, green, and blue—used by devices such as scanners or monitors to reproduce color. Photoshop works in RGB mode by default, and even displays CMYK images by converting them to RGB.

saturation The purity of color; the amount by which a pure color is diluted with white or gray.

scale To change the size of all or part of an image.

Secure Digital memory card Another flash memory card format that is the most popular type of removable storage used in basic, intermediate, and advanced non-SLR digital cameras. They are also used in some MP3 players, digital phones, and other devices.

selective focus Choosing a lens opening that produces a shallow depth-of-field. Usually this is used to isolate a subject by causing most other elements in the scene to be blurred.

self-timer Mechanism delaying the opening of the shutter for some seconds after the release has been operated. Also known as delayed action.

sensitivity A measure of the degree of response of a film or sensor to light.

sensor array The grid-like arrangement of the red, green, and blue-sensitive elements of a digital camera's solid-state capture device. Sony offers a sensor array that captures a fourth color, termed *emerald*.

shadow The darkest part of an image, represented on a digital image by pixels with low numeric values or on a halftone by the smallest or absence of dots.

sharpening Increasing the apparent sharpness of an image by boosting the contrast between adjacent pixels that form an edge.

shutter In a conventional film camera, the shutter is a light-controlling mechanism consisting of blades, a curtain, plate, or some other movable cover that controls the time during which light reaches the film. Digital cameras can use actual shutters, or simulate the action of a shutter electronically. Quite a few use a combination, employing a mechanical shutter for slow speeds and an electronic version for higher speeds.

shutter lag The tendency of a camera to hesitate after the shutter release is depressed prior to making the actual exposure. Point-and-shoot digital cameras often have shutter lag times of about 0.5 seconds up to 2 seconds, primarily because of slow autofocus systems. Digital SLRs typically have much less shutter lag, typically 0.2 seconds or less.

Shutter-Preferred An exposure mode in which you set the shutter speed and the camera determines the appropriate f/stop. See also *Aperture-Preferred*.

side lighting Light striking the subject from the side relative to the position of the camera; produces shadows and highlights to create modeling on the subject.

single lens reflex (SLR) camera A type of camera that allows you to see through the camera's lens as you look in the camera's optical viewfinder. Other camera functions, such as light metering and flash control, also operate through the camera's lens.

slave unit An accessory flash unit that supplements the main flash, usually triggered electronically when the slave senses the light output by the main unit, or through radio waves.

slow sync An electronic flash synchronizing method that uses a slow shutter speed so that ambient light is recorded by the camera in addition to the electronic flash illumination, so that the background receives more exposure for a more realistic effect.

soft focus An effect produced by use of a special lens or filter that creates soft outlines.

soft lighting Lighting that is low or moderate in contrast, such as on an overcast day.

specular highlight Bright spots in an image caused by reflection of light sources.

spot meter An exposure system that concentrates on a small area in the image. See also *averaging meter*.

subtractive primary colors Cyan, magenta, and yellow, which are the printing inks that theoretically absorb all color and produce black. In practice, however, they generate a muddy

brown, so black is added to preserve detail (especially in shadows). The combination of the three colors and black is referred to as CMYK. (K represents black, to differentiate it from blue in the RGB model.)

T (time) A shutter setting in which the shutter opens when the shutter button is pressed, and remains open until the button is pressed a second time. See also *B (bulb)*.

telephoto A lens or lens zoom setting that magnifies an image.

threshold A predefined level used by a device to determine whether a pixel will be represented as black or white.

TIFF (Tagged Image File Format) A standard graphics file format that can be used to store grayscale and color images plus selection masks. See also *GIF* and *JPEG*.

time exposure A picture taken by leaving the shutter open for a long period, usually more than one second. The camera is generally locked down with a tripod to prevent blur during the long exposure. See also *bulb*.

time lapse A process by which a tripod-mounted camera takes sequential pictures at intervals, allowing the viewing of events that take place over a long period of time, such as a sunrise or flower opening. Many digital cameras have time-lapse capability built in. Others require you to attach the camera to your computer through a USB cable, and let software in the computer trigger the individual photos.

tint A color with white added to it. In graphic arts, often refers to the percentage of one color added to another.

transparency A positive photographic image on film, viewed or projected by light shining through film.

transparency scanner A type of scanner that captures color slides or negatives.

tripod A three-legged supporting stand used to hold the camera steady. Especially useful when using slow shutter speeds and/or telephoto lenses.

TTL Through the lens. A system that provides a view through the actual lens taking the picture (as with a camera with an electronic viewfinder, LCD display, or single lens reflex viewing), or which offers calculation of exposure, flash exposure, or focus based on that view through the lens.

tungsten light Usually warm light from ordinary room lamps and ceiling fixtures, as opposed to fluorescent illumination.

underexposure A condition in which too little light reaches the film or sensor, producing a thin negative, dark slide, muddy-looking print, or dark digital image.

unsharp masking The process for increasing the contrast between adjacent pixels in an image, increasing sharpness, especially around edges.

USB A high-speed serial communication method commonly used to connect digital cameras and other devices to a computer.

viewfinder The device in a camera used to preview and frame the image. Digital cameras may have an optical viewfinder, which is a window that provides a direct view of the image, bypassing the lens; an LCD viewfinder on the back of the camera that produces an image captured by the sensor; or an electronic viewfinder, which shows the sensor's view on a small LCD within the camera itself and is seen through an optical window. The viewfinder of a digital SLR shows the image seen by the lens reflected onto a focusing screen and viewed through a window.

vignetting Dark corners of an image, often produced by using a lens hood that is too small for the field of view, or generated artificially using image-editing techniques.

white The color formed by combining all the colors of light (in the additive color model) or by removing all colors (in the subtractive model).

white balance The adjustment of a digital camera to the color temperature of the light source. Interior illumination is relatively red; outdoors light is relatively blue. Digital cameras often set correct white balance automatically, or let you do it through menus. Image editors can often do some color correction of images that were exposed using the wrong white-balance setting.

wide-angle lens A lens that has a shorter focal length and a wider field of view than a normal lens for a particular film or digital image format.

xD card A very small type of memory card, used chiefly in Olympus and Fujifilm digital cameras.

zoom In image editing, to enlarge or reduce the size of an image on your monitor. In photography, to enlarge or reduce the size of an image using the magnification settings of a lens.

Index